CW00519539

TAKEAWAY HERITAGE

Core Refugee Radio Books

TAKEAWAY HERITAGE

TRUE STORIES FROM MEDITERRANEAN, MIDDLE EASTERN & NORTH AFRICAN RESTAURANTS

STEPHEN SILVERWOOD

Refugee Radio Books
Registered charity: 1133554
www.refugeeradio.org.uk

This edition 2016
Copyright © Refugee Radio 2016
First printed September 2016

ISBN-13: 978-0-9929374-2-3

Book written and designed by Stephen Silverwood
Research conducted by Euro Mediterranean
Resources Network and Refugee Radio

The first part of this book consists of interviews with the owners, managers, chefs, waiters and customers of Mediterranean, Middle Eastern and North African restaurants in Brighton. They were recorded by volunteers and staff from local charities, Refugee Radio and Euro-Mernet. The second part attempts to analyse the hidden heritage uncovered.

Note on the text: all quotes are based on verbatim transcripts and have not been overly edited into standard English. This is to preserve the sound of the speaker's voice and is not intended to be disrespectful. We all use grammar differently when we are speaking as opposed to when we are writing and people who have different first languages will construct English in different ways. Strictly correcting everyone's syntax would just airbrush out all of these interesting differences and would not stay true to the people speaking.

Contents

Part Two: Social History

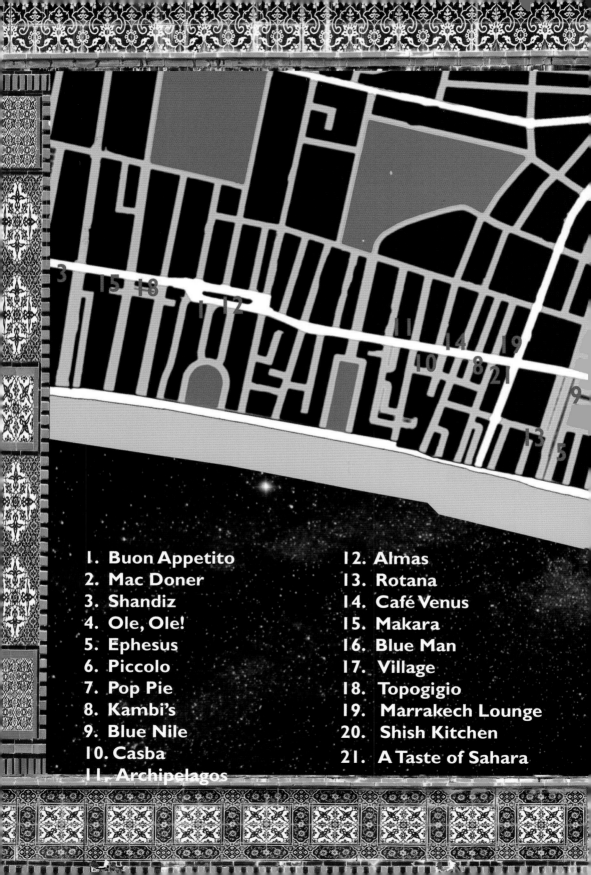

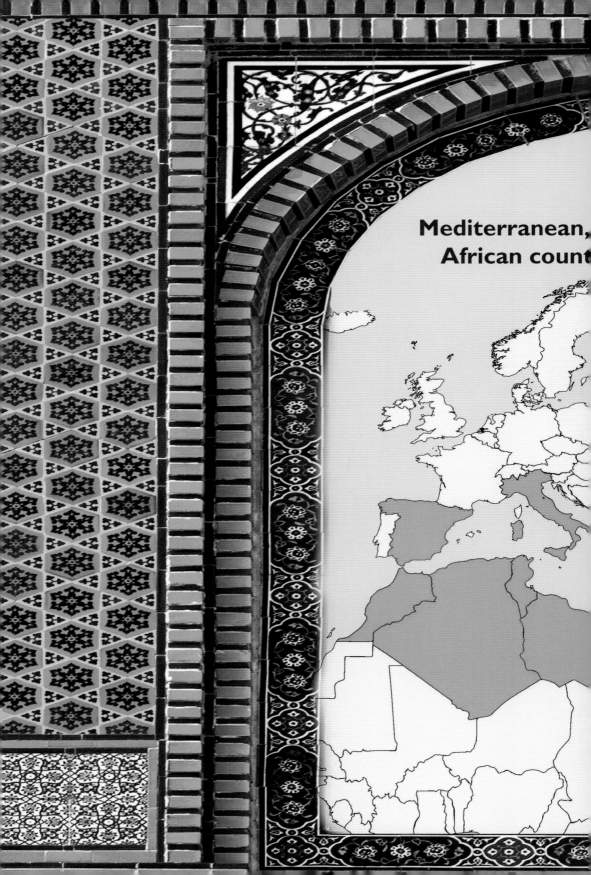

Mediterranean,
African count

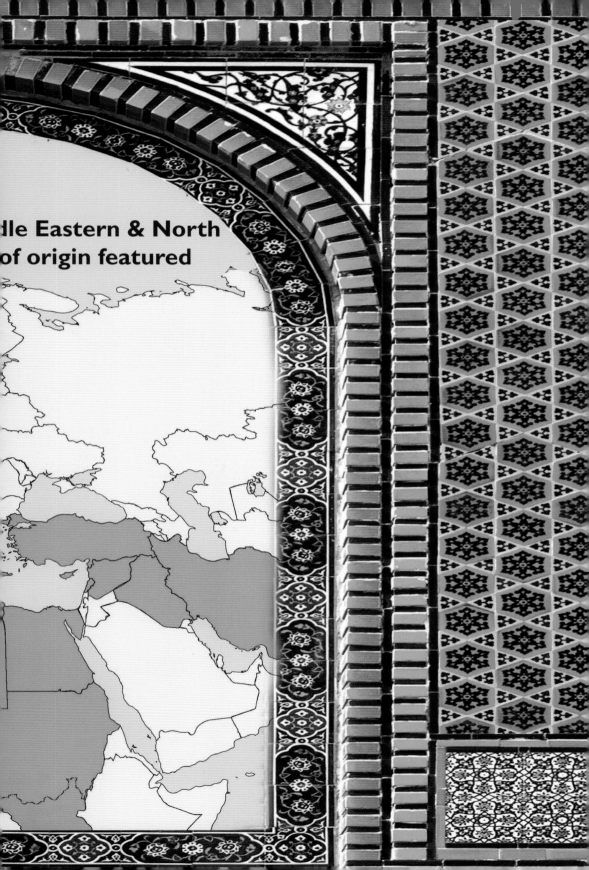

dle Eastern & North
of origin featured

Part One: Oral History

Buon Appetito

Buon Appetito is a family restaurant. And, like any good family, this one starts with a love story.

Early one morning, Eugenio Saulle was waiting outside his father's restaurant to open up. He had been working there since he was fifteen years old, helping his father serve the customers from their little seaside village. As he waited that morning, Eugenio saw a woman approaching. He recognised her as one of the women who worked in the kitchen. Every morning when they opened up, the staff would gather to drink coffee and chat. This woman had often told Eugenio about her children, including her two young boys and also her daughter who was around the same age as him. Maybe he had thought nothing of it, but later that day a girl came in to drop off some keys for her mother. Eugenio saw her come in and he said to himself: "Who's that girl?"

Eugenio is a family man, through and through, and this is intrinsically part of his business. His decision to move to England to start an authentic Italian restaurant was simultaneous with his decision to start a family.

Since his boyhood helping out in his father's restaurant in their village, Eugenio has devoted himself to the family business and in the past two decades he has launched four successful restaurants in the South East of England

while winning acclaim from customers and reviewers. He feels that family is critical to his success and you can see this from the way some of the staff even call him Papa.

"It's still run as a family business. My wife is involved, my brother, my brother in law. So we are a big family. Everybody cooking in the kitchen. And then we got really good staff around me. We got one chef here in the kitchen in Hove, he's been nine years with me and he does an amazing job, so it's a very long time. And all the staff around like to work with me because they feel like their own home. Some them call me Papa. It's good because most of the staff that work with me, they come from a foreign country, not from England, and they need someone to say: 'Come on, I'm beside you, don't worry', you know, every day you need a sweet word to them. You need respect and passion. Buon Appetito is a family restaurant for the customers and for the staff. In fact, we got lots of customers that's really regulars in here. When they come

in they say: 'Eugenio, when I come in here, I feel like it's my home'. Most customers come with family, you know, when they got relatives come from London or other parts of England, they bring them here to say: 'Look, she's my daughter' or 'She's my sister, this is Eugenio, this is my best friend, we come to see you'. It's very important. I like that."

For three weeks, Eugenio didn't see the girl again, but he thought about her and about how much he liked her. His father's restaurant was usually closed on Wednesday so the staff could have a day off. But on the following Wednesday Eugenio saw her again with her mother and her baby brothers. He was introduced to her and it was: "Nice to meet you, bye-bye," and she was taken inside. Eugenio was left outside wondering what to do. That might have been the end of the story. But then he saw her five-year old brother and, in a moment of inspiration, Eugenio said to him, "Call your sister. Come out. Call your sister." And she came outside and started to talk and, as he says, everything went from there.

There are over five thousand Italian restaurants in the UK (not counting pizza takeaways) with a turnover of more than £1billion every year. Last year the Guardian newspaper reported that Prezzo alone boasted profits of £17million. And the trend is nothing new. La Lombarda in Aberdeen's Castlegate area was opened in 1922; while the Ristorante Italiano in Curzon Street, London, was opened in 1936. The invention of the espresso machine in 1945 paved the way for the modern café boom that continues today. But the roots of Italian culture in the UK go back even further.

Ever since the Roman Empire colonised Britain two thousand years ago, Italians have maintained a small but steady presence. Lombard Street in London was named after a community of Italian merchants in the year 1000AD. In the early 1800s, more Italian immigrants journeyed to the UK in response to the turmoil of the Napoleonic wars, bringing ice-cream makers from the Liri valley, organ grinders from Parma and artisans from Como. Most of them settled near St. Peter's church in a part of Clerkenwell that became known as Little Italy. By the time of Jack the Ripper there were four thousand Italians but by the turn of the 20th Century there were ten thousand, a figure that had doubled by the First World War.

Today, the dire economic situation in Italy has seen youth unemployment rise to more than 43%, and this has fuelled further emigration. Most travel to Germany and Switzerland but the UK still remains popular. Around fifty thousand Italians register for National Insurance numbers in the UK every single year, according to Italian newspaper The Local.

Eugenio got the idea of moving to England when he visited the country on a school trip. He was impressed by the difference between England and Italy, especially the way that life and society were better organised and the idea that if you worked hard you would be rewarded.

"When I come in here, I feel like it's my home"

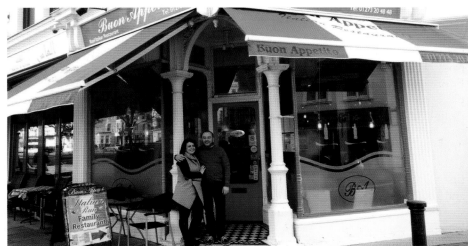

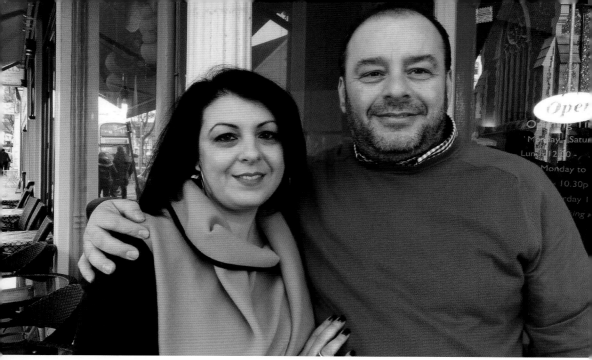

After he met Enza, they discussed whether it could be a good place for them to build up their family life. But Eugenio had to wait until the end of the summer season in his father's place before he could leave, as his father needed his help.

So it was not until the winter of 1995 that he came to England, the year Robson & Jerome battled with Shaggy for the Number-one in the Singles Chart. Eugenio had to come alone. He was keen to learn English and to work for an English company so he found a job in a pizza restaurant and started to convince himself that it really could work.

Two years later, Eugenio and Enza were married, on the 18th January 1997. Money was tight as they were saving to realise their dream of opening their own restaurant. They didn't honeymoon but five days after their wedding party they left Italy to start their new life in England. They rented a small one-bedroom place and furnished it with anything they could, including an old beer crate for a bedside table.

"From then I was working double: morning and the night. In fact five o' clock I was finished first place and six o' clock starting second place and I was passing the house where we lived: she was waiting outside with a panini in her hand and was opening the window, catch the panini, boom, go! It was a pit-stop for me."

Enza found work in an Italian delicatessen and after four months came the news: she was pregnant with their first baby, and then shortly after came their second baby and then their first restaurant. "I was in the morning, bring the kids to the nursery, because one was four years old and Melanie she was two years old," Enza says, smiling at the memory, "And in the morning take them to the nursery and go to work in the restaurant: cleaning, preparing the kitchen, staff, everything, and two thirty close the restaurant and go picking up the kids, you know. Mummy life. And seven to put the kids to bed and go downstairs to work and make sure the kids were asleeping and I had this baby monitor in the kitchen with me to hear the baby upstairs."

Their first restaurant was a small twenty-six seater in Haywards Heath, West Sussex. The early days were a struggle for them to juggle everything between just the two of them and the baby-monitor, but they always insisted on fresh ingredients and fresh pizza dough and they never used a microwave, unlike some other restaurants, and their customers could tell the difference. Before long, the restaurant was a success and expansion was soon on the cards.

"On the weekends it was so busy we had a babysitter to make sure the kids was fine. And my job is I was cooking, washing up, pizza, everything, and when Eugenio was finished on the floor he would come to the kitchen to help me to finish. Nothing was very hard for me because I was a mum working in the restaurant, everything, but it was all fine in the end. We did it, but we were very happy to do it, because it was our life and our decision to do this and we always loved each other, never fighting in the kitchen."

I met Eugenio and Enza on their nineteenth wedding anniversary at their Hove restaurant, Buon Appetito. It is situated on the corner of one of Hove's pleasant Regency squares and is marked by the architectural characteristics of the area, with columns framing the doorway and a marvellous wrought iron arch over the classic check-tiled step in the Brunswick style. It gives an appropriate hint of Palladian romanticism as you enter the Tricolore canopy.

I was accompanied by Umit Ozturk and Debora Barletta, who thoughtfully brought a bunch of flowers to celebrate the wedding anniversary. I had first heard about Eugenio through Umit, who told me that he was a very friendly man who ran an Italian restaurant at the top of his street and who was also a musician. This was exciting for me as I love music and have played in lots of bands so I was keen to talk to Eugenio about his music when I met him. But he shook his head and said, "No, no."

I was really puzzled and demanded that Umit tell me where he got the idea that Eugenio was a musician. Eugenio quickly interjected, "I understand why you said this. Because a certain someone lives just at the back of the restaurant and when he passes by every night he can see me with a little guitar in my hand without strings! We pretend to play music with the castanets to 'That's Amore' song, the one by Dean Martin. We do that with the customers because it's very nice. Yeah, in the night we switch off the lights with the candles all on the table of course and we come with this song. I will be with the guitar pretending to be playing it and then we come out with cooking pans and give the customers the spoons, bang bang, bang! Very nice. I like it. Very nice and successful. Everybody love that." I understood the situation. Every night on his way home, Umit had walked past the restaurant and seen Eugenio serenading the customers without realising that the guitar had no strings. It was an air guitar act with Dean Martin instead of the usual headbangers.

Italian food in the UK has come a long way since the time of the Romans and there have

"That's Amore" was written in 1953 for the film The Caddy where it became Dean Martin's signature song.

Martin was known as the King of Cool and was a star in the original Rat Pack version of Ocean's 11.

been many changes. There are now several large chains operating across the UK. The biggest is Pizza Express, whose first restaurant opened in Soho in 1967 and who now have more than four hundred branches. Papa John's and Prezzo both have over two hundred each. But many of the places serving Italian food are not run by Italians anymore and some of the Italians we spoke to said that this meant they were less authentic. It is a concept that is explored in more detail throughout this book.

Eugenio and Enza pride themselves on providing genuine Italian food and an Italian run family restaurant and they believe their customers can taste the difference.

Enza and Eugneio now have four children and their oldest is now eighteen, "He is a waiter now," says Eugenio, "In a restaurant every Friday and Saturday and, you know, because he was asking me money-pocket I say ok, if you want a money-pocket do as I did when I was your age!"

Who knows, now that their son is working as a waiter, much like his father when he was a teenager, perhaps one day a girl will walk in to the restaurant and turn his head too, leaving him to wonder, "Who's that girl?"

We say, "Buon anniversario, Enza e Eugenio!"

Buon Appetito, 81 Western Road, Hove BN3 2JQ

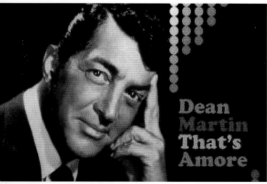

Mac Doner

I used to think that cooking was just about food. But after I visited Buon Appetito I got to thinking about the connection between food and family and what it means in our modern world. In the UK today, only two-thirds of children live with their birth parents. Then there are single-headed households and reconstituted families with second-spouses and step-children, not to mention adopted families and foster families. Increasingly, it seems, we can't just define family by the traditional nuclear unit of immediate relatives but instead perhaps by the process of being a family and of being together. And what more central activity is there in this act of family life than that of cooking and eating together?

When I visited the Mac Doner kebab shop on St James Street, I learnt that cooking is basically about family. On some level, sharing food together is the most active expression of being a family. On the one hand you have a self-proclaimed, "family restaurant" like Buon Appetito that is run by a husband and wife team but on the other hand there are the single Kurdish men of Mac Doner who found themselves alone in exile without the traditional family unit to provide for them. In response, they decided to cook together and create a new kind of family.

I sat down with Awat, a good-natured worker who loves cooking. When I asked him how long he had been cooking for, his answer surprised me. He said, "Lets call it since I been alone in England. Mummy's not around, so..." his voice trailed off.

◀ **Jowanro the chef stands outside the Mac Doner on Brighton's St James Street**

"All the family is together. They sit at the same table and they're always a group. It is always more enjoyable than when you eat alone."

"What it is: in this country when boy or girl they turn eighteen, they have right to leave the family and go wherever they like. In our country they don't go anywhere until they get married, so they stay with the family, so all the family is together. They sit at the same table and they're always a group. It is always more enjoyable than when you eat alone. You get used to it. And in this country, for example, when I cook, I phone my friend. I invite my friend over. I say: 'Come around, I cook something, let's having it together and have a laugh and joke and tea after'. And yeah. How it works. That is the main part of it. That's right. That's what it is."

So the single men from this traditional culture who had never really cooked before found themselves living alone, separated from their home, seeking sanctuary and asylum in a new land. And after a few years they decided to come together to cook and share food and create a kind of surrogate family in exile. This act of cooking and eating together must have been hugely reassuring and bonding for them as they found their feet.

But then something even more interesting happens: many of them find work in the world of catering and then go on to establish their own takeaways, continuing the process of cooking together and eating socially as a cornerstone of their integration into their new community.

I had previously assumed that catering was just a broad-access labour market, like taxi-driving or care-work, where refugees and migrants could easily find work without necessarily having any transferrable qualifications. After all, I had met many people who had worked as doctors and lawyers in their home country who were now driving cabs and waiting tables. But now I began to realise that there was something more meaningful about the role of food. I knew that food, like music, had the ability to cross borders, create new fusions and collapse the boundaries between different people, but I had not given any thought to the way that cooking and sharing food would make someone feel.

I began to see the kebab shop as equivalent to a transnational public house; a way of opening the home and heart to strangers and to share something of your culture in the way that the British share drinks.

Kurdish culture is very traditional, with a heavy emphasis on the family. But today that culture is affected by a huge diaspora, with over a million Kurds living outside their homelands. Most of these are living as refugees in Germany but there are at least fifty thousand in England and Wales, with communities growing in Hackney and Haringey. There are at two Kurdish community groups in Brighton. Both hold Newrooz parties for their New Year celebrations where they can indulge their love of traditional music and food.

"Personally I like cooking," said Awat. "Is everybody got a different habit so my habit is very much cooking. I start cooking since 2005. I put so much effort into the cooking because when I want to cook something I spend time with it to make sure it is as perfect as possible. I don't like to cook something which is not tasty, not nice. I like to do something nice and enjoyable. Otherwise I wouldn't cook."

Mac Doner is something of an institution in St James Street, where it is famous for its freshly baked naan bread. This is an unusual addition to the usual kebab shop menu which normally relies on serving kebabs in ready-made pita bread. "This place has been a kebab shop for quite some time, over 30 years," according to Awat, "and we made slight change into a Kurdish style, if you call it, because we do a different style of kebab and shawarma and we add into the fresh naan bread which all our customers love about it. We been doing that over a year because in my country every corner of the street you will find one, so everybody have that fresh bread every day, so it's normal to us to do that so as we want to make some things different compared to just having pita bread. Instead of pita bread we decided to have fresh naan bread and let's see whether people in the area are interested or not. It seems people were interested a lot and we become a bit famous in the area.

"We are still doing doner kebab which is not our style but is Turkish style. The doner kebab is famous in England. Most majority of our customers are English and they love doner kebab so we didn't touch that. So overall not much is changed but slight. Specially kofte kebab we make our own style. We literally just do a pure meat. We don't add anything on it. And just you feel that you just feel the meat, you don't find a different taste: you just feel you have a proper meat. And chicken shawarma, we get the fresh meat twice a week and slice it thin as possible and then when you put them in a burner will grill it properly. You don't feel like you eat a cooked meat, you feel like you eat a grilled meat. Which has become nice and crispy. This is the idea."

Freshness is important to Awat in his cooking. "Obviously, yeah. Hundred percent has to be fresh. The meat has to be checked. If I'm not find it, I'm not happy with it. Reject it. Has to go back. Not accept it. I would not give it to the customers something which is I don't eat it." Awat agrees that there are differences between the meat he cooks with in the UK and the meat he was used to back home, "Obviously, yes, you do because in this country

"I say: 'Come around, I cook something, let's having it together and have a laugh and joke and tea after'."

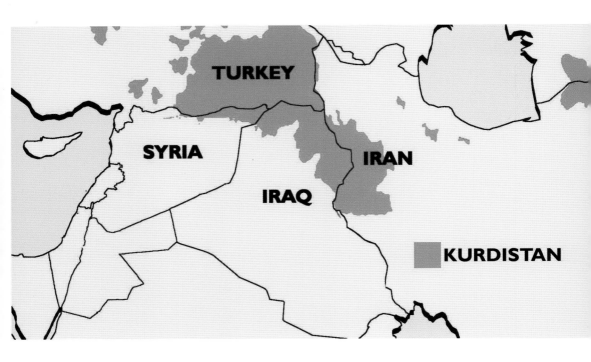

TURKEY

SYRIA

IRAN

IRAQ

KURDISTAN

Kurds are one of the largest ethnic groups in the world without a state. Their home, known as Kurdistan, is not recognised as a country. Ever since the First World War and the partition of the Ottoman Empire, their land has been split between Turkey, Iran, Iraq and Syria.

Kurds in Iran have long suffered discrimination by the state and are denied equality in employment and political participation. Dozens of activists and journalists have been arbitrarily arrested and imprisoned, facing torture and execution without proper trials.

Under the Assad regime in Syria, the Kurdish language was banned and the culture was outlawed. Children were not allowed Kurdish names and even wearing traditional dress could land you in serious trouble. The government's multiple security agencies routinely detained people without arrest warrants. Torture was common and many people were, "disappeared" by the secret police. Since the Civil War began in Syria, many Kurdish people have been caught up in the international refugee crisis, including the desperate crossings of the Mediterranean Sea. The single most famous image of the crisis was of the tragic drowning of three-year of Alan Kurdi who had fled Kobani with his family to escape Daesh (ISIS).

Kurdish people in Syria have been fighting to reclaim their lands from Daesh. They have declared their independence from the Syrian state and have abolished the laws that repressed their culture, introducing freedom of religion and equality for women. In fact, many of their fighters are women, who

There are thirty million Kurds, all without a homeland.

Most are split between the countries of Turkey, Iran, Iraq and Syria.

state that Daesh are afraid of them because they believe they cannot go to heaven if they are killed by a girl.

However, the military action of Kurds in Syria has exacerbated the incursions of Turkey to the North. In Turkey, Kurdish people have been persecuted and displaced for years, with millions forced from their homes by the Turkish Army. Human rights abuses committed against the Kurds have always been one of the key obstacles to Turkey's hopes of ever joining the European Union. Now the situation is far worse, with the Turkish Army shelling the Syrian Kurdish militia in Aleppo, in violation of the Russian ceasefire at the time of writing. There are also increasingly alarming reports of human rights abuses on the ground, including assassinations, such as that of human rights lawyer, Tahir Elci,

who was murdered in broad daylight at a press conference in Turkey when he called for an end to the violence.

As well as fleeing to Turkey and Europe, there are vast refugee camps in neighbouring countries such as Iraq, where the Kurds have established an autonomous region following the Western invasion. There are now around a million refugees in Kurdish Iraq alone, a reversal of previous years where Kurds were forced to leave Iraq because of persecution by the government of Saddam Hussein. When he was finally captured and put on trial, one of the main charges against Hussein was the campaign of genocide against the Kurds in Al-Anfal. His cousin, "Chemical Ali", was convicted and executed for his role in the poison gas attack that killed five thousand Kurds in Halabja.

the meat is fast-growing, but in our country is organically grown so obviously if it's organic is taste different. For example, the chicken here is take just forty days, I believe, to grow up! And the lamb is fast-grown here also. I don't know how they do it. In our country, it takes a long time to grow because they grow up in the mountain, and they take them to the village and they look after the organic side of it. They don't give them anything, no chemicals. I mostly grew up in the city but also we had a place in a small village in the mountains."

St James Street in Kemp Town is a long way from a Kurdish mountain village. It was the first shopping area outside of the Brighton Lanes to be developed and was originally the home of Brighton's wealthier residents. The street has never been widened and retains many of the original early 18th century houses but retains little else of its high-flying heyday. Now it is a crowded one-way street of tall terraces with dark side-roads, dotted with empty shops and a serious litter problem. The noted Lyons Corner House was converted into a Jobcentre in the 1970's and is now a Sainsburys Local. A recent report by the BBC claimed that 95% of residents feel unsafe in the St James Street area and avoid it at night due to the amount of street drinking and begging. But St James Street is also the entrance to Kemp Town, Brighton's gay district, and is home to many of the scene's landmarks such as the Bulldog pub and Legends. For many visitors it is a buzzing and cosmopolitan nightspot, welcoming to transvestites and funseekers alike. Before the drinking laws were relaxed, St James Street was the one place in town to buy alcohol after hours and was often packed with scores of drunken twentysomethings trying to keep the party going. In times past it was home to a Jewish Deli and a pie shop that was famed for its hot beano pies. Awat and his colleagues at Mac Doner love the street and feel like they are a part of the scene, "I would say it is a kind of a small different community, for gay community. They love this place. The majority of them come here and we're friendly and they really like us. Is kind of different place from the other part of Brighton."

"Each time the new people they come in here they say, 'That was the best kebab I ever had!' and walk out smiley faced and thank me for ten times!"

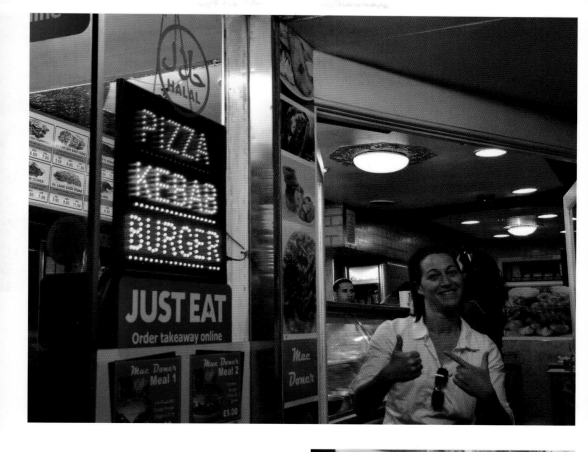

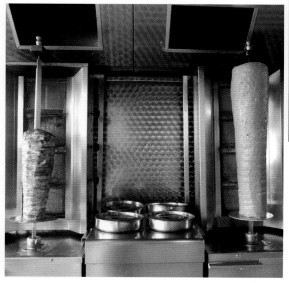

◀ The traditional British doner, also known as a "döner kebap"

Mac Doner attracts a loyal crowd. "We got mostly our regular customers. The majority of our customers come in here, they know us very well and day after day they introduce more people and more and more and more. Because they never have any problems with the food they always feel good about it and they always happy. And each time the new people they come in here they say, 'That was the best kebab I ever had!' and walk out smiley faced and thank me for ten times!"

Jowanro, the Kurdish chef from Iran, agrees, "I have a lot of regulars. Eighty percent of my customers are regular. I know straight away fifty, sixty customers when they come in I know how they want. They ask for burger, pizza, shawarma. I know how they want. I see them coming, I put it straight on for them. They say, 'Oh you already put it on!' I always have time for them." When I visited the shop at lunchtime it quickly filled up with a nonstop flow of people from all kinds of backgrounds: Japanese, German, Russian, Turkish, all of them young and all of them hungry.

Jowanro has been in the trade since he came to the UK. "I like it. Since I come to this country I work only in kitchens. I worked at Piccolo's and I worked at the American Diner for four years. I was head chef. I was starting

as a kitchen porter and slowly I was always helping with chef. It wasn't my job but they was always happy, I was always hard working. Hygiene is good to know about it, but some people they don't know anything. If you work in someplace you have to know everything about it. If you work in a kitchen it's different to working in this place. You don't see the customers, so it's less stress but I like working here. If you work in a fast-food kebab place you always at night get drunk people. You have to be patient and handle it, not argue with people. My old boss said: 'How you gonna work there, how you gonna do?' It's more hard seeing people everyday, but it's my place, I have to be nice to people. It's customer service."

One of the things that initially attracted me to the business was the name. "It was Shawarma Express before here," says Awat, "and we sat and came up with the idea. Just literally come up. When I heard the name 'Mac Doner' I thought 'Ah, that's a perfect idea for American side of it or England side of it they love the name.' So I said 'Why not? Let's go for it'. Mac Doner. It just seems to be connect with a name and a kebab same time. There is some people in America whose name is actually 'Mac Doner'. So I saw a lot of people they take a picture of the sign outside. They were surprised and they called each other and they

say 'Mac! That's your name here!'" The signage outside the shop is very eye-catching. It has the classically brash exterior of bright colours and shiny surfaces that is common to many kebab shops but in a cheeky manner that is quite British in a way, like Two Tone music or the Carry On movies. It was a deliberate move. "Because I wanted something powerful. When you look at it, for example when you look at that picture of a tomato and vegetable, it just takes your interest. I want to do something like this. Instead of a sad and uncomfortable colour. I want something powerful to take your interest." The interior combines the typical glass and wipe-clean plastic surfaces with an array of Aladdin's Cave-style details

such as archways and flying carpets, but these were inherited from the Shawarma Express and Awat is fairly dismissive of them, "Previously they been there. I have no idea. It was a Kurdish guy who done that. He put the carpet on the wall. Kurdish, Turkish, Persian, Arabic, it's just traditional. They all have that."

Awat has been married for one year now and they are expecting their first child, a boy. Now that he is starting a family of his own he does not cook at home so much and leaves that to his wife. She is, he says, a very good cook and her food is delicious. It would have to be.

Mac Doner, 116 St James St, Brighton.

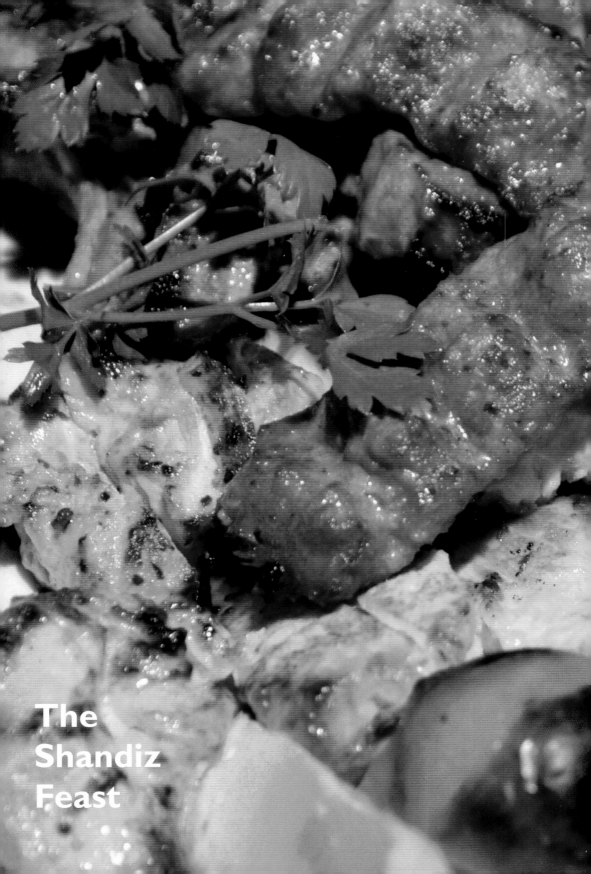

The
Shandiz
Feast

Shandiz

This is the story of how I was nearly murdered by hospitality.

The restaurant business is known as the hospitality industry, and many cultures pride themselves on their hospitality to guests, but they take it to another level in Iran. The Persian culture has a concept called, "ta'arof". It is a code of etiquette governing things like being a good host or worker or even a customer in a shop. It is a bit like the typically English performance involved in offering to pay for the bill when you are out with someone senior to you and you know they are going to pick up the tab, but you feel obliged to fumble about for your wallet anyway. The process of ta'arof is much more ritualised, though, and just offering a cup of tea involves a series of refusals, counter-offers and refusals that would embarrass even Mrs Doyle from Father Ted. Similarly with food, there is an obligation to decline an offer of food several times, no matter how hungry you are, while your host insistently piles up a huge plate of food, which you will then eat no matter how full you are and then, when you think you could not possibly eat any more, the process begins again with another plate. Which you will also eat. And then dessert.

I had no idea about all of this before I visited Shandiz, an Iranian restaurant in the smart corner of Hove. But I had a much better understanding when I rolled out after a delicious feast, several hours later and several stone heavier.

My would-be assassin was the restaurant's frontman, Ashkau, who runs Shandiz with his older brother, Amir. Ashkau is a cheeky presence in love with his licence to kill with kindness, like a Persian version of James Bond. After our interview, he summoned forth a kingly banquet of Iranian food that would have felled six people. And we were halfway through when he revealed that this was just the starter…

Ashkau moved from Iran to England when he was five years old. "I was a good kid, actually. I was a good kid. I think so. You can quote my mum on that!" His mother was from the capital, Tehran, but his father was from Ahvaz in the south, where his business involved importing and exporting homeware and kitchenware. "It was much better for him there, but then we moved over here and slowly, slowly started getting into the takeaway game. Of course, when you first come here from any country you first go into a kitchen, most people do."

Ashkau's father started working with his uncle in the old Open Grill takeaway in Brighton's Preston Street, which he eventually bought and started running himself. A succession of takeaways in Brighton followed, including Bodrum and Nayeb, but young Ashkau was never interested in joining the family business. "I was younger then and I wasn't really into work. I was a mummy's

▶ **Persian tea**

▶ ▶ **A bowl of ruby- coloured barberries, the sweet and sour berries used in Iranian recipes.**

▼ **Faloodeh, an Iranian cold desert of rice noodles in sugar and rose water**

boy so I could get money off her and never work but now it's time to get to work. It's a bit late now! I'm twenty five. I got away with it for a very long time. It's been a week now I haven't taken any money from her. No, I'm joking…" he says, laughing. Ashkau has a mischievous sense of humour about his own history. "I went to university for a year but I didn't attend many lessons so I thought if I'm not gonna do this properly then I might as well not waste my own time. I only went to university cos my mum said she'd buy me a car if I went. So I went to university and I got the car and then I stopped going. So that was it." He leans in to the microphone and adds, "I hope she doesn't listen to this!"

When I asked him what he studied at university, Ashkau smiled. "Business. Like any other Iranian." There was no interest in food or cooking before he started working at Shandiz. "Not at all, no, no. The only reason I really clicked with this place was not because I am a chef or anything, it's just that I like to talk to people. I like to be around people. That's the thing I like about it. I couldn't work in the kitchen. I couldn't make any of the food. I only like socialising with people when they come here, having a good time. That's how I pass time. I work most of the day, twelve to twelve, but I don't get bored. Cos there's always new people coming in, new people to talk to, and most people that come in here are fun and not moody or anything. Well if they come in moody they're not leaving moody, so…" he laughs again and points towards the counter. "I have a guitar there. I don't know how to play but I do bring it out

sometimes and pretend to play. Just strum it along, just tap it a few times, that's it. I create my own songs. Just having fun. But it's good to have fun, it's a whole experience. When you wanna go somewhere, you wanna have fun. Let your hair down, have a nice time, sit down. It's really fun when it's someone's birthday: everyone in the whole restaurant, we have some lights as well, get fireworks going off in here, clapping, everything."

Shandiz prepares traditional Persian cuisine cooked on a charcoal grill. They employ a noted chef from London whom they bring down to Brighton every day to the kitchen. The restaurant has a mixture of bright tables near the bar by the front windows and cosier booths at the back for more intimate dining. It is decorated throughout with fine Persian tablecloths and paintings and there are neat little touches like the Polaroid wall by the dumb waiter and the samovars in the wooden shelving.

It was Ashkau's father who originally came up with the vision for the restaurant two years ago. "We had a load of takeaways before but this was the first proper restaurant we opened so it was a bit different for him. He had a lot of experience before with this kind of business, though. That's what the basic thing is: if you don't know how to do something then you don't get into it really, do you? If you don't know how to cut hair, you don't open a hairdressers do you? Well, some people do but it doesn't last very long, does it?

"A sit-down restaurant is quite different to a takeaway, as when you get a takeaway and you get the food home it doesn't feel the same, so it's much better when you have it here hot, in front you. By the time you get takeaway food home, it's cold, so it's not the same experience. It's got a different feel to it. Some people say, when they come in here, they say they feel like they're somewhere else anyway, they don't feel like they're in Brighton. And they say the service is really good. So that's down to me, I think! I'm the frontman. I speak to the customers, welcome them in. That's a whole little thing. It doesn't matter how good the food is, some people come for the service. You

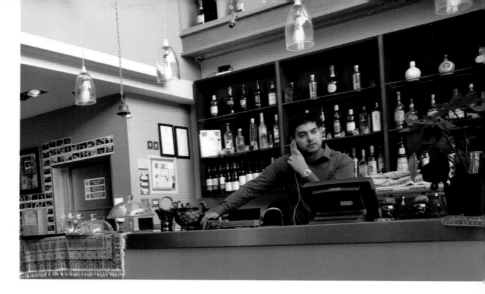

▶ Amir, the "serious one", mans the bar by the Polaroid wall

have to be very nice to people. It doesn't matter if you got really good food but bad service, people are not gonna come back. Good service keeps the people coming back for more."

Ashkau runs the restaurant with his brother, who is older by five years. In Iranian culture the older brother has quite a lot of seniority to the younger siblings. "In Iranian culture, yes, but we're in England right now," laughs Ashkau. "We have to adapt to English culture!" The brothers have a clear separation of duties that avoids conflict. "His role is to keep the money so I don't spend it! He's like a back office kind of guy but he still works here in the front sometimes. He's the more serious one. But you do need that in business, don't you? You need someone that's fun but then you need the more

serious one. He's more serious." I asked him if they were like Lennon and McCartney, with him as the more light-hearted McCartney figure but he decided that he wanted to be John Lennon instead, "I think I'm more John Lennon because he was the wild one, wasn't he? I'm the wild one in that way."

When his father and brother sat him down to pitch the concept of a new Iranian restaurant, Ashkau was unconvinced. They really wanted it to happen but he told them he didn't think that it would work. He told them that there had been a number of Iranian restaurants in Brighton before but none of them had endured. "So I didn't think it would work. But it has. And we're still here. Two years, four months, three days, two hours and thirty

▶ Ashkau, the "John Lennon" of the pair

▲ Iranian tea and baklava

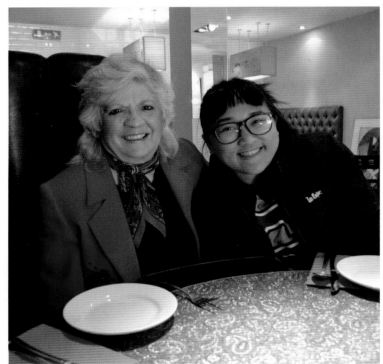

▶ Farah and Shintya preparing for the Persian feast

Migration to Brighton and Hove

The largest groups of migrants to the city for the past thirty years have been Iranian, Chinese and Sudanese.

Most of the Sudanese community are Coptic Christians who claimed asylum due to persecution of their religion by the Muslim Brotherhood and settled in the city as refugees. Some are originally from Egypt, which is where the name, "Copt" comes from.

The Iranian community was originally made up of people who fled to the UK in the late 70's and early 80's after the Islamic Revolution against the Shah. In the decades that followed, people left because of persecution for reasons of their sexuality or religion (including Zoroastrians, Christians and Bahá'ís), as well as those who migrated for trade.

There are dozens of international language schools in Brighton and the two local universities account for six thousand student visas every year. Some of these students stay on in the town and join the newer migrants from Eastern and Central Europe.

The UN Gateway programme relocated eighty Ethiopian refugees to Brighton in 2006. Since then, the city is no longer used by the government to accommodate asylum seekers. The number of new refugees to Brighton has fallen, but there are still a few people every year seeking refuge from places like Syria, Afghanistan, Zimbabwe and the DRC. Local charities like Refugee Radio continue to provide advice and support to new arrivals and information for the host population to help overcome barriers.

seconds later!" It is strange that none of them had succeeded before, because there is a well-established community of Iranians living in Brighton and Hove and you might think it should be a certainty, but Askhau said that several establishments floundered after the first six months when business dropped off. "They start well but then they just go really bad downhill. But in my opinion since we opened up, we been going uphill. Our standard of food has even got better. And that's not from me saying it, it's from other people." He says that the other places run by Iranians in the town are either Arab-style takeaways or actually Italian restaurants, an anomaly that has puzzled the Italian-run restaurants we have interviewed but which includes some very popular destinations.

So what has been the secret of their ability to endure as an Iranian restaurant where the others have failed? Ashkau responds with a twinkle in his eyes that it is all down to his management. "I don't get bored here, that's the thing. I do work a lot and it is fun. That's why I think it's still open, cos after two years of that, if you get bored of it then you lose the passion. But no, I like it still. And it all depends on the management, how the restaurant is

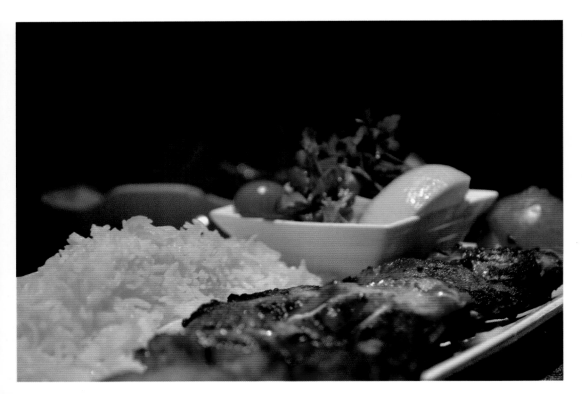

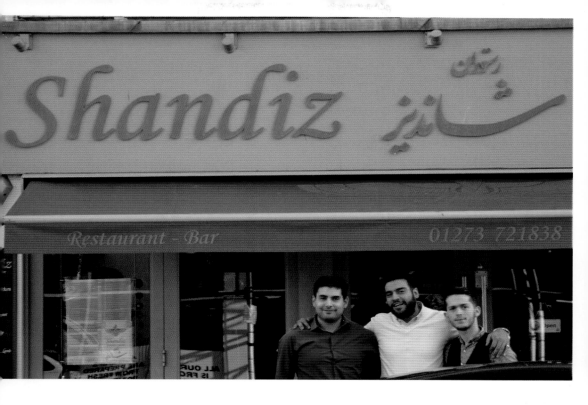

run. If I act bored or act tired then everyone else is gonna do that. But if I act happy then everyone else is gonna be happy. If I treat my staff well, they're gonna be happier. They're gonna set the food down better. If I want to start going up to the kitchen and shouting and being horrible to them, then the quality of the food is gonna go down. It all depends on it. We're all a family here. It's not like staff here. We don't have staff here, it's like a family." This is borne out by the fact that the workers in the kitchen have been with them since the start, something quite unusual in the world of hospitality which is so characterised by high turnover and employee dissatisfaction. "It's cos we treat them very well. When they first came here they didn't think they were gonna stay very long as well, cos of their previous experience in other places, but here it's good."

Ashkau does not remember his early childhood in Iran but he likes to visit his family when he can. He does like to preserve some traditions from back home, however, including the idea of ta'arof. "My favourite dish here is the Shandiz Feast but I've never done it on my own yet.

It comes with four starters and naan and then you get a selection of the charcoal grill. You get lamb chops, you get the koubideh, you get the joojeh, you get the barg. You get a lot of things. You get one stew as well, ghormeh sabzi, gheymeh, gheymeh bademjan bamieh or fessenjan. All of them nice. And then you get a mixture of the rice with the barberries, with the barley and some plain saffron rice. Accompanied by some piaz and salad. It's making me hungry just thinking about it!"

I visited Shandiz with our intrepid photographer, Shintya, and long-term community champion, Farah Mohebati, so fortunately I had some help tackling the Shandiz Feast banquet ahead. "Is this going to be like the American gluttony TV show Man vs Food?" I asked.

"No, there's four of us," said Ashkau. "It will be like Come Dine With Me!"

Shandiz Persin Cuisine, 118 Church Road, Hove, BN3 2EA

Tapas at
Ole, Ole!

Olé Olé!

This is a story about two little boys who met at the seaside and became lifelong friends.

Jorge was just eight years old when his parents told him they had got an apartment at the beach to spend the summer holidays. Then Jorge discovered that they were going to share the apartment with another family. He did not know them, but they came from his home town in Cartagena, Spain, and they also had a child: a ten year old boy named Karim.

Jorge and Karim quickly became pals and they looked forward to every new summer when they would be able to play together again. "We were playing these kind of games like when your dad tells you: 'By ten o' clock you need to come back home!' it's a bit of freedom, the summer, you can stay on the street until ten o' clock when you need to get back home." Jorge fondly remembers those early days with Karim, as he told me when we met. "We were very little, eight and ten years old, we've known each other for a very, very long time, playing football together, on the beach, in the summertime… For a kid, I remember, when I was little, summer used to be like three months, the longest, long time. It was good fun and it was different, totally different to the rest of the year. You had entertainment, you had the beach… Karim and I would only see each other in the holidays even though we actually lived in the same town. It was that time when you are so young you can't decide what you do, but my parents used to take me to the school, I don't go out, I just see friends from the school. We were very, very little back then."

After a youth full of summertime adventures, the boys both started working in restaurants. In 2000 Karim turned 18 and announced that he was going to move to London to work. A short while later, Jorge decided to pay him a visit. It was 2004 and Jorge was just 21. He planned to just come and spend the summer holiday with his friend. It would be like the old times. But twelve years later Jorge is still here and the friendship has evolved into a business partnership.

"We started from 18 years old. The good thing in Britain is that the restaurant they offer you opportunities. I've been working as a supervisor, assistant manager, manager. One of my longer places I was working together with Karim was at Yo Sushi, the Japanese place. We were working with raw fish, very high standard of food and hygiene. With raw fish you must know what it is about! Very high standard. We learn so much, we been working together in hotels as well, Hilton Metropole, and many other places. We got so many good friends that we been working together, friends that they open restaurants because is my culture, my kind of business. I remember when we opened the first restaurant I asked a friend of mine that's got a restaurant: 'Can I design my menu in your kitchen with you?' So it's a relation."

▶ **Father & son at the Don Ole delicatessen**

Jorge and Karim opened the first Olé Olé! in 2009. It was an exciting time but there were some challenges with the venue. "We used to be in Kemptown, not in the best part of Kemptown. It was in New Steine, underneath a hotel so no one could see the venue from outside. It was a basement that you need to come down stairs to get to. Still, all in all, we managed well. We had flamenco every weekend and it was busy enough. But, obviously, if we had a better spot, better location, it would help a lot. So we relocated to the Lanes in a very nice venue, very nice spot, very busy with so much passing trade, it is a wonderful spot." It is an amazing testament to their hard work and skills that they were ever able to make a success of a business in such a difficult venue, especially enough to enable them to move to a more central and expensive location. "The other restaurant was cheaper, obviously, with the rent and taxes, but we knew what we were doing. It was gonna be looking well and it was good time. There were not many

Spanish places. Since we opened the new venue in 2011 there's been so many Spanish restaurants that have opened and closed, so we are happy for what we do, how busy we still are and the way everyone offered different things".

Karim is the head-chef of Ole Ole and Jorge runs the front of the house, dealing with suppliers, bookings and staff. "Anywhere I been working in kitchen, there is no secret between us and Karim can manage the front of the house as well but is better to have an official head-chef and an official manager. Things are more simple and is better to have one captain rather than two."

Since the successful relocation of the restaurant to the Lanes, the pair have even been able to expand further. I first met Jorge at their new Spanish deli and sandwich shop, Don Ole, on the corner of Trafalgar Street and London Road. "We been trading in this deli since

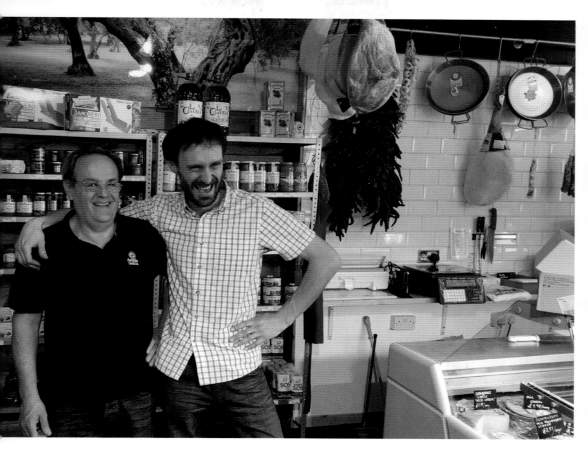

February," he told me. "All in all, we very happy. We didn't start at the best time of the year. February meant to be a quiet time but it's all been working very well. For local neighbours it's a nice spot. London Road is the exit for Brighton and Trafalgar Street is the street for the station. It's quite a good passing trade. We love the spot and the venue. It's been working very good for these past months, it's getting busier and busier. So now we can cook Spanish food in the restaurant and we can make people cook at home with all the Spanish ingredients that you can find. We have all kind of legume and rices to cook paeallas; there is a nice charcuterie section with cured meats, iberic meats, all the chorizo which is very popular these days; and cheeses, we got plenty of good selection of cheeses; we got olives and many other of the most popular Spanish products. Another good thing for us in this shop is we are now exporting a palette of products every week from Spain to provide for the shop and the restaurant so now we get a bigger margin, better prices and better quality. We used to have a few UK-Spanish suppliers. Now we put down the prices and improved the quality. I'm very proud, so it's win–win, two winners."

The new deli has helped to transform the corner of Trafalgar Street and London Road. In previous years, the stretch of London Road opposite St Peters Church was notorious for the number of heroin addicts squatting above the derelict shops. At one point there were so many fatal overdoses that it became known as Death Row.

With its smart décor and the front door always open, the deli has opened up the corner and made the whole space feel much more inviting. For many years before, it was a pawnbrokers with a dispiriting, "Cash Loans" sign outside and the obligatory security on the door that gave a sense of the corner being somehow

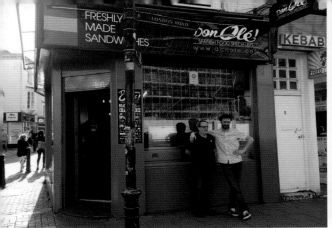

shuttered up. "This has been transformed completely. All we got left is the big window which we love it. Before, the space for customers was like five square meters, very small and they stored so much second hand things, like jewelleries and guitars, but now it's been totally completely changed. What they left for us was a big safe! We needed to hire a company to move it. Each safe was three thousand kilos. And there were three of them!"

The deli is part of a wider change in the area and sits well alongside the new North Laine pub that replaced the grotty Gloucester nightclub. There is also a new independent supermarket, hiSbe, that used to be a large empty unit. Rather than the more incongruous signs of gentrification elsewhere in Brighton, these developments are entirely welcome signs of the community rejuvenating areas of neglect. "This area is been developed a lot. I remember the council developed Kemptown and St James a few years ago and now they focused on this area so it's the right time to find a good location. There are so many student houses up the road, so many new houses on the other side of the road, so it's working very good. Since we opened three months ago we have catered several events at the Fringe Festival, we have been in the Phoenix gallery with the canteen last weekend, we been cooking paella for a birthday the other day, catering for fifty people. Today we've got a loyal customer and very good friend of ours whose mum passed away. The flamenco team and some of the staff members they are playing some flamenco with the family to pay their respects."

The deli also represents a change in the local demographics. "It is like with Polish people a few years ago when they came into the European community: now Spain is quite bad with jobs, there's not much opportunities after the credit crunch so a lot of Spanish are leaving." But there is a further change in the type of people who are moving to Brighton. "A few years ago it used to just be young people coming here, but now you see families coming over and all sort of ages and professions, all kind of people from everywhere. I think there has been a change. For example: American Express is a very big company, with thousands of employees, but when they closed down the American Express in Madrid, Spain, they relocate so many employees over here in UK so it's a bit different than it used to be."

Of course the deli only exists because of the success of the restaurant, Olé Olé! which you can find tucked down the brick-stone alleys of the Brighton Lanes. Not to be confused with the nearby North Laine shopping district where you can buy Mod suits and rare vinyl, the Lanes are full of tiny shops selling things like jewellery, antiques and posh chocolates. They are at the heart of the oldest part of town, formed of a network of narrow little twitters that were originally the pathways between medieval allotments and hempshares. Somehow they were spared destruction in the blitz and then, even more miraculously, they were spared the wrecking balls of the brutalist town planners who destroyed so many of Britain's historic streets. Being so narrow, they would have provided housing for poorer families in the past and until recent decades were not seen as an asset to the town. Now, though, the Lanes are touristy and

even a little chichi in places but they also contain some of the best outlets in town such as the groovy Marwood Coffee Shop, a tidy Games Workshop and, until a few years back, the long-running independent music store, Rounder Records. To this list we can also add Olé Olé!

During the week the restaurant offers a perfectly decent place for tapas, with draft beer at the bar and a profusion of green plants hanging from the ceiling. It is on Thursdays, Fridays and Saturdays, though, that it really comes alive. With a live Flamenco band and dancing, the whole place lifts off with a carnival atmosphere that is hard to believe. "Our menu is focused on tapas," says Jorge. "We got over twenty tapas on the menu. Main courses we don't do that much, meat, fish, different kind of paellas. We are focused on the tapas variety to fill up your table with tapas and have so many choices going on which is something very common in Spain. The music at weekends is our main difference to the rest, because all the Spanish places they obviously do tapas, or they have much more elaborated dishes and are a bit more expensive. We respect the products, flavours and it might not be so elaborated dishes. For example, come to my mind like chorizo. Chorizo is something not much elaborated but if you got a good product you will offer at the end it will be a good result and a good honest food and honest with the flavour and with ingredient we use, we try to be as original as we can." This simplicity of approach is a central feature of the best Mediterranean food, but Jorge told us that when he visits certain other Spanish restaurants the Spanish waiters quietly advise him not to order certain things on the menu. "They say, 'As a Spanish person, you won't even recognise this as original tapas!'

"To be honest with you, we are very happy because we were very lucky about this: we always mixed the Spanish

and the English customers, which I think is the best thing, because when you go to a Spanish place or, say, a Chinese place, you like to see the Chinese people or the Spanish people eating there! There is some franchise or chains with the Spanish or the Chinese, at the end of the day I won't say names, but you go to chains of Chinese restaurant or Thai or whatever you want, and the Thai people or Chinese people don't go? There must be a reason for it. But we been very lucky because people know what we do, the live music people love it, they give you good feedback. I think what they love the most is that you can come one night and spend a couple of hours or three hours and without changing venue you can see live music, eat well, have some drinks, they even stand up and dance, the second half of the show they interact with people, the dancer used to come down and bring some people so it's something that is working quite well. It is very popular. People like to enjoy live music and their food at the same time."

There are certainly not many other venues in town that can offer such a rambunctious floorshow alongside such exquisite food. A night out at Olé Olé! really does feel like a night outside of your ordinary life. The Flamenco band are expertly skilled musicians who have clearly grown up with the music and have mastered a vast catalogue of songs and styles. When they take to the stage it switches the dining experience into something completely different, as if you were to find yourself all at once on a boat in high seas. "You can see it in Spain, especially with Flamenco. It might not be in big restaurants but in the Flamenco venues in the south of Spain where the Flamenco comes from, they used to do in caves. With not much variety of food, just traditional Spanish cured ham, charcuterie, platters of starters. And they might bring a whole bus with the foreigners, you know the Japanese people is so interested in Flamenco music and it's something that happens in Spain. Caves are a typical venue because the sound is very good and the temperature of the caves is cooler. Is something very common is happen in Grenada, Seville, South of Spain, Andalusia, all the Flamenco venues are caves."

"We mix traditional flamenco with some modern flamenco. We been supporting Spanish artists since 2009. So far we have three or four different dancers, four or five guitar players and we offer the job with local terms and conditions. They come over from Spain and it's been working very well. All our employees have been always from Spain. But all of the musicians obviously come from Andalusia where the Flamenco come from. And employees in the kitchen and front of the house, all of them Spanish. For a chef it would be so much helpful as it is a strong culture with gastronomy, is something that you want explain to your customers: what is a traditional thing, what is a bit more modern, what the mixture with the modern and the classics, something that will help you if you grow up with that culture or that gastronomy."

"My favourite thing that Karim cooks I will say is tapas. I like variety. I love to have different choices. No much of nothing. Have a bit of this, a bit of that, keep going, keep going, aperitifs… Then when you realise you are eating and you have tried million things! That's the best way. That's what I enjoy the most. Try to mix this with the other, see if the result of the mixture is good. That's what tapas is. I think the best is to enjoy the mixture of food and try to bring new things up."

In many ways, Jorge and Karim have created what we might call a tapas kind of business. It is composed of little bits of many different types of business: they have the deli selling cooking ingredients; the Flamenco musicians providing entertainment; the sandwich shop selling tasty lunches; the catering for events; and the restaurant every evening. A little bit of everything to provide that mixture of elements Jorge loves to find. The various businesses are also playing a role in cultural education and exchange, but in different ways. "You chat a lot with customers. In the shop it is more about foods, things that they don't know. If the labels are in Spanish you translate to English and, even if the translation is there, they might not have seen it before so they want you to tell them what you know about it. These days, people know so much about Spain. They been living in Spain or they got some relatives that they might

have an apartment so they go for holidays so they know a little bit about the culture. In the shop we talk maybe more about food and in the restaurant you talk about everything else. People drink, they are in party time with live music, especially weekends, so they chat a lot about everything. They want to know about culture, gastronomy, everything really."

"We give so much advice to everyone. I mean the English people: five years ago when we opened the restaurant, their knowledge of Spanish food wasn't as good as it is now. They have tried bad things and good things so they recognise what is a good or bad thing.

For example, let's say chorizo. My chorizo is coming from Avila. Avila is one of the biggest producers of pork. But you see chorizo now these days is very common. Tesco's, Sainsbury's, all the supermarkets they do chorizo these days, same as the wine, the rioja is very common to find it everywhere, but obviously the chorizo that is in those supermarkets is not as good as the one you find in Avila or the quality that you find in Spain. And is very nice to be in the shop people interested make you questions, you showing where the Iberic pork, black leg, what it means, the race of the Spanish pork, why is Serrano, why is Ibérico, the variety of the olives, is very nice because when you see a reaction of people that is interested is something that you appreciate when people get to see why is the difference, why is better quality, why this cheese is cured because of the meat and so on, it's something very nice. It's something very nice to let people know what the real thing is."

Like many restaurant proprietors and managers, Jorge does not get a lot of time for himself. "To be honest, time is one of the things we are most short of! But I like to enjoy family times. It is one of the best things for me. In our culture I cannot miss my dad's birthday, I cannot miss Christmas time, this is something that you need to be with your family. Even if it

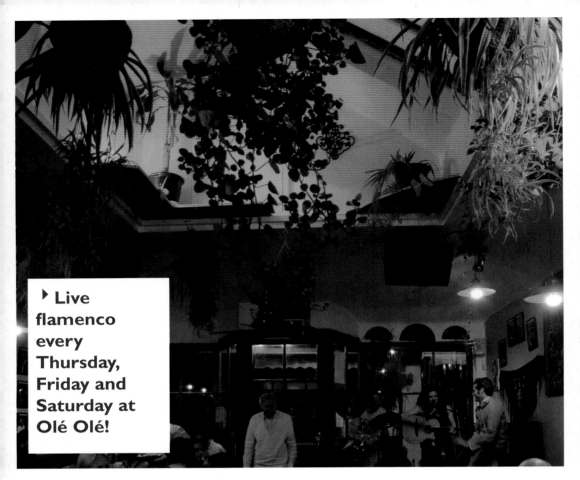

▶ Live flamenco every Thursday, Friday and Saturday at Olé Olé!

is one day, go for Christmas Day, pay your flight ticket for £300? I do. I do. £300 to go and £300 to return, I will do. I won't think about it. Family is our culture. It's very important."

At this point in the interview, we were interrupted by an older man in the deli who was photographing us talking to Jorge. This seemed a little bit strange so we asked him what he was doing and we discovered that it was actually Jorge's father, visiting from Spain. "I used to go a lot to Spain," said Jorge, "But my parents now they come very often. They no working any more, they retired, so they don't just come for bank holiday weekends: they come, they stay for two weeks or even a month. So now when I go for holidays I can choose some other destination. It can be in Spain but doesn't need to be home, parents. You don't have to mix the holidays with the compromise to see your family. I mean, if you don't have holidays for five, six months then you need to see your family. I am lucky for

that because I see my parents so often." This is an important change for people living outside of their home country because, as Jorge told us, so often their well-earned holiday from work is hijacked by the need to go home and spend time with their families which does not quite meet the need for rest and relaxation that two weeks on a beach will give you.

Jorge told us that he does not get the chance to play football on the beach with Karim any more, though. "It's not like it used to be. Not like it used to be. I was speaking to you earlier on, and I remembered how long the summer used to be when I was a kid. How the feeling for the summer used to be and it has changed. It has changed. But we enjoy what we do. Weekends are great, we enjoy it. It's a good fun. Work is a pleasure."

Olé Olé! Tapas Bar and Restaurant, 42 Meeting House Lane, The Lanes, Brighton BN1 1HB

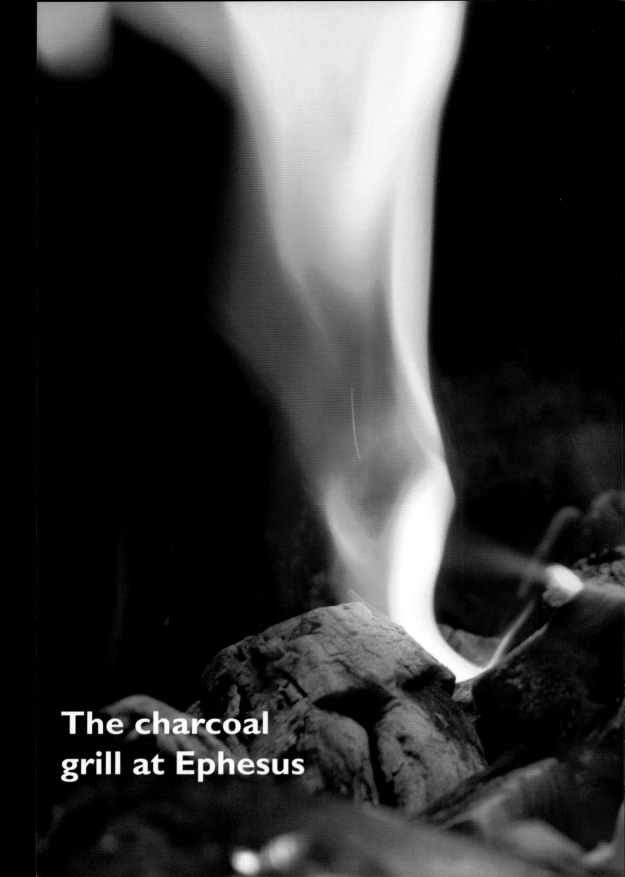

The charcoal
grill at Ephesus

Ephesus

Kep left Turkey when he was eighteen. He came to the UK to study English so that he could help run his father's business importing and exporting textiles in Istanbul. With a population of over fourteen million, Istanbul is bigger than any city in Europe with nearly four times the number of people as Berlin. "It is a busy, mad city," said Kep. "When I first came to London, it was like a village to me. It was so quiet! So you know what is Istanbul like by comparison. It is a city twenty four hours. It never sleeps. You go out here on Friday or Saturday and it is busy but in Istanbul every night is like a Saturday night, put it that way. We don't have a Monday or Tuesday. You go out, it is busy everywhere: traffic, all the shops, the restaurants are full. Go to Asia, Europe, whatever, they have to pass through Turkey. It is the heart of the world, actually. It puts Asia and Europe together."

The plan was to stay for just two months but somehow Kep found himself settling here permanently. "My parents wanted me to go back to help run the business but there you go, it's life. But they are happy for me because they say, 'If you are ok there, you got your own business running and everything,' so they don't mind." Now he is married with children and a parent himself. "Life, you

never know, is full of surprises," he told us. "It was supposed to be two months but it's been over twenty years now and I'm still here!"

Kep had been studying accountancy and book-keeping when he left Turkey, but in London he soon found himself working as a waiter and then a chef. "When I came to UK I started first in a kebab shop, like most of the Turkish people do. It wasn't a plan. I wasn't thinking, you know, one day I will come to the UK and do a kebab when I was living in the Turkey but this is what Turkish people usually been doing because it was very late hours and not many people used to want to do it. We were only doing it because we needed the job then, not because we liked it, we didn't have anything else to do then. You see, you never know. Like I say, I mean here I know so many people they were doctors in Turkey and they are cutting the doner kebab in London. Because at that time when they came to UK they wanted to work and then the only times it was the kebab shops then." He says that this has changed in the past two decades though, and now fresh options are available for new Turkish immigrants as more Turkish people own different businesses. "You can walk down the high street now you can see it from barber shop

to off licence to jewellery shops to… you name it, taxi driver, policeman, everything. Yeah, it's different now. Before it didn't used to be like that. You had a very limited choice. I don't know why it was in UK like that; if you go to the other countries like Germany and this and that, they been there how many generations so it was a bigger market and they had everything. But, here, now, there is slowly, slowly you can find that every business, Turkish people they are running it now as well."

Other things that have changed since Kep arrived are the technological advances that allow people to keep in contact across distances. This has had a profound effect on people's lived experiences of migration. Back in the day, it was a case of upping sticks and leaving your friends behind, whereas now it is less of a sacrifice. "Twenty years is a long time. Back then you didn't have the Facebook or nothing like that so I lost all the contacts for my friends. If it was just a few years, yeah of course you go back, you find them, you know, but after twenty years later you don't know where they are. Technology is better now. You see them every day on the Facebook or Skype. It's

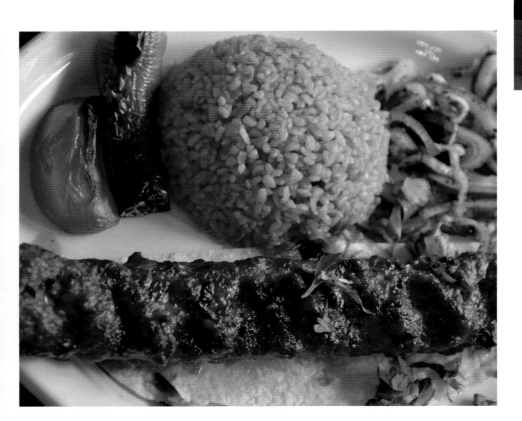

different now. For years and years ago we used to put lots of money to talk to Turkey on the phonebox. You were lucky if you got a minute for one pound. It was more like one pound for ten seconds! Now it is more easier. I can sit at home, put the Skype on, speak to my Mum face to face, no problem, so it makes it easier now, the technology, so I don't miss it as much. In the beginning I used to miss my home a lot, in the first few years. It's not easy because you are born there, you grew up there and then moved to a different country, you know, you do miss it, you have a feeling and then we are all humans. But after that, once you got your own family and once you get used to it, you don't miss it like that. Now when I go there I start missing here! It's the other way round now. This was my second home but this is my first home now."

Ephesus has only been open for two years but Kep is happy with the progress so far and is proud of the good feedback on the traveller's website, TripAdvisor. The restaurant is situated about halfway down Preston Street, opposite Rotana on what has been known as The Street of a Thousand Restaurants. "I counted it the other day. From the beginning to top is forty places to eat in one street. It used to be that if you wanted to go out for a meal in Brighton, if you are hungry, 'You wanna go out?', everybody used to go to Preston Street. But this is years ago, I'm talking about like twenty five years ago when there used to be a lot of Greek restaurants here. But these past ten years the street gone downhill a little bit. So many Chinese restaurants opened and closed, open-close, open-close, but now for the past two years it has started picking up again so hopefully it will be the place to go and eat again like it used to be." I asked Kep if business will be impacted by the i360, a five hundred-foot high observation tower being built on the seafront that at the time of the interview had not yet been opened. "Big time," he replied. "So many business, they are waiting for that. Obviously there will be more tourists come to this area. At the moment they are on the other side, round Brighton Pier, round the Lanes. There is quite a lot of buzz. And when it is finished it will make a big difference. What I like about Brighton is that it's a nice small city, it's all mixed, all international. You can get all different cultures in one place and it's such a small city but you can

▲ **Kep, owner of Ephesus Turkish Restaurant. Also known as DJ Kep**

find everything you like. If you like going out, meals, clubs, theatres, whatever you do, you can find it here in a very small, very friendly city."

Another thing that has changed since Kep arrived is the type of food people consume and the way they purchase it. "People used to go to Italian and Curry houses before years and years ago and it wasn't much places to go. Now if you look at it you got Turkish, you got Arabic, you got Lebanese, got many different, different food coming in and obviously is more choice to go now and is more competition so people's tastes change. Like: years and years ago, people they see kebab as a clubbing, drunk meal. People used to go pub, club, after that used to go kebab shop have a kebab but now they chose more healthier options. Every club now you go opposite there they have a salad bar or a Subway. So the new generation's food is different. Not like we used to eat, you know, we used to go have a drink, after that we used to go have a kebab but now it's changed and obviously the restaurants are changed too.

"There's not many Turkish restaurants in Brighton. We got quite a lot of Turkish students here and also they want to try the food and also they want to make their friends try the food: 'This is how we do the food in Turkey, and there's one in Brighton so we don't need to go all the way to Turkey we can just go down to Preston Street and try it there'. This is a good location for tourists and also for locals who want to eat near their home. So we are open to a big market of tourists, students and locals. It's different when you see the kebab shops, takeaway, it's nothing to do with a Turkish restaurant or food, it's just a takeaway. I don't want to say 'junk' food, but it is really just like kebab. Here you can get a proper sit-down meal which is freshly cooked in front of your eyes, so this is a different class of restaurant, this is a proper Turkish restaurant I can say. You can sit down, have your drink and everything. It's not like a takeaway shop, kebab shop, so you can see the difference once you eat here as well. We have an open-plan kitchen so you can see

your food is cooking freshly on the charcoal grill. No secrets, nothing behind the doors. You don't have to worry: is it coming from the microwave, or god knows what the chef is doing, or do they drop my food on the floor?"

Ephesus has an open kitchen, with the chefs preparing the food in front of the diners, including dramatic flourishes of flame on the charcoal grill. Not only does it add to the inviting aroma of the cooking, but it is part of a trend towards openness in the dining experience. Writing in Time magazine, the business journalist, Brad Tuttle, suggested two sources for this trend: the prosaic explanation is that it evolved from the space constraints inherent in New York eateries; the second, more glamourous, explanation is that it capitalises on our fascination with watching celebrity chefs on television. All that noise and steam and action is now part of the show. It is also one of what Kep calls the, "golden keys", secret ingredients in the dining experience that make it more desirable than eating at home.

"The main thing is you need to have a nice hot barbecue. If you can have that then the food change, the taste is much, much nicer cooking on the charcoal than cooking on a gas pan at home, so that's one of the golden keys: you need to have a nice charcoal grill."

The menu at Ephesus opens up a fascinating insight into Turkish cuisine. With familiar Greek-style starters like tzatziki (or, "cacik" in Turkish) alongside more Levantine dishes like baba ganoush, you can really taste Turkey's unique position as a global crossroads. The restaurant itself is named after the fabled city of Ephesus which contained the Temple of the moon-goddess Artemis, one of the Seven Wonders of the World; and the city was ruled over at various times by the Persians, the Greeks, the Romans and the Ottoman Empire. The main courses include a range of traditional oven dishes and casseroles alongside the expected kebabs and grills, with the chef's specialities including sarma beyti made from lamb. The food is delicious and the set menu

is great value with choices including baby chicken and lamb ribs and some very tasty home-made baklava for desert that is just dripping with honey and scrumptiousness.

A large part of the appeal of Ephesus is the vibrant décor. The walls are emblazoned with oversized photographs of the façade of the Library of Celsus and other sites, bordered by embossed plaques containing facts about Turkish history and culture. The ceilings are criss-crossed by wooden beams, strung about with multicoloured glass hanging-lamps. The wood panelling throughout has the feel of a cowboy-ranch, creating an overall sense of a kind of Wild West Aladdin's Cave. "Most of the decorations you see here we bring it all the way from Turkey. We want to give it a nice cosy atmosphere for the customers when they're coming in here, we want them to relax and enjoy the food and have something to look at and feel warm like a home. And as you can see all the tables and everything nice, good big size is not like pushed and sitting on top of each other. The customers are always looking at the photos and they want to learn more. That's why we wanted to do that, put some pictures around of Turkey and it's not only about the food we're teaching them, we are also showing them about Turkey as well, with the pictures, with the culture and with the warmness so people can have an interest in a different country.

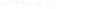

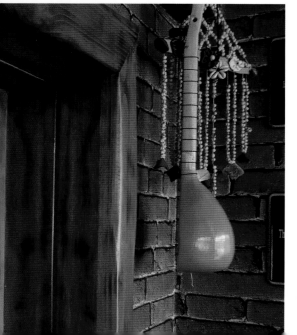

"Most of the tourists I have spoken to who come here, they have been to Turkey. The main reason they go there is cos of the sun, I think! And then the Turkish food and friendliness and everything, because they get everything there and not only the sun. You know, you can get the sun anywhere if you go to the other Mediterranean countries. But they say the food is very nice and the drink is very nice, they're all coming in here and they say, 'Oh I wanna have this beer, I used to have it in Turkey, I can't find it anywhere, oh can I have a glass of that please?' There's quite a lot of tourists they go to Turkey every year and then when they see a Turkish restaurant they say, 'Oh, wow, let's go there!' There's really, really good quality hotels in Turkey serving really, really nice high-quality food and every time they go there they have a really good time and they wanna go back. So when they see that there is a Turkish restaurant opened in Brighton they say, 'Oh we don't need to wait until summer now to have a glass of raki or a beer or nice food, we can just book it and go.'"

It's not just the décor that sets the tone, of course. Another golden key has to be the way that music informs the ambience of a place, and this is an especially important trick to get right for an ethnic restaurant where the experience has to be situated within a multi-sensory cultural dialogue. Being a Turkish restaurant does not just mean you should play Turkish music, because Turkey's unique selling point is its diversity. "We are very careful with what kind of music we play. We play world music here, not just Turkish music. And we have a different, different playlists, depending on what day and what time of day. I mean, night time we play more easy music to go with the meal, we don't want bang-bang-bang stuff when you are eating but daytime little bit more energetic music, lively music. So it is all Oriental and Turkish. We play Spanish music, we play Greek music and the customers they coming in here they say, 'Oh, this is from our country.' Yeah, it's good. The music is international language so you can't just say, 'I want to listen to Turkish music'. We find the music that is similar to Turkish music. The music is very important. When you go to restaurant it's not only about the food, it's everything: the service, the music, the atmosphere, from the

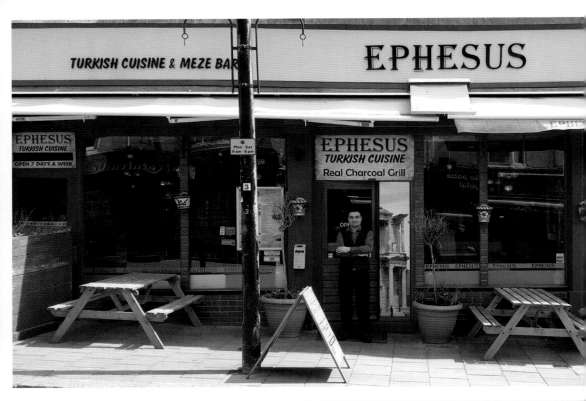

minute you walk in front of the store until you leave, everything needs to be perfect then you will enjoy and you will come back again."

Music is also important to Kep, or should I say DJ Kep, due to his secret life as a dance DJ in the nightclubs of Brighton, something that he does not get so much time to enjoy these days. "I like music, I like making music. I am into DJing. I love music but I don't have too much time to do it. When I have two days off, obviously you don't want to do your hobby, you want to spend time with the family and with your kids but if I can find the time I will do my hobbies as well. I do modern computer music so I started from zero to finish, from all the kicks, the beats, everything. It's dance, electric house, trance music stuff. It's just for the clubs, like 138bpm. I've been doing it since I was a kid. I was always interested, I play instruments and I still keep

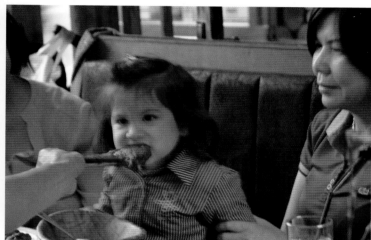

that. It makes me relax after a busy working week to just play with music. I play keyboards, drums and a few instruments I can play."

The average chart song is around 100 beats per minute, so 138bpm is pretty fast and Kep must enjoy the fast pace of a busy restaurant. Given the choice between hospitality and music, Kep admitted that it was a 50/50 proposition but that his business was more serious. This does not mean that he enjoys cooking at home as one of his hobbies, however. "I eat five, six times a week here. When I go home I just want to eat cheese on toast! Something simple and easy because I had enough eating out at the restaurant all the time. I don't cook at home. I am lucky I got my chefs here and I got my wife at home so that's the benefit I get here."

Ephesus Turkish Restaurant, 80-82 Preston Street, Brighton, East Sussex BN1 2HG

Ephesus lamb
and chicken
kebabs

Piccolo

On a cold morning in 1979 two young teenagers huddled together as they arrived in Brighton. They were brothers, evacuees from the revolution in Iran, sent to England for safety by their family. Back home there was fighting in the streets. Armed rebels had overrun a weapons factory and captured fifty thousand machine guns. The Shah had been driven into exile. It was a dangerous time.

For the two brothers, Farshad and Farshid, it was the beginning of a new life without their parents, staying with an English family who would act as their guardians until they were old enough to live on their own. The youngest of the two, Farshad, dreamed of becoming a police officer. Either that or a pilot. But he could not escape his destiny to follow in his father's footsteps and open a restaurant. The only problem was that he was an Iranian living in England, and things were not so simple.

Farshad was born into the trade. His father founded and ran the renowned Hatam in Tehran, and Farshad grew up around the restaurant ever since he was a child. "When we were younger, we used to go there to get away from school! We go to restaurant and help out. Well, my family's always been into catering business, so automatically we were dragged into it. Since I was a baby. They owned the big restaurant back home: Hatam Restaurant in Tehran. They still got it. Been going now for fifty years at least. My dad passed away so my oldest brother is running it now. The beauty of it is we serve two thousand people every day on one dish. We haven't got like twenty nine pizza, twenty pasta, like a board outside. We got only one dish. It's a barbecue chicken and they cook in front of you in a big, big kitchen."

When Hatam became successful, Farshad's father continued to work there even when he did not need to be there anymore, serving food and greeting the customers just for the

love of the place. I was introduced to Farshad by my friend, Farah, who remembered visiting Hatam before the revolution, "I tell you about the restaurant of his father," she said. "Really amazing restaurant, and it was very famous in Tehran. I used to go weekly with family and big gatherings. We went there and the food was perfect. Always very perfect. And his dad honestly always serving and checking everything and the food was excellent. The chicken I never taste like that really in my life. And it was very close to our place. We used to be Zafar Street and then beginning of the Zafar was Valiasr Street was there and the restaurant still is famous. So many people talking about that."

When Farshad was settling down to his new life in England, he found a poignant reminder of home, "I remember we were coming to England and there was a guide-book which says about Tehran, like you got about Brighton: you got Marina, you got Laines. In this book about Tehran there was a Hilton, there was just one other place and that was Hatam restaurant." He felt proud to know

that his father's work was even known overseas.

Eventually, Farshad and his brother started working in the restaurant trade in England. "I suppose that was the only thing we knew, I suppose it's in your blood. My dad used to come home, talk about customers. So slowly, slowly, the idea grows on you. We worked in a few different Italian places. The last one was Pizza Express but before that, Al Duomo, Al Forno." After a while they decided to start their own place. Piccolo was born.

"In the beginning it was hard, hard. Very hard. Cos it was the neighbours. They could see we were not Italian. They thought we were Arabs or Indian and they looked down on us. What it was: in five years before us, five times this place went bankrupt. Five people had it within five years and five people they all went down. It was so funny, everyone saying 'Two Indians, Two Arabs, they come to open Italian restaurant. We give them three months. We give them two months!' Because it had a bad reputation this place, everyone open for few months, ten months, eleven months, then they close it. And it is a hard work as everyone knows, catering. And it think if it was me by myself I wouldn't could have run it. There were two of us brothers so we managed it better and run it better. Is like nine in the morning till two, three, the early hours of the morning."

"I was just twenty three when we opened. And my brother is one year older, twenty four. Imagine: twenty three, twenty four, opening the restaurant in the middle of the Lanes, with the high rent and rates. A couple of the suppliers come in and said this: 'Oh that shop, you gonna stay six months!' I think that was one of the reasons really made us to work harder to prove that can happen. And all of them, after a few years, they were all eating here, you know!"

I asked Farshad why he went into Italian food rather than Iranian food and he responded that it was due to the popularity of the food in England and the high demand. Back in those days Iranian food was pretty much unheard of in the UK, so that was one answer. But I also wondered: why Italian and not Chinese or Indian, which are equally popular? Farshad thought about the question. "I don't know. They got more or less the same attitude and the same mentality. Italians and Iranians.

Looks-wise, culture-wise. They got dark hair like us... When we opened the place we used to get loads of American Air Hostesses. We used to provide them with the ten percent discount card. And they love it. But they were talking to us and saying, 'Oh, which part of Italy that you come from?' Soon as you say 'Iranian' they look at us as terrorists. As soon as you say it, the conversation ends! They kept their distance from us!" he laughed at the comedy of it in spite of the racism he experienced, "But we carried on. You can't change it: where you come from. I wouldn't change it. I'm from here, I'm from there. I wouldn't change it. But, you know, it's good and bad everywhere. You buy a box of orange, you find ninety of them is good, ten of them is bad. You know, not everyone can be good. There's good and bad everywhere."

There was a sizeable Iranian community in Brighton when Piccolo opened, but Farshad says there were not a lot of Iranians who had their own business. "After we opened, there's lots of Iranian they have opened and they are successful. Some people they like to say, 'No, only we are successful', but no, no, they are very successful. They are very, very, good, very good. At the moment I think there is ten to fifteen successful Iranian people who runs Italian restaurant."

Over time, other members of Farshad's family came to live in the UK, but they all eventually returned to Iran. One brother studied hotel management for seven years in the UK and then three years in Switzerland before opening a venue for weddings and functions in Iran. Another brother studied as a beautician but sadly passed away. Farshad and his brother, Farshid, stayed in Brighton and continued to develop the restaurant, as my friend Farah remembered, "I used to have a boutique in the Lanes and my friends come and directly came here and twice a week we been here and the food was excellent, really everything was perfect," she told me. "All of the food of here is lovely too. And also the manner of the brothers and family was unbelievable. They was so kind. Really I will never forget their kindness. Also I remember there used to be Christmas time all of the homeless people, the brothers were serving them food and they had a queue to the end of the street, just come here and they

serving the food free of charge. I will never forget about the kindness of the family."

The brother's charity even made it onto the news. During the Millennium celebrations for New Year's Eve 2000, most restaurants were making a fortune charging at least forty pounds per head. But Piccolos was closed to the public that night. The brothers decided to open to the homeless people of Brighton, with free food for everyone.

"Back home my father's restaurant had a nice name and we wanted to carry on to find something like that, what my dad had back home, like a good name. And we did, in my opinion. We did have a good name. At one time I was somewhere in Spain, really, really far away, on one of the islands, and we were talking and they said 'Where are you from?' I said Brighton, they said, "Oh, every time we come to Brighton we go to that place, Piccolos, it's got nice cheesy doughballs'. These cheesy doughballs: we invented it, me and my brother, and is never ever happened I mentioned Piccolos to these people!"

"Having the money is one thing, being successful is different thing. I went to USA

to visit one of my friends for three days. I went to New York. I didn't have much sleep and I was coming back really tired and I was thinking to get some rest. And this lady was next to me on the plane she start talking: 'I'm from Crawley,' she said. And soon as I told her I'm from Brighton she said, 'Oh, Piccolos!' I never said anything about Piccolos! They drove me mad. 'Cheesy doughballs, cheesy doughballs, cheesy doughballs!'"

Despite predictions that they would close down in six months, Piccolo's restaurant has been open in Brighton now for twenty eight years. I asked Farshad why he thought they had survived when so many businesses had gone under in the same location. His answer revealed something about the asset-poor business-strategy of ethnic restaurants everywhere and also something about the changing nature of dining in the UK over the past thirty years. "I think from my experience what it was with the other businesses, it was a big company, what it was, and they had a manager here, not someone who really cares, I think. All they wanted to have their wages at the end of the day and go. I think the profit of this place comes from having a second dining room on the first floor. Just having this lovely bit downstairs here would just pay for everyone but the main thing is upstairs where the profit comes from. Lots of tables. And also when we first open we have no table and chairs outside. We used to have just three or four table and chairs outside for food only, no drink, and hardly anyone sits there. Now in the summer we got about seventeen table and chairs outside."

This is a huge part of the story, because al fresco dining seems like such a natural part of life in the Brighton Lanes and in any lively British town. It is almost impossible to imagine that thirty years ago this was a rarity. Partly the influence of people holidaying on the Continent, and partly the influence of migrants from warmer climates, this change in dining habits coincided with social developments like the rise of pedestrianised zones in city centres and the introduction of catalytic converters and unleaded petrol that reduced pollution and made eating outside more pleasant. There was also a loosening of the licencing regulations over the same period.

"It was very hard to get a licence for a drink for outside here. We were the first ones to get the licence in Brighton for outside until late, I think twelve o' clock. I think most of it was until nine, like that. This was in 1991, 1992. And then, as you know, once they issue one licence everyone else get it. So once we done it, everyone else applied for it. A good thing we had a very good solicitor who used to be a clerk for the licensee."

At Piccolo, the pizzas are prepared downstairs in the restaurant while the head chefs prepare some other dishes upstairs. Amazingly, three of the chefs have been with them since the first day they opened, twenty eight years before. Only one of them had experience as a chef before and the other two learnt the trade from the brothers.

"We both worked in Italian restaurants so we both knew the trade, from cooking, from running it. The beauty of it is that our chefs can't play games with us. 'Ah, it's too busy, I'm gonna go,' you say 'Go. If you wanna go, go.' If they complain they know you can do their job! And at the moment we are short of staff. After twenty eight years I find myself cooking pizza every night at the moment! But I enjoy it. I like the busy place."

Farshad admits that he regrets not expanding the business. His accountant and his bank manager always told him to open more restaurants but he did not have the desire at the time. He also wonders if he could have opened an Iranian restaurant that was a more direct tribute to his father, "You know what? Few years ago it run through my head to open a restaurant and call it the same as my father's restaurant. But I'm few years older now. If I was ten years younger I would have done it. It would have tried to make it successful. Because he had a lovely name."

But now Farshad's brother is not working in the restaurant with him anymore, and he feels that it is time to finally call it a day. He is planning to sell the business and by the time you read this it may already be gone. "Twenty eight years; I'm done. I've got enough. I'm gonna do a smaller café, not do so many hours. Especially as my brother is not here with me anymore, it's too much on my own. After nearly thirty years, it's a long time. It's two life sentences! We had so many customers over the last few years. I remember lots of customers they used to come with their kids and we used to give them lollipops. And now those kids are coming with their girlfriends and boyfriends!"

I said that they will be asking for lollipops for their own kids next.

"Haha, let's hope I don't see that. I'm out of here! I've got a little boy now. I'm gonna spend some time with him. With family. He is only four years old. Once you got the catering it's like this is your baby. You get up in the morning, you wanna know what's missing, what you have to do. It's like having a baby. One of my friends in catering was telling me his wife was giving birth. He says when she's having the baby he was phoning the restaurant to see if they are busy or not!" He laughed and added, "That's catering."

Piccolo Restaurant, 56 Ship St, Brighton, BN1 1AF

Pop Pie

Think of Greek food and your mind sails across the Mediterranean Sea to a whitewashed taverna with Aegean-blue shutters where old men play backgammon and eat moussaka. But this could not be further from the world of Pop Pie.

With its walls painted candy-apple red and a funky clientele of international students, Pop Pie is something else. Popping up at the top of Brighton's bohemian North Laine district, Pop Pie is the UK's only Greek pie and pastry shop. The co-founders, Kyros and Yannis, have found a niche serving up a delicious range of snacks that are part of everyday life across Greece but less familiar over here. As Kyros explained, "The thing that everyone knows about Greece is moussaka and souvlaki, feta cheese, olive oil, Greek salad, many other things. But nobody had the chance to taste the actual pies and pastries, only if they come to Greece. If somebody introduce the taste they will say, 'Ah, ok, let's try it!' but it's an actual tradition in Greece to have unique pies and pastries with different filos and different ingredients. It consists of a taste from Asia, taste from Africa, taste from Europe. All combinations start from there and end in Greece and so you get the result of all nations in one pastry or pie."

Pies are a huge deal in Greece. The Greek people love them more than the English love a sausage roll from Greggs. Maybe even more than the lunchtime Meal Deal at Boots.

Most Greek pies are made from paper-thin sheets of filo (or "phyllo") pastry. The most popular ones are tyropita (feta cheese) and spanakopita (spinach, onions and feta), but there are countless variations. They are purchased on the day of baking and are best enjoyed hot from the oven in the shade on a lazy lunch-hour. "Everything you see here in Pop Pie is traditional from Greece and it's been freshly baked every day, all day, all day long for the customers from eight o' clock in the morning until six o' clock in the evening. Everyday, all day."

Each different type of pie comes from a particular city or region and every area has its own favourite variation. "Many islands, many different parts of Greece, they have different pastries, different recipes. We have people here who are students and workers that come from different parts of Greece: from Thessaloniki, from Athens, from Crete, from islands that they keep on saying, 'Oh we do this, in Crete' for example, 'But we don't use that, we use this'… let's say, 'We don't use feta cheese, we use yellow cheese' for example. So in many different areas in Greece there are specific recipes which come from the one person to the other, from the grandmother to the mother, to the son or to the daughter, it's like decades of recipes so every area has its unique traditional recipes. If you go now to Greece, they will say, 'No, I have the best one', the other one: 'No, I have the best one, cos it has that ingredient inside', 'Oh no, I have the best one because I bake it in the morning', 'No it's better to bake in the evening!' It's good because it puts you in a test, that it gets you getting better and better to what you do. Even if you have something traditional from your place then you get better and better in making them and everyday having the same product to give to the customers. It needs the exact ingredients. If

you use feta cheese you have to use a specific type of feta cheese. Many people think that it's just one type but there is many different type of feta cheese. And, for example, when we do the spinach and feta cheese, you need fresh, fresh spinach, not frozen one. I mean, it all comes at the end, at the result, you can see that when you make that first grab of the munch of the spinach and feta cheese, you get to understand and you can't compare the taste."

Kyros explained that the two secret ingredients are the wisdom of the elderly and something even less tangible: "I've been to lot of places in Greece, I've seen the recipes and you have to go to the other place to get to know about that pie and pastry. So you get to know when you move to a different island or city in Greece, you see that you talk to people, most of them elderly ones, they're the ones, the experts, you know, they can beat any chef anytime, so they can tell you from the smallest ingredients. But I believe what everyone saying to me is that the most important ingredient is love. If you don't give love, then it will fail.

"We have a saying in Greece that love first comes through the stomach and then out. So if there is no belief in that, then at the end you don't have the exact result of falling in love with someone. I believe in the past it was more like that. People who are my parent's age believe that if my wife knows how to cook then I will marry her. Nowadays it's not like that. But the Greeks are known for the habit, let's say, of having a nice meal in their table."

Kyros told us that the elders are the true masters of the recipes. In a similar fashion, his impetus to get into cooking as a child came from the senior branch of his own family. "My inspiration did not come from a chef or somebody like that. It comes from the people that we have close to us that gives us the amount of knowledge every single day to say that, 'Now you use this, you have to get it fresh, if you don't get it fresh, it's not gonna be the same taste at the end.' So it was my grandmother. She was the one that get me into the whole idea."

"My main memory from childhood is of always having relatives around the home. I believe that's the most important thing in human life, to have family moments all together as a child, so when he will grow up he will bring all the same ethics and same things that lived back in their childhood.

Student friends and business partners, Kyros ⏶ and Yannis ◀

Even something like food, for example. As we all know, gathering around the table and eating together is very important in the Mediterranean area. I believe you can see the impact of that when you get older. That it was, I remember since I was young."

Kyros grew up in Thessaloniki, Greece's second city and the home of the bougatsa, a custard pastry that is traditionally eaten for breakfast. Kyros feels that Thessaloniki looks a lot like Brighton, with its beaches and marinas and a vibrant cultural life. It was back home in Thessaloniki that he first got interested in computer science, which he eventually came to study at the University of Brighton in the early noughties. The science of automating algorithmic processes might seem a long way from the science of pastry but there is no getting away from computers, even in a bakery. "Computer technology is tomorrow's thing, so every time something is updating, something is new, you keep on having the computer in your life, so I cannot escape it, even if I spend every day all day here in the shop, cutting pastries and pies. We're all in somehow computers in our minds."

One of the most common questions Kyros gets asked is whether he came to the UK and opened the shop because of the economic crisis in Greece, but he is at pains to point out that he has been here for much longer than that. The crisis has still had an impact on his life, though. Some of his friends were forced to leave the country and now it has become very difficult for most of them to come and visit him in the UK because now they all have to work two or even three jobs each just to keep afloat. The reason Kyros did not open the business until after the crisis hit was just because of the timing. "We were searching with my partner, Yanis, we were searching for the shop, the specific shop to have our recipes and pastries and coffees. Cos you cannot get just any shop, anywhere, it has to be a specific one, so it takes too long to find that shop, to make the deal and then start running it. So, in the beginning every one is a bit like: 'Hmm… we don't know that food…' but we made some samples, we went out in the street, giving people samples of small pieces of pies

and trying to tell them that you can come inside you can try more and, yes, slowly, slowly, it's getting busier and busier and busier."

"Me and my business partner, we said in the beginning, 'Lets open something unique, something that the whole UK hasn't got the second one,' so that was our purpose to start something authentic, something original that you cannot find it anywhere and slowly spread out across the UK, the world and slowly get the people, I mean, everyone, not just British people but everyone to know about Greek pastries and pies and all the recipes. I don't know why they are not promoted more in Greece."

With its bright colours, branded uniforms and bold design choices, Pop Pie already looks like it is part of a national chain or franchise. "That was the thing from the beginning. With my business partner, when we started the whole idea it was to grow and to spread around UK, so that's slowly what we're start doing by giving out the new taste with pies and pastries and now that we see that this is successful, we can open a second shop and then a third one in different areas, not only Brighton, and try our luck that. It seems like we have good luck, so let's hope it will remain like that in the future. That's my near-future dream. That's why we said 'Let's do it!' and we were both on the same boat, floating in the sea of trading."

His business partner, Yannis, is originally from Kavala in northern Greece, a short drive from Thessaloniki and another town that prides itself on its pie heritage. Yannis came to the UK when he was just nineteen to study Civil Engineering. It was at university that he met Kyros and they soon became friends. After graduating, Yannis decided to return to Greece where he was able to enjoy the delights of the bakeries and foodstalls of his homeland again. He became increasingly taken with the idea that when he was in the UK he had been unable to find anything similar. And that got him thinking. Meanwhile, back in Brighton, his student buddy, Kyros, was having the same thoughts. When they caught up to reminisce, the business plan just came together.

Yannis admits that he left all of the cooking to his mother when he was living at home. "Yeah, actually my mother was cooking in the house, so when I moved out the house to study, I had to learn how to cooking every day my food. Because it's good to buy from deliveries and take out, but you can't eat it every day, you have to make proper food. So yeah, I had to learn how to cook my food. And when I start to learn how to cook I was on the phone like: 'Oh mum, what I'm gonna do now? What's the next step? What I have to to do? What is that? What is that?' You have to learn if you want to eat properly. I mean, you have to know how to cook your food. So yeah, my mother was my teacher in that!"

Yannis grew up in a nuclear family with his parents and his sister. "I think it's difficult for the mother to be cooking every day different food for family, to keep everyone happy. Because when we are little children, me and my sister, we said 'I don't like spaghetti' or 'I don't like spinach', 'I don't like that, I don't like that...I don't need that, I don't like salads' let's say. So for mothers it's difficult as a job. And she is not getting any help, I mean from no one. She is cooking for the family. It's like what she loves to do, every day for the family. It's like love, I can't explain it, it's for the family."

Now her son is running his own food business, you might think she would appreciate the extra helping hand with the cooking when he visits the family home but in fact he does not get a look-in. "No, my mother is like: 'Oh my children came back, so you don't have to do anything, you stay, you relax, you don't do anything. I will do everything for you'. And that's it, mother!"

"When I am in the UK I have to cook because I like to cook myself homemade food, and also I like cooking because you can put your imagination to it, you can make by yourself what you like to eat and to combine the taste with different things that you like, and I think it's something magic. I try to avoid to making pies and pastries at home because we have them here all day, so when you go home you want to eat something different.

"But there are some times that I'm not sure about something and I have to call my mum," he added, laughing, "To tell me her opinion or to give me her advice, 'Do this' or 'Do that'. So yeah, I trust my mum!"

Kyros also keeps in touch with his mother, except instead of using the telephone he has introduced her to the video-chat application, Skype, so that they can stay in touch. "It's very funny, you call them through Skype and they said, 'Oh, I can see you, like... wow, what's happening?' I mean, I am trying to teach her how it works because it is easier for me as I studied computers. She said to me, 'That's why you went there but I didn't follow you so I cannot follow you here!' so I have to be there to tell her, like, which button to click and where to look. But you know, when she's using the video chat, she is looking at the image of herself like she's looking in the mirror! So she starts making her hair, you know, things like that. So it's funny as well."

Both Yannis and Kyros recognise the importance of their matrilineal food heritage. It is a solid part of their cultural traditions but these gender roles are starting to change. "I think in Greece it goes like that," said Yannis. "You get recipes and all you have to learn is from your mother and it goes like that, from grandmother to mother and it goes from child to child. So most mothers, they get to know how to cook from their mothers and went like that all these years. In the old years, it was like the woman has to be at home cooking and preparing everything at home and the man has to go outside to work, to bring home the money so the family can live, but in nowadays I think the couples they have to do everything together. The woman has to go out to work, the man the same. When the couple come back to home, I think the men nowadays they're helping their wives to make the food or some jobs in the house altogether, so they can have more time to spend with each other. I think it's good to help each other as a couple."

When they first opened the shop, most of the customers at Pop Pie were Greek, but this is starting to change as well. "In the beginning, it was eighty-twenty, like 80% Greeks, 20% the rest, but now it is like sixty-forty: 60% are Greeks and 40% are the rest. And that's what we wanted to do from the beginning, to introduce that to everyone and get to make people know about the pastries and the pies from Greece. Because people still come in and ask us: 'Do you have Moussaka?' or, 'Do you have Souvlaki?' unfortunately because they see the sign outside saying 'Greek food' and they think it's going to be like that. It's good to see that everyone knows about the Greek taste but we want to offer more."

That's not the only thing they get asked about, though. A lot of the local customers pump them for tourist information about Greece. "There are people coming before summer, like April or May, and saying: 'Oh I'm going in Greece on July, August' and, 'I'm going in Rhodes' or, 'I'm going in Crete' or, 'I'm going in that island', in Kos or whatever and I know where to go so I'll tell them about the beaches, about where to go and where to eat. But I will definitely tell them to try

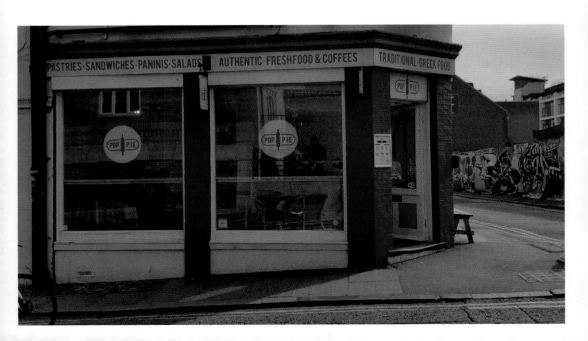

new things, new tastes. I mean food-wise, to try something, let's say, that's not moussaka and souvlaki! Of course they will eat that but also they can be trying to get the actual tradition of the island, cos even many Greeks they don't know about those local traditions, they would have to go there and spend some time there to get to know that tradition. For example, let's say in Kos Island they do a sweet dish from tomatoes. I mean, that's something nobody knows about, only people from Kos, or whoever goes in Kos, so it's a specific tradition in Kos Island. It's called Glyko Tomataki and you eat an actual tomato and it's sweet. It's not sweet... it's like very, very, very sweet!

"The problem is that when people go on an all-inclusive holiday, they don't have the chance to try things. They're stuck inside the hotel, and they get to eat whatever the hotel decides for them to eat, so they don't have the chance. Those agencies are not giving the details about different menus and different beaches to go or different food to eat, or different nights out or days out around the area, so they like keeping them in, in order to spend more in the hotel which they already have the deal."

And that is the dream of these two young men, abandoning careers in computers and engineering in order to share their love of humble Greek pies and pastries with the whole world. And it all starts in Brighton.

Pop Pie. (Formerly at 25 Church St, Brighton, BN1 1RB, now in the process of moving).

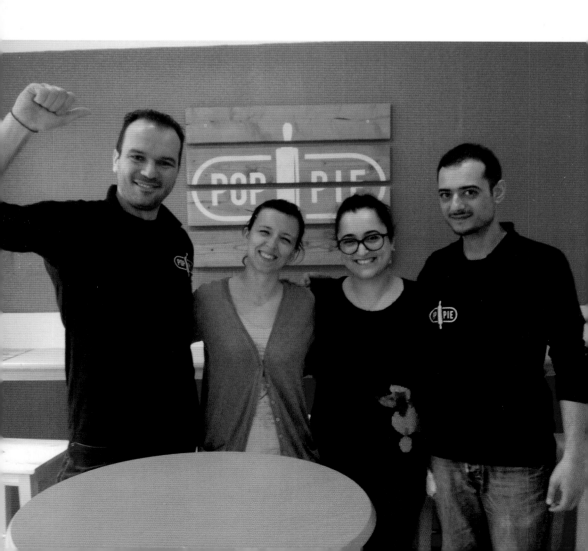

Kambi's

Full disclosure: I love Kambis.

I love the food and I love the atmosphere. Situated halfway down Western Road near a dozen or so other Middle Eastern places, Kambis is a little bit different. It has a takeaway by the front window that bashes out kebabs and wraps to hungry punters and a sit-down restaurant behind, accommodating those who prefer to kick back with their food. The food is Lebanese but Kambis itself is international. The staff and the customers are so multiculturally diverse it would make the bridge of the Starship Enterprise look like a UKIP rally. There are Spanish waitresses, Kurdish businessmen, Arab students, English families, all rubbing along together and tucking in to some seriously tasty cuisine.

My friend, Haval, works at Kambis and I can easily waste an hour of his day sitting there drinking tea and discussing world politics. He was the first person I told about the idea to make this book and the first person I asked to interview. Haval is a Kurdish refugee from Syria and has lived in Brighton for about eleven years. He is a musician and plays traditional Kurdish folk songs on the saz, an instrument which is related to the tamboura or bazooki. We have had some adventures in music together, including pirate radio and a refugee orchestra, but these days he prefers to keep a lower profile. He spends most of his time either working at Kambis or helping out asylum seekers or other newcomers to adapt and survive in their new country. He has been instrumental in some community charity projects but if you asked him about it he would tell you it was nothing and would change the subject.

Haval's work at Kambis is flexible. He is in a lot of pain most days because of a problem with one of his legs, but you will always find him smiling and welcoming, helping out wherever it is needed. He should be sitting down to rest but he is always in a different part of the restaurant. "I do work everywhere. I do some cooking, I do paperwork and serving downstairs with the guys who do waitressing." Haval started working at Kambis shortly after it opened in 2011. "Actually it was my first experience working in restaurant. It was my friend's idea to open his restaurant and because I was his closest friend he said you need to be next to me for the paperwork. My English was a bit better at that time and he wanted someone to help with the reading, writing invoices and emails. I never expected me myself to be working in such place. But I enjoy it. To be honest I enjoy much more working in the kitchen downstairs. Doing papers and invoices is a little bit more boring than doing pastry in the kitchen or serving customers downstairs! I work as a waiter downstairs if it is busy or just to cover some people who might be ill or away. Also in the kitchen if the chef needs some assistance. There are some types of food, speciality for let say Middle Eastern which is a bit hard to make, like one dish is called Kibbeh and it is hard to make. It is only the chef and me who know how to make this recipe. We try to teach those who work here, because it requires some skills."

"When my friend, Sadiq, opened the restaurant, he had already an idea what food he wants to sell because Lebanese food became recently very popular in English culture here. Lebanese food is eaten with rice and it has lots of vegetarian dishes so it can satisfy all tastes and varieties of people. And vegans. We have lots of dishes which do not have any animal product at all, so it became a successful idea. But we also got big chunky dishes for meat eaters as well. We make it on a daily basis so we receive a fresh delivery from London with lamb. We do not freeze it and whatever is left at the end, we throw it away. That is why it is a bit more costly, but it has to be like this to keep customers satisfied and keep the food tasty. We have all kinds of grills; we have a mix grill like chicken fillets, lambs minced or chunky ones."

"We have introduced a few new dishes, like, because there is a big Iranian communities around so there was a demand for Iranian

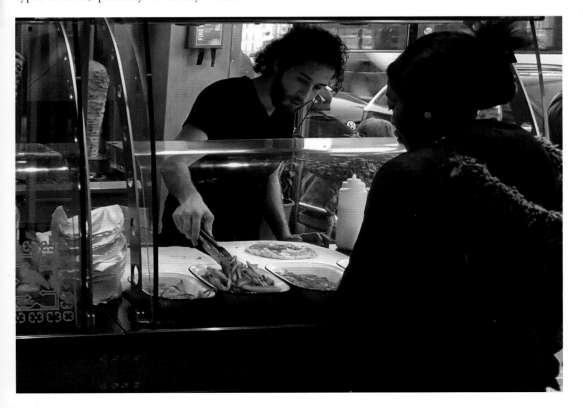

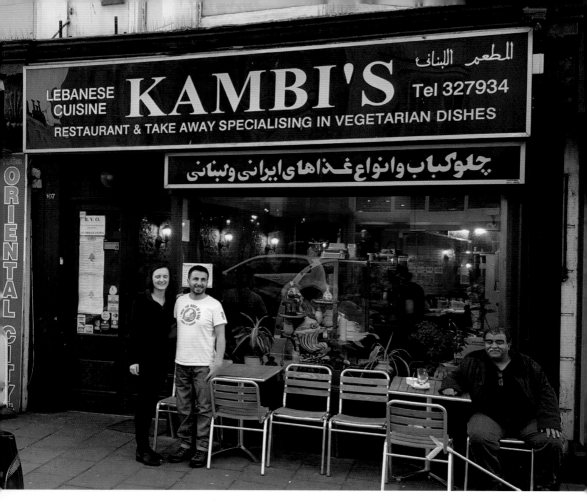

dishes. So we introduced few Iranian dishes, like one is called Soltani, or chelo kebab, which is prime lamb from the back side of the lamb. You make it flat. It's a bit hard to make it because you need to make it very flat but it is very tasty."

The dish is called Soltani because it is good enough for the Sultan to eat. This is appropriate, as the name, "Kambis" derives from Kamboja or Cambyses, which is an Indo-Iranian title for a crown prince of Persia.

Haval grew up in a small town called Afrin in the mountainous North-West of Syria near the Turkish border. He was the youngest of two brothers and three sisters. All the family loved music and he picked up the idea of playing an instrument from his sisters. Originally he wanted to become a professional musician but it was not to be. He says all of the big musicians from his country are old men, not like the youth-obsessed popstars of Europe.

They are the ones who are considered to have spent enough years mastering their craft and it is a difficult world for a young person to enter. Instead, Haval's older brother exercised his seniority in the family and decided that Haval should pursue a career in dentistry.

"I am qualified as a dental technician. When I came first time to Britain, I could not get this job. I always want to get work because it is my passion. Especially something to do with art, as I am a musician. Making teeth was a kind of art for me: carving or using all different types of wax or metal alloys, it was interesting and enjoyable for me to work and I worked for a few years in Syria. Finding a job in that field here though was very hard for me as I had to have an English qualification which took nearly a year." The issue of non-transferrable qualifications is a huge barrier to refugee integration. Under UK laws, many professional degrees from overseas universities are not

deemed to be equivalent to British universities, even though many of those universities were established in colonial times and adopted the British educational system. So we have the situation in Brighton and around the country where we have well-educated and experienced professionals such as doctors and lawyers forced to take work driving taxis and making kebabs to make a living. "I worked in a laboratory in Haywards Heath for nearly eight months, but the pay was poor and I had to travel every day from here to there. I was struggling, to be honest. I was getting paid minimum wages and there was transport to pay. I would have stayed there, but I had another job being a bilingual assistant in schools because there were some school kids who come from Arabic or Kurdish background so I had to work with them. It was better for me. It was local, they paid my transport and I was getting paid double from what I was getting there. That is why I changed my job."

Haval is from the Kurdish minority in Syria.

When he grew up in Syria, though, his ethnicity was suppressed by the government. Children were not supposed to have Kurdish names or learn the Kurmanji language. Haval eventually had to leave when his family's interest in Kurdish culture drew the attention of the authorities. These days he enjoys a newfound freedom of identity in Brighton and also the trans-national microcosm of Kambi's. "We have two Kurdish guys working here, some Arabic workers, and we've got Iranian as well, so we do not mind actually what nationalities we choose. The chef is Syrian but he has to be specialised in Lebanese food. That was the most important thing, because he controls all the dishes and recipes. Apart from that, we don't discriminate with nationalities. We have to employ anyone who is qualified and it does not matter where they come from, as long as they know about their job. We have got staff from Poland, from France, Spain, we've got many from Spain in fact, lots of Africans. If we need waitresses there would be lots of Africans from Spanish backgrounds coming.

"The customers are enjoyable. They are fun to work with. Sometimes we get an issue with Arab culture, when we get Arab students, because their manner could be different for the European waitresses to understand. So we've got cross-cultural differences. The way an Arab student asks for things can seem rude in their European view. It is just like a straight forward question. They ask, 'Can we have this?' for example. They are not particularly trying to be rude; it is just because that is how it works where they come from. They are not trying to be rude but the way they ask might be viewed as rude.

"We have got two shifts, the morning shift which starts from eleven until six and the other one is from six till midnight. The kitchen closes at eleven pm so we have two rounds of people working here. We tend to have more student customers during daytimes. We got lots of Arab students or, like, students in general, because we have a special twenty five percent discount for students on main meals. So those customers come in during daytimes while at the night-times we get more families coming, some English, some other. They can bring their own alcohol as we don't have alcohol licence, so it's much cheaper for them than order drink here as well." Since the time of the interview, Kambis has now successfully applied for an alcohol licence and is now able to serve drinks, including on the tables outside.

"Sometimes we do get drunk people coming in to the restaurant, like especially after a football match from the pub opposite us, the Temple. After the match is finished, they pop in, but they will behave. They're OK, they just come for quick kebab and that's why we keep the front bit for takeaway especially. Its easy serve, easy go, and don't mix with other tables. We have in mind that we might have trouble with customers being drunk or it could be awkward if they are getting in touch with people sitting on the tables, so in this case is better to have the front bit just for takeaways, standing takeaways, and the restaurant with tables in another section."

When I started out on the journey to make this book, I had notions of debunking stereotypes about the people who work in takeaways and restaurants. I also had a vague idea that the businesses are beset by drunken racists abusing the staff and that this would be a common theme. But like so many other places in Brighton and Hove, Kambis does not seem to suffer from this problem. In fact, the actual notion itself is a form of stereotyping against the British. In reality, people working in these establishments are not constantly negotiating a hostile tirade but are part of a more sophisticated community of difference where the problematic encounters are far more nuanced than might be presumed. "To be honest, I have never experienced racism from the customers or any such thing," said Haval. "English people are very friendly, the English customers are very well educated and they do not evaluate you according to what kind of job you are doing. In the Middle Eastern mentality, sometimes we always look for a high qualification. We evaluate people. If he is a doctor we will look differently at him than if he is a cleaner. I had only one occasion like this, with two students from the Sussex University who were Lebanese. Their attitude was a little bit different. They were not friendly, they were looking down at me, ordering, you know, in a manner which could be not friendly. I did not feel comfortable, but OK, these things happen sometimes. I do not have to explain myself, I do not have to tell them what qualification I have. You get people from all sorts of walks of life and you have to be accommodating to all of them.

"I feel more comfortable with English culture to be honest, behaving in the English way. I do not forget my culture and I have to keep up with my culture as well because I have lots of friends from my own background. But I go out and drink, I go to pub, I don't have meat preferences, I can eat pork, I do not have a specific religion to follow, so I am pretty much easy. I think it is much easier when you live in a foreign country and if you gonna live there for long time to adopt that culture rather than living on your own culture.

"On Fridays it is maniac. Lots of people come in at once from the mosque after they finish prayer and most of them would be hungry and they head straight to restaurants around the mosque and one big attraction is Kambis because we serve halal food and freshly

clientele from further afield looking for a taste of home. "We have actresses and actors when they come to visit England like from Lebanon. Sometimes singers are coming here, when there is some event like Christmas, or the Coptic community sometimes they have parties, they invite their own singer. So when they come they try to look for the local restaurant that provide with Middle East or Lebanese cuisine."

A large part of the appeal is down to Kambis' head-chef, Lui. He grew up in Syria as part of a Christian minority and started his working life as a jewellery-smith. "I used to do loads of necklaces. It is very complicated to explain you what jewellery is. It is a very, very, very huge topic. I worked with gold. I did men´s jewellery, ladies´ jewellery, it depends. But most of the time always ladies asked for gold!"

Lui moved to the UK six years ago but he could not find any work in the jewellery trade. Unlike Haval, he was not hampered by the lack of a transferrable qualification but by the language barrier of not being able to speak English fluently. "I could not find this job so I start here as a kitchen assistant at the beginning and slowly, slowly, I am head-chef. I used to work for the previous head-chef here and I start to learn as well, slowly, slowly catching everything. It was good for me as my food culture is similar. You know, Syrian and Lebanese are similar food so it was easier to learn. Yeah, as you see we are very busy so that means it is good food we do here.

"To be honest, I miss jewellery but I like to be a chef. I like the job here with the guys. We work here for a long time here with the same group so we are like a family here."

"Recently we have re-decorated," said Haval. "It might look old-style but we had to change because it was two years and eight months it looked the same. So we thought of changing to an older version. We deliberately left the red bricks and painted them with over gloss. There was one column inside and we removed as well so it was a big change. We still need to make more changes in future; we need to make the front area a lot bigger. It is a collective idea between me, Sadiq and Lui, so we sit down and try to think in the best way."

brought meat from London. So it might be frustrating for them because they have to wait. Imagine like fifty customers coming within two hours! It is a big demand but eventually everyone get served and happy.

"I think this Western Road has been always like this mixture of foreign nationalities. Since the day I arrived here, it's always had lots of restaurants from different backgrounds and different countries. I think the people mostly live around this area, that's why. There is a mosque and other shops, mobile phone shops and Waitrose and I think it is an attraction for them."

Kambis is not just a destination for locals anymore, though. They also attract a glamorous

"Yeah, we had more than one year to decide what to do for the décor," said Lui. "So we decided to do this thing now and in the future, in couple of few months we gonna change something too. We gonna move the kitchen downstairs, it is going to be up in front. And even the menu. We gonna add more starters and main courses and some Persian as well, maybe some Moroccan as well but we did not decide it yet. We want to make the menu bigger, and too many people are asking for some Moroccan sometime. Lots of people come here so they like that food so we try to give them what they want to make a business.

"The best thing to cook is what you really like to eat so when you cook it you enjoy it. We have a big menu, but we try to add a little bit more to make our customers to feel something new on the menu, that is the only reason. For the business we are good, we keep going and we are busy all the time so just the little changes are for the regular customers."

Lui is always laughing and finding the positive side of life but he eventually admitted that it was not always easy. "Well for me of course, everywhere in the world you can find some time hard time to work. Some problems with the staff or customers. But we sort it out all the time. Well you know, we are serving hundred people every day. Some customers say: 'Oh, we need more salt in the food', some say: 'Oh, there is not enough lemon!'. So you cannot do good things for all of them. That is the job for the guys downstairs, so all the complaints start with Haval and he come to me. It is not easy. It is not easy. Working with people is not easy and we work with something very sensitive: we work with food. Food is sensitive because of hygiene, quality, time for the service. But we try our best all the time.

"Couple of years ago it was very easy for us because we used to bring products from Syria and from Lebanon. After the situation on the Middle East it is getting harder and harder and even the prices are going up a lot. It is like more than double. So as I say it is not easy at all. Now we found a way to bring it all from Turkey so it is little bit similar. We always try to give them a traditional way.

It is not easy but we always try to do it."

Lui seemed to be the kind of chef who loves his work so I asked him if he also enjoyed cooking at home. "I'm gonna tell you the truth: I have been in Brighton for ten years. First eight years I was alone, no family and I did not have any pan at home to cook. If I wanted to eat something big, then I did it in the oven or takeaway. But now my mum she came here to live with me so for last two years she has been cooking for me. But for me, I never cook. Well I am fed up to cook. Everyday I am here twelve hours sometimes. So when I go home just I forgot about the food, about cooking!"

Lui has a small tattoo on his hand but it is a statement of faith rather than a part of the recent fashion trend for getting inked up. "I got my tattoo back in Syria. It is kind of for Christian people. It is kind of cross for Christians." The tradition for Christians in the Middle East to obtain this kind of tattoo can be dated back to the 7th or 8th century and can function both as a symbol of belief and as a form of ID. "I'm not gonna get any more, though," Lui told me. "I don't think so. Maybe when I have some kids then I will get something which will remind me of them. But not yet!"

Anna is one of the many young waitresses and staff at Kambis. Originally from Poland, she moved to the UK to live with her boyfriend. "Before I am studying in Poland pharmacy," she said. "I finished there and I came here because my boyfriend is here. So I found the job here and I work here. I am happy to be here, because I am with my boyfriend and I miss not a lot from the life in Poland. Maybe after one or two years I will find a job here as a chemist and I will be happy because I will have my boyfriend and job. And that is it."

"We have two different groups of customers. We have the student-group customers, they are Arabic people, they speak little, little English, so you must think, 'What they want, what they want?' I understand a little Arabic because the other staff told me about the menu in Arabic. So now I know that this one is this and that one is different. Then the other group is the rest of the people, like English or Arabic or actually from everywhere. And the people are not too bad.

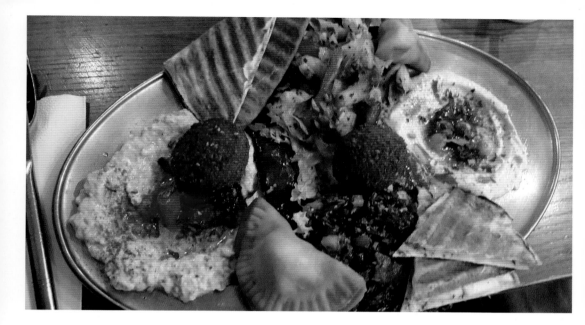

Sometimes people are drunk so they make little mess. But it is OK, the people are very nice. I have been working here for four months. But I worked here before in summer holiday for two months. The staff here are very nice. I work mornings with one guy and sometimes, you know, we speak together when we have a time.

"Lebanese food is completely different to Polish food. Here, lots of food is done from lamb and back in Poland we eat a lot of pork. But here it is banned to eat pork. Yeah, it is very nice food because it is not that spicy food, as for example food in curry or the Indian food. We also have lot of food from the grill. And they make very nice basmati rice.

"My friend had a friend, an Arabic guy, and he said to her that one restaurant is looking for a waitress and my friend told me and that is how I got a job here. It was a bit of a difficult road for me to get this job. The first time I came here asking for job in the kitchen or to clean this place. But the boss here told me 'No, you will start here with the customers.' So I slowly, slowly, learn, learn, and eventually it was OK."

"The first time I came here, the guy was like: 'Oh my god, this is the only girl here!' But I don't think about this. The students are very young guys so I do not care about it. There is no discrimination here, no, no. I am Catholic and I wear the cross. Sometimes the customers ask me about the cross and that is it. It does not surprise me actually, because in this place everybody just gets on with each other and they do not make a big deal of things. But here on Fridays, mainly Arabic students are coming here and they ask me many times about Poland, about my life, so it is not too bad.

"I would just like to add: please come to Kambis! It is very nice food here and very nice staff. And come in the morning, because I am working in mornings!"

Haval adds, "I would like to thank you to giving us the opportunity to come here and introduce our restaurant and shed light on our menu and give us this opportunity to talk about it." But he need not even mention it. The idea of writing this book without visiting Kambis would have been unthinkable. It is the perfect example of the kind of cultural exchange and social change that is happening on the high street and subsequently in people's homes across the town and across Europe. And it does a great kibbeh shamieh.

Kambis Lebanese Restaurant, 107 Western Rd, Brighton, BN1 2AA

Blue Nile

"I've been watching this programme on BBC TV about the North Pole and how can people survive on that part of the world," said Ali, "And it amazed me how can people survive in Sudan as well. Its lack of water, the heat of the temperature over there and it's basically the Sahara, the part where I'm from. And the river Nile is coming, crossing the Sahara and obviously the dry weather is everywhere and it amazed me: how can people survive far away from where the water is, with such an organic and simple way of cooking food and it still tastes nice as well, if you know what I mean? So it is basic recipes and people enjoy it and it keeps them going, you know, surviving."

Sudan can be a harsh land. Desertification and droughts are common, with dwindling supplies of decent water. The deserts and dry regions are plagued by haboobs, nasty sandstorms with winds of up to a hundred miles an hour, driving loose sand and dust into the air and blocking out the sun. The haboob storm-front moves in a giant wall of sand up to three thousand feet high and it can last for hours. Outside of the sandstorms, the number of hours of sunshine is incredible, sometimes topping four thousand hours a year. This is more than three times as much sun as you will see in London. The deserts of Sudan have virtually no rainfall and some have literally no oases at all. But through it all flow the waters of the mighty River Nile, the source of life and of hope.

We met Ali at the Blue Nile café on Preston Street. Ali is passionate about his food, about Brighton and about the river that lends its name to the business. But not all of the customers understand the name, "People know the river Nile but they don't know the Blue Nile and they don't know the White Nile, you know. There's two Niles combined together. They get together and

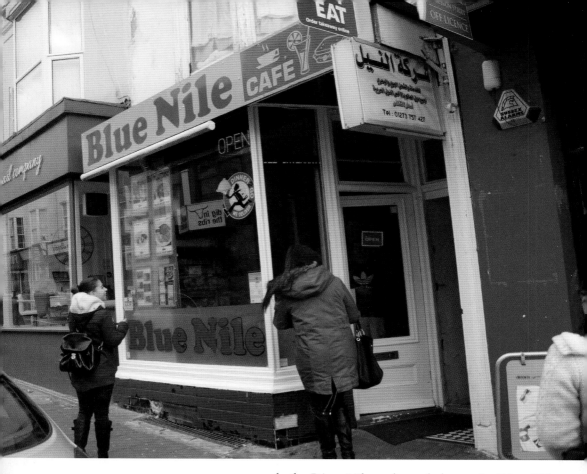

Preston Street in Brighton is known as the "Street of a Thousand Restaurants" including Chinese, Lebanese, Japanese, Indian, Thai, Italian, Vietnamese & English.

made the River Nile, and people know the River Nile rather than anything else. It is a good opportunity to start talking about it, so whoever asks me about the Blue Nile, definitely I would have plenty time to explain what's Blue Nile is. The minute they locate where is Blue Nile and they figure out in their mind which part of the world it is, obviously there will some asking me: is it African food? Is it Mediterranean? Is it North African food? It's cos the location of it is in Africa, and Sudan is half Africa and half Arab and obviously they ask what sort of food is in it? When you talk about North Africa, the majority of the people they know that it is like Mediterranean food and they tend to ask about what's occurred in where you are coming from, you know, and what you giving to this community, food-wise?"

Sudan has its roots in the lost Nubian Kingdom of Kush, a monarchy which predates ancient Egypt and which may even have been the location of the world's very first kings. With rich deposits of gold, the kingdom became a trading point for luxury goods such as incense and ebony. The Kushites were a warrior nation. They eventually conquered Egypt and initiated a reign of, "Black Pharaohs". By the end of this period there

were twice as many pyramids in the Kingdom of Kush than in neighbouring Egypt and vast necropolises full of mummies adorned in rings and bracelets of gold. But the Empire was weakened by the arrival of the Romans from the north and pressure from new kingdoms to the east, and Kush eventually collapsed around the third century AD.

Sudan was colonised by the British in the 1800s, with Egypt as a joint-ruler. Following the British colonial practice of, "divide and rule", the country was split into two provinces, the North and the South, exploiting old tribal rivalries. The colonial powers developed the infrastructure and administration in the Northern Province but slowed down the economic development of the South. The country gained independence in 1956 but it was an unsustainable colonial integration of the South and the North into one country ruled by a capital in the North. Almost immediately, this led to a series of civil wars and conflicts, including the genocidal war in Darfur, all of which culminated in the separation of the country into two states, Sudan and South Sudan. Sudan is now dominated by Islamist political organisations and has been criticised internationally for persecution of the Coptic Christian minority and for human rights abuses. It retains close ties to the UK government, who are

◀ Soup is a popular part of Sudanese cuisine

▲ Ali at the Blue Nile cafe, Brighton

◀ Spicy garlic and peppers were introduced during the Ottoman empire

the only nation in the world besides Iran who continue to provide Sudan with military support and training.

Before the secession, Sudan was the largest country in Africa and one of the top ten biggest countries in the world. There are still rich mineral resources of gold, silver and uranium and significant deposits of petroleum. And there will always be the Nile. The people of Sudan often identify as being either Arabs or Africans, but, like the White Nile and the Blue Nile, they can mix together, and many people have dual ancestry. Arabic is the official national language but the Bedawiye people speak Beja along the Red Sea coast in the east. To the west you can find Fur and Zaghawa people and in the mountains of the south there are Nuba who speak a language known as Hill Nubian. Outside of the capital, many people still live a nomadic existence, herding cattle and camels, as they did thousands of years ago. In cities such as Khartoum there are migrants from the rural areas, as well as refugees from various conflicts and the Fellata from West Africa.

Sudanese food is not world-famous in the same way as Moroccan cuisine and there are only a handful of Sudanese restaurants in the UK. Something of a

The Nile is the longest river in the world. It reaches over four thousand miles in length and, unusually, it flows from south to north. It is associated with Egypt but in fact this is just one section of a huge river that flows through eleven countries:

Egypt
Sudan
South Sudan
Eritrea
Ethiopia
Kenya
DR Congo
Burundi
Rwanda
Uganda
Tanzania

The River Nile is actually formed from two different rivers. The main body of the Nile empties into the Mediterranean Sea through the north of Egypt but, further south in the Sudanese capital of Khartoum, it splits into two tributary rivers. Heading to the west by Omdurman, it becomes the White Nile. Heading to the east it becomes the Blue Nile. The source of the White Nile is still a mystery, but it flows north through Lake Victoria and is the longer of the two tributaries. The Blue Nile carries most of the water though, and begins its journey at Lake Tana in Ethiopia.

Surrounded by desert, the Nile creates a fertile valley which gave birth to some of the oldest civilisations in the world through a system of farming in the rich black soil of the flood plains. The reeds that grow along its banks include papyrus, which gave the world paper and spread the art of writing. The river was also an important source of food and, crucially, trade. It offered safe and speedy travel at a time when the world moved more slowly than it does today.

mystery to many, Sudanese cuisine was recently parodied on an episode of the American sitcom, Brooklyn Nine Nine, when foodie character Boyle fails to share his Kawari stew, "The hoof is the best part! Oh man. Think of it as a marrow nugget wrapped in a thick toenail. Mmm." Comedy aside, Sudanese food is proving increasingly popular. One of the most well-known dishes is kisra, a thin fermented bread made from sorghum or wheat. This can also form the basis of the porridge known as aseeda, which is one of the main foods eaten in Sudan. Just as Sudanese people do not really eat breakfast first thing in the morning, the porridge can be eaten at any time of the day.

"My favourite recipe is kisra and waika," says Ali, "It's a basic one. Its main ingredients in the recipe are water and dried lady's fingers [okra] and a bit of onion and flour. You can't get a simpler recipe. You can make a meal out of flour and dried lady's fingers and bit of salt and onion. And it taste amazing. In order to keep travelling and fighting in really strong, constantly hot weather across the desert and to survive across that, it does need strong will and enjoyment as well. So this is what my favourite meal is. It's called kisra and waika. It's well known Sudanese recipe. It's the main dish every Friday. And it's cheap!" he laughs.

The food at the Blue Nile is true to the name,

"Well, we've got Mediterranean and North African food basically, mainly according to the name Blue Nile. I don't doubt very much everybody knows the Blue Nile, but this river goes across Sudan, north of Sudan all the way across Egypt, to the sea. That is where I'm from, Blue Nile. So, we do that kind of food: lots of meat, all different types of what you can make out of lamb and chicken, and our speciality is the Blue Nile fish, which is the Tilapia fish. Very nice fresh water fish."

Ali's father travelled from Sudan to London in 1970 for post-graduate study and was awarded a PhD. "I got a brother who was born in London and I lived in London when I was really young. Not for long. And then I moved back to Sudan when he finished his studies. My brother started his journey back to United Kingdom when he finished his high school. And then my mom, bless her, and myself, we followed. Due to her illnesses, I decided to stay, to care for her… And luckily I met a nice lady, got married too. She is from Yorkshire. She lived in Brighton, had parents in Brighton. And that's how why I got tied to this part of the world, with three kids. This is my whole entire story!"

Ali spent his early years in Sudan, "This is where I came from, like I said, that's where I grow until I was a teenager, and

"You can't get a simpler recipe. You can make a meal out of flour and dried lady's fingers and bit of salt and onion. And it taste amazing."

"It's the water. Maybe it's a psychological thing. The ingredients are the same."

then I left Sudan, I left the Blue Nile…
Of course I do miss it. I miss the freshness
and the organic feel of the nature in
that part of the world. Of course."

When Ali is cooking recipes from back
home here in the UK, for some reason they
taste different, even when he uses the same
ingredients and follows the same recipe.
Returning to the theme of the Nile again, Ali
believes the secret lies in one key difference:
"It's the water. Maybe it's a psychological
thing. The ingredients are the same."

He accepts that the different weather may
also affect the way things taste but the key
change for him is not cooking in the waters
of his beloved Nile. He may well have a
point. There are a lot of chefs who would
not dream of cooking something like pasta
or soup with unfiltered hard water, and high
chlorine levels in water are also associated
with bleaching the colour out of food, so
it is established that different types of water
can have a chemical impact on food. This
effect could well be exaggerated with a recipe
like soup or kisra where the food absorbs
so much of the water used in cooking.

Food and cooking were not on Ali's mind
when he first came to the UK, though, even
before he found himself caring for his mother.
He had his sights set on other things, "I was
running a business to support all the Middle
Eastern students in Brighton and Hove, they
come over to study the English language and
perhaps some of them they join Brighton or
Sussex University for studying. I've lived in
Brighton for the last seventeen years and it's
a new thing that the Middle Eastern students
start coming to Brighton. It wasn't like it
seventeen years ago so I've noticed a business
opportunity to earn a living and not just
that but the pleasure of helping vulnerable
students that come to this country for the
first time in their life, to guide them and try
to help them out with how to get involved
in this community and to learn as quick as
they can the way of the lifestyle in Brighton
or United Kingdom. cos I can guarantee that
there is absolutely huge difference between,

you know, Middle Eastern and United
Kingdom, cultural-wise, language; there's lots
of gaps that students suffer from. And I was
quite happy to expand a little bit by having
the opportunity of getting this restaurant
which is still, like I said, business and pleasure
in the same time, which is quite good.

"Cooking: it wasn't in my career plan, it
wasn't what I was doing for living. Well,
I've learnt from the Blue Nile itself, to be
honest." He adds, laughing, "I mean not as
the river but the Blue Nile cafe in Brighton!
I've started loving and having been inspired
by cooking and enjoying it, when I had to
work in the Blue Nile in Brighton, and that
gave me really good opportunities to learn.

"I had the background about how to cook
Mediterranean or North-Africa food, obviously
off my mother, but like I said, it wasn't what
I was doing for living till I've start working
in Blue Nile cuisine in Preston Street. It's
been last three and a half years working in
this restaurant. It's been my pleasure to get
closer to enjoy cooking and to enjoy seeing
big smiles on people faces when they like
and enjoy the food I cooked them, and
enjoy more when they come back for more
food. So I believe it wasn't just making
money out of business, not just that, it's like
I said: it's to provide the community with
something new, with something that they
enjoy it. All sort of nationalities that they
lived in Brighton, I believe I come across
them and I believe they enjoying tasting
different ways of cooking food, basically."

Like most of the people we interviewed for this
book, Ali loves Brighton and he loves living
in the town. "Brighton is an open community
and it can take in more than you can imagine.
It's huge, you know." He also loves the social
involvement with his extended family but there
is one thing in particular that reminds him of
the Nile that always keeps a characteristically
big smile on his face, "Like I said, I live near
the sea and I'm happy, as it is still water," he
adds, laughing, "And that's what I can say!"

Blue Nile Cafe, 60 Preston Street, Brighton

Casba

The post-pub kebab is a staple of British drinking culture and a rite of passage in the life of any young carouser. But what about the people who work in the kebab shop? What is their story and what do they make of this boozy behaviour?

Loui and Fadi are two brothers from Syria who run Casba, an unpretentious takeaway surrounded by pubs, laundrettes and takeaways down on Western Road where Brighton folds into Hove. We asked Loui if he ever had any bad experiences with people coming in drunk. "No, no, no. Is very nice customers. Yeah, is coming drunk, OK, but I am always good with them so why would they do something less good for me, you know? I am talking nice. If they

tell me, 'My friend, straight away I'm drunk', I say 'Don't worry, man enjoy your life. This life is for you'. Yeah, it's good. I don't have any problems with any customer. And I've been here for four years… it's good man."

Sometimes, though, people do come back the next day. Not with regret for their behaviour but with a concern for their waistline. "So, like, some people is coming and eating only hummus and salad. That's it for him. And, like, somebody else is eating halloumi with rice. Yeah, there are a lot of healthy people in this town, man. Like sometimes I see customers is coming drunk and eating fat… next day is come saying 'I'm very, very drunk, last night. I am so sorry I'm eating so much fat. I need some veggies.' Is healthy people we have!" Loui is keen on healthy

The first döner kebab shop was opened at number 53 Newington Green Road, London, in 1966 by Cetin Bukey. It was named in honour of the legendary Sufi philosopher, Nasreddin Hodja.

There are countless stories about Nasreddin. One time, he was standing near a river. A man on the other side shouted to him, "Hey! How can I get across the river?" Nasrudin looked at him and shouted back, "You are across!"

Another time, Nasreddin and his friends were chatting in the coffee house about food. They were trading recipes and one friend described how to make a heavenly stew of liver and lungs that was so exquisite it made you want to eat the bowl and the spoon as well. All this talk of food was making everyone hungry. Nasreddin asked him to write the recipe down on a piece of paper. His appetite whetted, Nasreddin put the recipe in his coat pocket and headed straight for the butcher.

Having bought a couple of pounds of fresh liver and lungs, Nasreddin started to walk towards home. With the recipe tucked in his coat pocket and his thoughts turning in anticipation of a delicious dinner, Nasreddin was swinging the meat package from its string and whistling contentedly as he walked.

Alas, misfortune was in the air. A large crow dived down, grabbed the meat and flew off. As the crow was flying away with the packet, Nasreddin put his hands around his mouth and shouted: "Alright then, take the meat! But you won't be able to enjoy it. I have got the recipe!"

▲ Barbora enjoys a shawarma

▼ Loui's brother, Fadi, also works in the kebab shop

pursuits himself, too. "Yeah, sport, man! The sport for life, for body, for everything, it's good. I go to the gym like five days a week, after the work as well. And in the morning, when I'm not working, I go straight away."

Loui studied for nine years as a chef in Lebanon and has been working in catering for fourteen years now. He studied a range of different cuisines including French, Mexican, Italian and Arab styles. It was in Lebanon that he opened a fish restaurant with the famous seafood chef Abou Tony. "Now, if anybody asks in Lebanon for directions to a location… 'Where's is like so and so?' If you wanna ask about something, you say: 'You see Abou Tony's fish restaurant, and then you turn right…' or 'You go left,' you know what I mean? We opened that place in 2002. I opened it with my friend. Now it's very, very busy, nothing has changed. Yes, I love that man! He's working like me. He kept his kitchen so clean, even the fireplace. The hearth was so clean, it was white. He's good!"

Four years ago, Loui left Lebanon to work in the UK. He decided that even though he had studied different cuisines of the world,

it would be preferable for him to stick to shawarma. "Yeah, the shawarma man! Mexican food is not for me, because it's not my taste, you know. When I do something, I wanna do it special. I know how to cook Mexican, but not the same as Mexican people, you know what I mean? Or Italian. Same the pizza. I do, like, lovely pizzas, but not the same as Italians. Everybody have, like, something for him." But that's not to say that Loui never gets to stretch his culinary muscles these days. "Sometimes, when I have friends, I cook something special. Sometimes if a French friend is coming to visit, then I do little bit fresh escargots, but sometimes nobody love escargot. But I love it. I do it like a professional one. I love it!"

The shawarma and other foods that Loui serves up in the kebab shop are a little different from the way the food is prepared back home. For example, when he bought chickens in Syria he would go to a big market and select the ones he wanted so he could be sure that he got the best and that they were always as fresh as possible. But in the UK the chickens are ordered through catering catalogues and when they arrive they are much bigger and drier than he

▼ **After grilling the kebabs, the real grilling begins. Umit, Barbora and Roberta prepare to interview Loui**

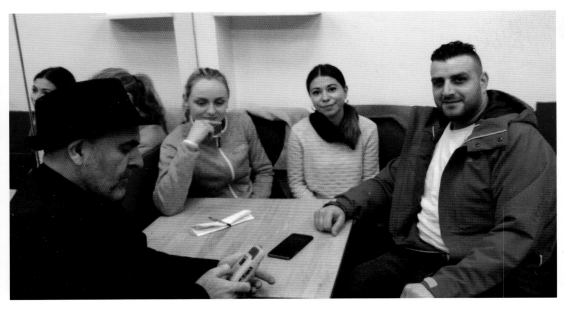

is used to. This affects the choice of sauces too. In Syria, he would only use a very simple sauce of lemon juice, oil, black pepper and tahini which is quite different to the kind of sauces normally used in a British kebab takeaway which need to do more of the heavy lifting and can often overpower the other ingredients. Loui said that he is still committed to this kind of cuisine, though, and that he does not want to start introducing people to Syrian specialities any time soon. "No, no… because you want people to know that food. If you don't know that food, what you tasting? You know what I mean. Now the döner kebab is coming here with the Turkish people. The Turkish, when is coming to England, they brought the döner. But in Syria is named shawarma. You know shawarma, you know chicken shish, the Turkish people brought that to England." The food Loui misses most from Syria is kibbeh, a kind of croquette stuffed with minced lamb and onion. Being a trained chef, though, means he is always able to cook it for himself at home so he never goes without the taste for too long. His favourite food to eat in the UK is the Full English breakfast. "It's not bad, man, it's good!"

The brothers are welcoming to their customers and Casba is a friendly place. During our interview we saw one customer arrive who just shook Loui's hand and gave him a hug. Without even having to ask him what he wanted, Loui got his order ready. "Yes, now it's like four years, and he's coming with his girlfriend all the time. The girlfriend, she take chicken shish with halloumi cheese and he is strict vegetarian, take it halloumi with falafel usually. All my customers is like regular customer and I become like a friend with him. Everybody know me. Before you tell me you need something, I know what you need. Like that. You've seen it with your own eyes.

"I have a good memory, because I am look after my customer, I am remember everything, you know. If I am working like staff, I not care. But, thanks God, I am working like business family." Despite the loyal custom from his regulars, Loui is not keen to expand at the moment or to upgrade the takeaway to a restaurant. One of the main reasons is location. Loui told us that his friend owned Kambis, the Lebanese restaurant a few blocks east of Casba, and that he would not consider himself a good friend if he were to open up another rival restaurant within the same mile. Nor does he have any plans to use his nine years of studying to start training up new chefs. "It's not easy man, it's not easy! It's very hard because, you know, the staff is working with me before. They don't have like brain for thinking about the work, they are just thinking about the money and how you wanna pay for me? But ask me about the chicken shawarma, ask me about the lamb shawarma or chicken shish, 'How you make that?' 'How we make that?'... it's not easy. You wanna find like, some people who love that detail! Now instead of the staff it is the customers who are coming ask me, 'How you do this?'"

Loui and his brother are the kind of people who have found what they love doing in life and are enjoying every minute of it. Their home in Syria is a very different place from Brighton and the environment they grew up in was far removed from the fun-town vibe of Brighton's nightlife, but their outlook and their hospitality means that they are perfectly suited as providers of sustenance to the skylarkers and merrymakers of Western Road.

"After I left home in Syria, I lived for many years in Lebanon, which is like Brighton. Although I liked it, the weather is different but it had the same kind of people, like same seafront, you know. Like that I have the Brighton Marina. I like the Marina. If I wanna go like for five minutes, I'll be in the Marina. I like Brighton. Brighton same. Still good! And friendly people. I love this country, man!"

Casba, 1 Western Rd, Brighton BN3 1AU

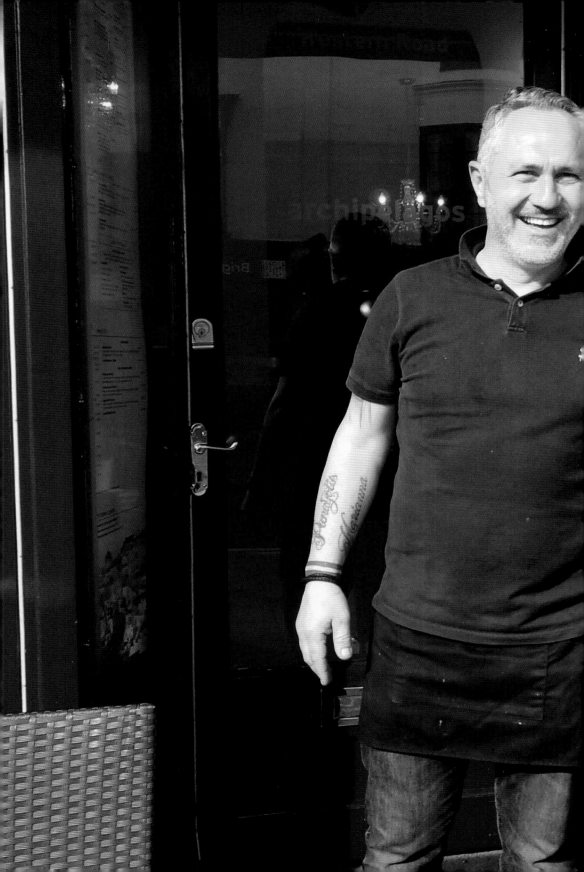

Archipelagos

Theo was born in the western Peloponnese in an area known as the Valley of Gods. It was also the ancient birthplace of the Olympic Games. The town is still one of the biggest tourist attractions in Greece, so Theo got used to dealing with tourists from a young age. When he reached his teenage years and started to look for work, he found that the easiest jobs to get were in the restaurants. Theo discovered that he loved the hospitality industry and, by the tender age of twenty one, he had already started his first restaurant. He sold it after a few years and left Olympia to start a new place on the island of Rhodes in the Dodecanese. After a while he sold up again and moved to the party-island of Mykonos in the Cyclades. He continued this pattern over several decades, before finally leaving Greece altogether.

"I tell you something: I married thirty years with a British woman. So, what I done is, I decided to come over here to follow my wife, because she is from England. I sold my last business in Greece and I came here to be closer to my children. That's the reason I came to UK. Running a restaurant and spending most of the time working yourself in the restaurant makes your family unhappy because restaurant is a very demanding, especially if it's more successful and successful, you have to stay more time than ever. So what's that mean, it makes your family really disappointed because you don't have time for them. So that's the reason. When I had the last restaurant that was a massive, big restaurant, my wife she was really pissed off with it, so she takes the children and left and she came to UK to start a new life. So that made me to sell my last restaurant and then came here to make a smaller one, just to have more time with them. And still you don't have time! That's the way it is with restaurants. You run every day, all day, nonstop."

Theo found himself living in Brighton and Hove after the collapse of his marriage. He chose to stay in the area to be near his children while they grew up. But he missed Greece. And so, as a habitual restaurateur, he could not refrain from launching another business in the meantime. Archipelagos Traditional Greek Restaurant opened in Hove ten years ago. Over the decades he had used the name before and there have in fact been four different places called Archipelagos but Theo insists that this one will be his last. "I am not doing anymore. I am nearly fifty now. So the last thirty years running places...

When you running a restaurant, you don't have time for family. It's very demanding if you want to have it busy. I run a place where, I believe, it's one of the busiest places in Hove. So if you are not here, you know, if you don't give your personal task everywhere? The business don't do well. This kind of business relies on personality: the way you creating food, the way you serving food and so on. That's what's missing a lot from some places. It's like the personal touch: to know the name of the clients and when they coming back and to know what they want and how they want and what they drinking, you know. That's what is missing a lot from some restaurants here. Like the really big companies run a restaurant from a distance: you have the manager and the people they don't come very close to you, they only always, always, in the distance. And then people start to get really bored. So is nice for the customer to walk in the restaurant and call you by your name and you have an ouzo with him or whatever else, so it's more personal. So that's the reason it's more busy here. People they coming because they want to have a dinner but they want to have a first lovely evening, having a chat. If you see here, lots of people when they coming in the evening, they know each other. So I have customers sometimes they coming for the last nine years and come, like, four times a week, so they know everybody. So when they coming in say, 'Oh, are you still here again? I saw you the last week, blah–blah–blah'. That's the way it is."

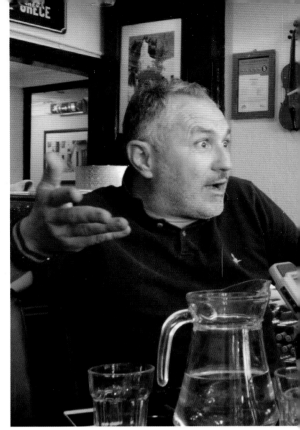

This kind of familial atmosphere is typical of many Mediterranean restaurants and cafes. This is especially true in Greece, where the tavernas and coffee houses are like extensions of the home. When the team went to interview Theo, everyone was made to feel like old friends. Theo enjoyed meeting all of the Italian and Turkish interviewers and pointing out some of their Mediterranean similarities in the context of this convivial atmosphere. "Yes, yes, it's quite nice to see that. Greeks, they are loud! So you can see if there are Greeks inside the restaurant, you can know straight away they are Greeks because they are very loud. Turkish is the same. Italian is the same, even more worse. So that's the way it is. We brought to UK our spirit: being loud!"

We might even call this loudness a characteristically, "Mediterranean loudness". It

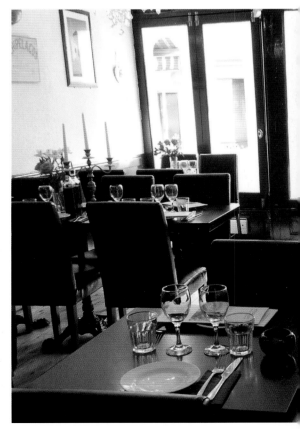

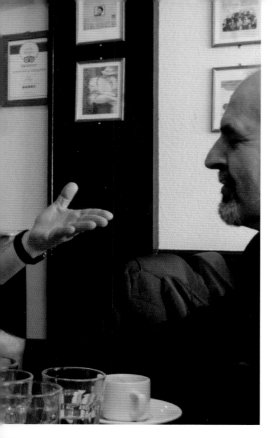

is something very different from the library-hush of those imaginary dinner-jacket experiences that come to mind when we think of fine dining. In some ways, it is the clearest sensory manifestation that the boundary between the public restaurant and the private kitchen is temporary and permeable. What this means is that when we cook and eat at home we feel that we have permission to behave largely as we please, speaking how we want to and making our own assessment of the facilities on offer. These permissions can feel restricted when we dine out. It is, in some ways, like visiting another person's home. We can't treat their kitchen like it is ours, we show respect to the demarcation of zones and we tend to quieten our voices. But when we are made welcome into a space of Mediterranean loudness, these restrictions are dissolved. Not only are we given licence to feel at home, we can even be permitted to visit backstage. "It's a very different thing, because when you're running a restaurant in Greece it is completely different than here, because in Greece you don't have menus. People, they asking you to provide them whatever you believe is the right thing to eat. And what exactly is: the Greeks they have access to your kitchen. So, for example, here we have the Health and Safety by getting that five-star hygiene rating. In Greece you don't need that, because the Greeks, when they coming in, the first thing they do, they walking to your kitchen so they can see what you been cooking. So the best judges of whether you are cooking well is the clients, because you can't give them something when is not right, because they coming in, you know what I mean? Like you show them everything and they get whatever you show them.

"I remember back in Greece that if people want to eat in your restaurant, they have to come in to see how is the state of your kitchen to judge how good you are at running the place. If you are the best restaurateur, you have to have the best kitchen: very clean and tight all around. That's the way it is. Here, people they are different. They coming in, they have someone else to rate your kitchen and they look at the menu to tell them what to eat. Now my customers trust me to advise them. Now they talk me like: 'OK, go and make us mezze', or: 'Go and make us plates to have the dinner'. They trust you more and more because you don't look at the business just to get the money from them, you want them to be as happy as possible."

One crucial element that further blurs the boundary between home and work, public and private, is the presence of family in the business. But it is not a simple matter for Theo to involve his family in the restaurant. He is living in a foreign country and he has split from his wife so it makes things tricky. He left his last restaurant in Greece in the care of his brother, but it can be more complicated to engage his children here in the UK. "I tell you something. I got a son where he's seventeen and he doesn't interested anything to this particular business. My daughter she came few times here, she is only thirteen. She run with me the place just to have an idea how is run and what she is capable of doing. And I had a friend here where he said to me, 'Oh my goodness, look at her, she is your next partner because she is love the place!' She run around and she was doing every single thing, naturally, without me to ask her lots of things, and I realised: 'Oh my goodness, look at her, she knows what she's doing'. Definitely, if she's going in this way, definitely, she will be very successful, because I have thirty years' experience and I saw the way she was running things. I said to myself, 'Oh my goodness, look at her, she has it'. She is perfect. That's it." Both of the children speak Greek and Theo says that he always tries to communicate in his language to keep it alive for them. His daughter was younger when she left and relies on a tutor whereas his son spent more time growing up in Greece and is still able to remember it well. It is also a way for the three of them to connect and stay close.

When Theo opened Archipelagos in Hove, he made sure that this new restaurant was going to be smaller than his previous business so that he would have more time to spend with the family. Unfortunately he still finds it difficult to find any downtime. "I don't have a day off, I'm working every day. I have a big problem because I'm always concerned about the restaurant. When you opening your heart to the clients, it makes it easy for them to tell you if is something was not right. So if the food it was not correct, or the drinks it was not right, or the food it was salty or not salty, they will tell you immediately. So that is the bad thing, because sometimes you want to control everything so that it is always correct. This is the difference between people running a restaurant from a distance and people who are open to them, because it's like a friendship so you receive any complaints directly from them. If you are distant the people they can't tell you if they didn't like something. They won't tell anything, they will just be gone and say bye-bye and never come back. That's why here is different. They will tell you, 'I loved everything but I didn't like that because I tell you it was a bit like salty'. That make you to concern always, so sometimes I'm away and I receive texts. For example the last time I was laughing about it, because I was having a dinner at home and someone texted me a piece of pita bread where it was it burned on the underneath. So they was serving them pita and he's taking a picture of the pita where it was lovely cooked on the top and burned on underneath, so he said to me, 'They are not always nice when you are not here!' Do you know what I mean? I said, 'Oh my goodness!' So you have to come back and see what's going on.

"Many people running a restaurant, they don't want to do that, because they want to separate the life, the private life and the business, so they don't want to interface with people. Most of them stay at a distance, send the waiters to run the place, and then never receive any feedback, you know, because they don't care. But that is why places like that are 75% empty. The other way of doing things is if you go closer to the people and take opinion about whatever they had, their feedback if they are happy, and that is what you get. So it's the passion, like, to keep running more and more and do better and better. But it's difficult because you have to put your life in the business. You know there are a hundred and ninety restaurants in Hove on TripAdvisor? For the last four years, the number one has been this restaurant here and second is Makara, which is Turkish. I remember one of the Turkish boys, he's coming here having a dinner and he said to me, 'I am working in Makara and the owner there is exactly crazy like you, he's all day in his restaurant too'. That is the only way you can run a restaurant, by being in your restaurant, all day. And the good thing is I'm cooking as well. So what I do, I cooperate with them outside and I cooperate all morning inside cooking with them, so everybody has to go in the same way, like everybody has to follow the same recipe and cook with exactly the same

cheese, we grill the cheese with honey on top, or we use the honey in yogurt. I brought back a lot of zea flour. Zea flour is like the first original spelt in this Earth, where is being created in Mediterranean, especially in Italy and in Greece. And I used that because is only 3% gluten, so I use that to make a base of béchamel with zea flour. I do bread for some guys around here, where they have intolerance to gluten, and they are like: 'Oh my goodness, where did you find this spelt, it doesn't exist around here'. It's true, it doesn't exist in UK. So it's increasing the taste and it's healthier. Most of the recipes, even if you want to make them as the way they doing in Greece, it's really difficult just because the ingredients are not all of them follow the same way. For example, most of vegetables they come from Spain, and some of them they come from Italy. They miss in taste so you have to add more things. You can't really say that you stick to the traditional recipe because you have to increase it by using different products. But we try. Our Moussaka is traditional and the Kleftiko is exactly the same… but you need to put the gravy to bringing more closer to the British tastes."

ingredients every day. So you keep the same level all the time, you know, you can't go up and down. You have to do it the same way. I cook every day. There are 95% of the recipes I would say is being created from me. So everybody has to go around, is like a small bible, where everybody dig in and has to follow around by bring only 7% of the ideas, but they have to go all around the same way. So that's the reason you can eat the same things, every day the same."

There is something nautical about Theo. Maybe it is all the time he has spent on those little Greek islands or maybe it is his piratical tattoos. At the same time, he has a businessman's habit of peppering his speech with percentages, and this lends a degree of incongruous acumen to his raffish sailor image. He still journeys to Greece regularly to fetch back the spoils of his adventures and spends his annual holidays driving a lorry around looking for new products. "I import wine from Greece myself. I import olives, I import oil, I import all the ingredients. Most of them, like 60%, they came from Greece, and I import them by myself. There is a difference between the taste of the food you can get in Greece. For example, last year I went and I brought a lot of honey. We use it on the

True to its name, the menu at Archipelagos is as diverse as a set of islands, with a wide range of fish and meat dishes. They also cater to Brighton's ever-growing army of vegetarians and vegans. "I

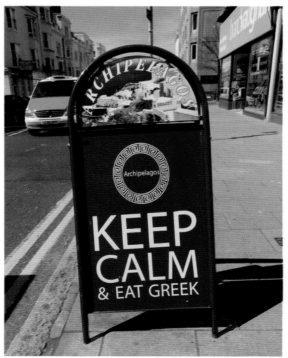

think bit of everything, really. 35% of veggie, 30% of meat and the rest fish, or other way around. Every area is different but here we get a lot of demand from vegans, you know. We try our best in the kitchen, because is not easy to cook moussaka vegan, but we find a way to do it, like using soya milk and gluten-free flour to make the béchamel. In Greece there are lot of veggie recipes, like deep fried aubergines, deep fried courgettes, beetroots and mushrooms and so on. Yeah, is like not many vegan recipes but you try, you put your imagination, you create some nice food for them without surrendering the taste. The vegetarians, they definitely like a lot the beetroot salad, with the feta and garlic, they do like veggie moussaka with layers of vegetables and potatoes and aubergines. A lot of things. There are lots of people they like roast peppers with garlic and balsamic vinegar. So we have many options.

"There is one dish I made myself by using all the restaurant and is one they called Midopilafo. I love it after all these years and it's very similar to paella but it's not paella of course. Is the number 53 on the menu and it is a great, popular dish, with muscles, prawns, garden peas, courgette, onions, aubergines, chillis, fresh tomatoes… and they cook with rice, wine, a little bit spicy. It is one of the most popular dishes. The other one is the Lamb Kleftiko, covered with courgettes and carrots and all the gravy… it's beautiful, slow cooked and it's amazing. Yes, today I'd have that!"

Some customers ask Theo about the recipes to find out if they can cook them at home. Even some of Brighton's local celebrities are not immune to his culinary charm, including the gothic songwriting-genius, Nick Cave. "The other day I had like, I was really laughing about it, they coming few famous people around here, one of them he was Warren Ellis and the other was Nick Cave, because he's coming all the time here. So his wife asked me to give her the recipes with the meatballs, Soutzoukakia, by describing using how many grams, blah-blah. So we had a long chat and done the whole things in schedule, how you can do the ingredients. She's done it! And it was lovely. She tell me she will bring me the next time some meatballs, so I can try. She said, 'I will bring them to try, it's not like yours, but, you know, I tried.' But they are right. Sometimes, you know you have to keep the recipes very tight, like you can't really mess around with quantities."

Other customers ask Theo about holidaying in

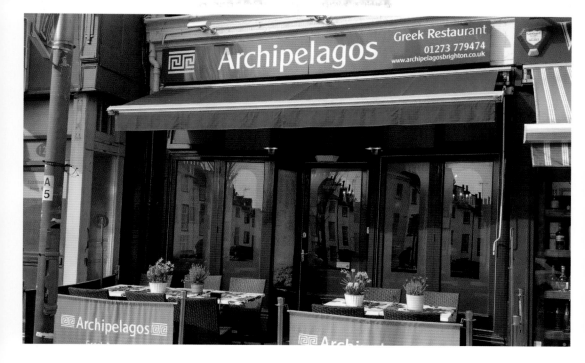

Greece, about where they can go and what they should try to see. Increasingly, people are also asking about Greece's financial problems, as well as the refugee crisis and the impact it is having on the beleaguered country. Theo finds the customers well-informed about Greece and about the issues it faces. He says that he does not find himself struggling with stereotyping, as so many British people have travelled to Greece and have a decent knowledge of the Mediterranean in general.

Theo plans to retire to Greece when his children are older and have started university. He still has a house there and, of course, another restaurant by the sea named Archipelagos that he misses. It is possible that he would never have come to the UK if it were not for the children coming here with their mother. "I'm coming from Olympia and you don't believe how beautiful my area is. I can't really describe it... I live in one area where we have a massive big lake, with thermal springs, massive big forest with pine trees where you walk everywhere. In that particular forest, in the mythology, there was the fight of Centaurs, the massive big half-horse/half-human creatures. And they have in that particular pine forest a hundred and seventy eight different orchids. And we

have the sea, the Mediterranean all around it. And we have areas where you can scuba dive underneath the bay and you can see the whole city of Anicent Pheia and swim around the ruins. I can't change... I'm gonna go back. That is the place I want to live the rest of my life."

Feeling forced to stay in Brighton for a while is not Theo's first choice, but he admits that it is his favourite place in the UK. "I love Brighton. I've visited different places in the UK. The first time I arrived in UK was 1992 and I stayed for few years and it was completely different. I lived in Southampton and it was completely different. There was not many coffees, the temperature was different, there was a lot of rain. So I hate it. I was working as a supervisor in Hilton, in Southampton and I didn't like at all and I said, 'I'm gonna go back straight away'. So I stayed a year and then I left, back to Rhodes. I tried to live in London as well but I didn't like it. London is so busy because I was born in a village of two thousand people. So London for me was like terrible. It's no way to live there. It's nice, fine, if you start business there, you work and you get best living ever. But I believe here in Brighton is more family, for the family is better. You can walk by the sea, you can be more relaxed. Here people are more smiley, more open and a lots more students. You feel like you

are somewhere in Southern Europe. You here like multicultural, how many people here like, Spanish, Portuguese, Italians, everywhere, so you feel like you are home. Brighton is different to other places. You can describe it like the Monaco of Britain! So it's different. A lot of youngsters, it is a lively city with all of good and bads of a big city. I'm not changing this one from nothing. If I go from here, I'm gonna go back to Greece. I'm not gonna go nowhere else in UK. I don't wanna go from south to west or east. I'm happy here in the centre. That will be the last. After few years I'm gonna go. The weather is good in Brighton. I mean, compared to the rest of the UK it is perfect. But in Southern Europe, you can't compare it. Us, we have the sun. In Greece from March down to the bottom of September it's like sun every day."

In the meantime, though, Theo continues to enjoy bringing a little slice of the Mediterranean here to the UK through his work in the restaurant. Whenever he does get time off, Theo does not like to sit still. He told us that his favourite things to do are riding motorbikes and jet-skis. With these adventurous, outdoor sports in mind, we asked him if he had any advice about healthy lifestyles and diet. "My advice

to people of Brighton and Hove if you want to stay healthy is not to become a vegan," Theo laughed, "But seriously, people should use a lot of vegetables and a lot of olive oil. People they don't live with olive oil here and I'm really surprised because personally I love oil and when I give them some salads where they do require oil, I am not asking them, I am just add the oil, just for them to realise how's the difference of taste. Because people want it blank, they don't want anything on, they don't want vinegar, they don't want oil, but this is where they can really come alive when you add olive oil or vinegar. It's healthier for them, especially oil, so they have to increase the diet eating a lot of vegetables, baked beans, all kind of greenery, lots of salad and avoid chicken and beef or stuff like that and eat lots more fish. I am not exaggerate but here in Brighton is one of the best places for fish. Near Hove Lagoon there is one of the best fish market probably in the south coast, with Dover soles, with lots of cuttlefish, calamari fresh, thousands of kilos of lemon soles, a lot. And people they have to start eating a little bit more cods, fresh cods not frozen, fresh cods and all kind of fresh fish, grill them all with the salad."

"And my advice to people about having a healthy lifestyle? They have start to make more love!" Theo laughed again, "Because here the British they sleep a lot. They need to exercise more, you know, they have to exercise more. They have a different culture here. They are more, like, how can you describe? They working a lot in the offices and they get lazy, they don't want to do things, they're not smiling a lot. They have to start smiling more and more. They have to change the humour. Different things. They grow up in a different options like, if you do visit big cities in Greece and you passing through places were the youngsters are having coffees, the only thing you hear is the laughing of youngsters joking about everything. Here is different, you passing through coffeeshop and everything, everybody is quiet. As you go more south to us, we spend more time outside. And Mediterraneans they joke about everything, they talking a lot and they expressing a lot more feelings and they having a dinner out all the time, not necessarily they have a big dinner but to meet people and chat more. Yeah, the big conversation of having a jokes and laugh, because people they don't laugh here… they need to laugh, you know, to laugh loud… loud as a Mediterranean!"

Archipelagos Traditional Greek Restaurant
121 Western Rd, Hove BN3 1DB

A lmas

Essam grew up in Egypt but he has spent most of his life in the UK. He moved here with his parents in the late 1970s and has rarely been back. His mother is Syrian and his father is a doctor who came here to practice medicine. Essam says that he still considers himself to be Egyptian because he was born there and because his father was Egyptian but when he does visit he always wants to leave again. "Sometimes I go there and I cannot bear it for more than a week or two, but it's still my country, and I will always love it and I will always be Egyptian. But England is my second home, and you make do with what you have here, and you build a life here."

Essam runs the Almas Lebanese and Middle Eastern Restaurant and Bar in Hove. It can be found just off Palmeira Square and is situated right next door to Buon Appetito. The idea to specialise in Lebanese food was not just driven by the rising popularity of the cuisine, but also because it represents a fusion of Essam's own dual heritage. "In the old days, back in the beginning of time: Palestine, Lebanon, Jordan and Syria, was all one country, called Bilad Al–Sham. I think that if you're gonna categorise it, you would say it was predominantly Syrian. In my opinion, Syrian cuisine is one of the best in the area and Syrian chefs are the best. Obviously I'm a little bit biased because my mother is from Syria. But my father is from Egypt and I class myself as Egyptian.

"I chose to specialise in Lebanese food because the Lebanese kitchen has taken a little bit from each country. Lebanon is relatively new compared to Syria and Egypt and Jordan, and it's taken a little bit from each country and put it in its cuisine. So I chose to make it a Lebanese restaurant because it covers a lot of the other middle eastern countries."

Essam left University with two degrees: one in software engineering and one in business studies. It was the latter path he followed, and, after he graduated, he decided to open an Italian clothes shop. "When you are at University you always think: 'This is so difficult, when I'm working things can be easier', but believe me, I'd rather be in University anytime. That was easy life!" By the early 1990s he was pursuing a career in catering. He started focusing on Italian food, which seemed like a natural business transition from the shop. His heart was set on Middle Eastern cuisine, but he knew that getting the right chef was going to be very difficult, "Especially in Brighton, because a lot of the good chefs prefer to stay in London. To get them from abroad is very difficult with visas or working permits and things like that. So I was trying to change over for about four years, then finally about two years ago I managed to get the right team together and from there we started." All told, it took nearly twenty five years in the industry to be able to pull it off, but now the plan is going well.

Essam says that Lebanese food is the fastest growing category in the UK. Last year, a Lebanese

Palmeira Square is a series of Italianate mansions just north of Adelaide Crescent on the Hove seafront.

It was built on the site of the lost Anthaeum, a kind of Victorian version of the Eden Project, with a gigantic iron and glass conservatory dome that collapsed on the day it opened and drove its creator blind from shock.

The elegantly stuccoed facades of Palmeira Square conceal walls made of, "bungaroosh", a preposterous technique where chunks of broken bricks, pebbles and assorted rubbish are bunged together and set with lime. If it dries out it crumbles, and if it gets wet it dissolves. Of course, bungaroosh is found only in Brighton and Hove.

takeaway was voted Britain's Top Takeaway. The cuisine incorporates a huge range of fresh dishes and is very accommodating to vegetarians. According to Essam, the real secret of its success is the trend towards sharing, "That's certainly what I see in the restaurant. People used to come in and spend forty five minutes having a starter and a main course then leaving, but now they go more for a mezze or tapas sort of dish, and here they would sit for an hour and half, two, three hours, or we have people sitting for even longer. I think people are starting to enjoy that way of eating more, where there is more relaxing and sharing dishes and trying different flavours."

Being a fan of Syrian cooking from his childhood, it made sense that Essam would seek some expert advice, "To be successful I knew I had to get the right recipes, and I actually asked my mother to make a few things for the restaurant. It's only my taste, my opinion, but that's why I got my mother to make things, because I like the way she does certain dishes and then she can teach the guys here. There's so many ways to make a dish, like even as simple as houmous, you can make it in so many different ways, with extra garlic, extra lemon...

and it's all a matter of taste, it's what you like. I like it simply plain, to be able to taste the chickpeas and sesame paste and just keeping it simple that way, but some people like it with a lot of lemon or some garlic or things like that."

His mother's recipes are certainly proving popular. Essam says that some of his Middle Eastern and Arabic customers eat there every day, sometimes three times a day. "But there is also a broad spectrum of customers that we get. You know Brighton is a very cosmopolitan place and we get every type of customer, there is not one particular type, obviously there are many more English, because it's an English country, but they also seem to enjoy the flavours, and even the people from India, Pakistan, because their food is totally different and the flavours are completely different, but they still enjoy this food and we have a lot of customers from that region. The Spanish obviously relate to it a little bit more because of the likeness to tapas, where there is a lot of sharing plates, and obviously the Turkish which, I think a lot of the ingredients are similar, a lot of dishes are not so similar, but the ingredients are similar, the end product is slightly different but, I think, everybody enjoys it."

During our journey of discovering these oral histories of people working in Mediterranean and Middle Eastern restaurants, one theme that recurs time and again is that of the multicultural customer base and of the harmony found within that community. It seems almost to defy expectation, especially with prevailing left-wing media concerns over xenophobic nationalism and right-wing media concerns of minority radicalisation, but the view on the street is that people navigate these differences perfectly happily, especially at the gastronomic interface of cultures. "England is very cosmopolitan, there's lot of nationalities and there's lot of different people and different races and so on. Hopefully they are living reasonably well together. Yes, there are a few problems in the world at the moment, but that's just a few wrong people doing the wrong things with being given the wrong direction I think. And you know, when you start talking about how you feel and things like that, religion comes into it, because if you're Jewish for example, but you were born in Egypt, and I was born where you were born, I would be Jewish and you would be Egyptian, so how can I blame you for what you are? You can't. Nobody has a choice on where they are born and where they come from, it's just the way they are brought up. So I think we all have to fit in."

Essam's friendships are similarly transnational. "Most of my friends I've got I've known for thirty, forty years. Some are in Saudi Arabia or the UAE. Some are in US, some of them are in Africa. I've got a close friend in Zambia. But I try to keep in touch with all my close friends and we try to meet up once very couple of years. Time goes so quickly, though. You plan to do a reunion in ten years and then very quickly it's upon you. Sometimes we meet up in London, sometimes we meet up in Saudi, sometimes we meet in Dubai, sometimes in Egypt, whatever it is."

Like many of the Brighton-based restaurateurs we have spoken to, Essam believes that London dictates the standards that everyone has to follow, and he has his sights set on expansion to the capital in the near future. "London is a much bigger market, and it's a slightly different market but as long as we keep the standards high and the food to the same standards that we do here, I don't think we have a problem in London, and that's the next challenge for me."

Unlike most of the ethnic restauranteurs we have spoken to, Essam is used to running multiple outlets. At one point he had five restaurants running at the same time. "As things

get bigger I feel they get easier. When you've got one business you tend to be a control freak, and you want to control everything there, but as it expands it changes. Like if you take the person who started McDonalds, it would be very difficult for him to try and manage each of his branches, so you have to delegate the responsibilities to different people, and I think as things grow, that's what you have to do. So I think as London opens, I will have more free time because at the moment I do the ordering, the accounts, paperwork, everything like that, but when you got few places you just can't do that, so otherwise you'll be up all night."

Like most people we spoke to, Essam does have difficulty balancing the demands of work and family life. "Honestly I don't feel I have a fair balance, I put more time into the restaurant than I do family life. I'm not condoning, I'm not saying it's right, but unfortunately that's how it is. When you are away from the restaurant, you know, there is a lot that can go wrong, you've got equipment, you've got lots of stuff, you've got lots of ingredients, something can be missing, something you need to get it, something you need to fix, somebody's not feeling well and they

من أقصى عليك

أحزاني

والتجار

دار غريب

don't go for work and you have to cover them, and obviously I'm the frontline of all this, so anything that happens it's me first and then it's diluted into everybody else and then I have to sort this out, so I don't have a balanced life. I'm trying to change it, but until you got the right people in the right place it's not always easy to change, but hopefully, now that I'm getting older I wouldn't be able to run around as much as I did before, so in the end you will be forced to do it."

When he does get the time, Essam's hobbies include Krav Maga, the fusion of martial arts and street fighting styles developed by the Israel Defence Forces. He also loves motorbikes but he does not get the time to enjoy them, "I got motorbikes that are just sitting there and I never got a chance to ride on them, so maybe I got more time to do a little bit of that. I wouldn't mind jumping on a motorbike and driving around Europe for a few weeks, so hopefully, I will have more time to do that, and I won't be too old and less able to drive!"

He may not be doing a lot of driving in Brighton, though. Essam says that the town has changed for the worse since he first arrived in the late 1970s, largely because of what he calls Brighton and Hove City Council's money-oriented parking charges. Last year alone the council made a profit of over £11 million from on-street parking charges, an amount it hopes to increase to £20 million through further price hikes. Brighton is now the third most expensive place to park in the UK, after London and Edinburgh. A day at the seafront can now cost you £20 at the parking meter, something many traders like Essam feel is driving off custom, especially the day-trippers that Brighton's tourism relies upon. "I'm lucky to have known Brighton in the past as things were a lot nicer then. Suddenly with the council everything is more money orientated now, I think it's taking away a little bit from Brighton, and that has made a lot of people not come to Brighton for that reason. I mean if you can imagine London, and you took Knightsbridge, Kensington, Chelsea, those areas that are affluent areas, the parking there is almost the same price that is in Brighton, and in Brighton you've got to pay

parking until eight o'clock, sometimes twenty four hours a day and including the weekends. I think that they need to slow down and look what they're doing to Brighton, and how it was before and the amount of visitors we used to have before compared to now. They need to reassess this and trying to make it more visitor-friendly, because I don't believe that it is as much now, and I think that's why people are saying, 'Are you gonna go to Brighton and spend five pounds per hour on parking, or would you rather be on a weekend in London and spending nothing on parking?' And that's the thing that we need to reassess."

The locals are not to be daunted, though. They are still dining out in style despite the difficulties of finding a good parking space anywhere in town and Almas remains a popular destination for its ambience and wide-ranging menu. The restaurant serves up some familiar dishes such as houmous, tabbouleh and falafel alongside stalwarts like the aubergine dish known as mutabbal (also called, "baba ghanoush", which translates as, "pampered father" and was invented in the royal harem). The main focus of the menu is the grill,

offering a range of chargrilled dishes from Iran, Turkey and beyond such as sambusas, which are a kind of beef samosa. Almas also specialises in stews, including bamia with lamb and okra. There are selections from the Gulf, like the mixed-rice dish, kabsa. "There are also a few dishes that may not work in the European culture and that are more relevant to the Arabs, like this one type of fish that only comes from the Gulf. It's popular with the Arabs but I think that western people may find it strange compared to the fish that they have here. It's a small fish called Pomfret which usually comes from Asia, around India, but there is different types. There is the white one, the gold one and the silver one, and the white one is the one that is relevant to the Gulf, and they eat it all the time here. It is served with rice, with dried fruits and caramelized onion and salad, but it's just a fried fish and they like it very well done!"

Who knows? It could be the next fish and chips.

Almas Lebanese & Middle Eastern Restaurant & Bar, 79- 80 Western Road, Hove

Fish and chips are one of the most emblematic British dishes, up there with roast beef and Yorkshire puddings. Notably they are almost never cooked from scratch in the home and are instead purchased hot from fish and chip shops. The two foods evolved separately, with chip shops dating back to the time of Charles Dickens and fried fish dating back to the immigration of Marrano refugees fleeing the Portuguese Inquisition in the 17th century.

It was not until the 1860s when an Ashkenazi Jewish immigrant, Joseph Malin, put them together for the first time when he opened his combined fish and chip takeaway in the East End district of Bow. Over time, the Jews of the East End relocated to North London and abandoned the trade for more "respectable" professions, leaving it to subsequent waves of immigrants including Greek Cypriots and Chinese.

The first actual fish and chip restaurant was opened in the 1890s by the entrepreneur Samuel Isaacs who died in Brighton in 1939. Isaacs's catchphrase was "This is the Plaice" and he is synonymous with the concept of nipping down to Brighton for some fish and chips on the beach. The location of his Brighton restaurant is now the site of a Harry Ramsdens opposite the Pier. His love of fish-related puns endures in the trade, and can be found in shop names such as Oh My Cod, A Salt 'N Battered, Frying Nemo, The Contented Sole, and even Battersea Cod's Home. I personally once lived in a flat in London above a chip shop called The Fishcotheque.

Rotana

Mohammed grew up in Libya, taking long walks by the beach and enjoying the sunsets on the waves. In his late teens he moved to Morocco with his family to live in the Atlas Mountains near Fez. The mountains were beautiful but he missed the sea. Now he lives in Brighton, where he can walk by the sea again and where he works in Rotana Lebanese and Moroccan Restaurant.

Rotana started life as the Couscous House in 2001, serving traditional Moroccan food. After piloting a successful combination of couscous with tagine, Mohammed relaunched the business five years later as Rotana, incorporating a new range of spicy dishes from Lebanon. Now he changes the menu every two years to make sure his customers always have something new to try. One of the challenges in catering to an Arab clientele is that they do not just come from one place with one set of tastes. "For Arabic customers is like twenty countries they come here with different cultures and everyone they want something different than another one. Like people from Tunisia they come here and like to eat couscous and from Morocco they like to eat tagine. From Egypt or Saudi Arabia they like to eat cabsa and rice, is a yellow rice with chicken meatballs. I am from Libya and my favourite food on the menu is tagine lamb, vegetables with lamb and rice. I like it!"

At home, Mohammed prefers to cook Italian food because it is similar to the food he grew up with. Libya was colonised by Italy and combines these culinary influences with ingredients from North African countries such as Tunisia and from the Middle East. Italian food is also a little easier to cook than some of the traditional Libyan dishes, which can be quite difficult. It is not the same as his mother's cooking, though, which he still misses. His mother lives in Morocco now and helps him with recipes over the phone. She was his first teacher and he says that he relies on her to show him new ideas whenever he is able to visit in person. "Whenever I am in Morocco, I have to eat a lot of food!"

Rotana has a loyal following from the local Arab community, especially among students. "They come four or five times per week, but when they finish study they will leave the country. Also, when they come here, they told me (I don't know if they lied to me), but they told me the food is absolutely like the food in their home, is like homemade and I was happy about that." Many of the ingredients are specially imported from Morocco, as they are not available in the UK.

"We also have English and Spanish customers that come regularly, like two times per week, and we know each other like from, like, four years or five years." Some of the people who try the food for the first time have expectations that it is going to be as hot as some of the other ethnic food they have tried, like Indian food or curries, and there is a bottle of chilli sauce for those who want to heat it up.

"I chose to open a restaurant in Brighton because it is a nice city. And one thing, they have a mix of international people and it'ss more happy. I like the sea also. I go walking by the sea for four or five hours every morning if the weather is good. I don't know why I like Brighton, but I love it! It's better than London because London is busy and crowded with everyone and everything but here I like lot of things. The sea, the people, the walking and the seagulls. People don't like seagulls but I like it!"

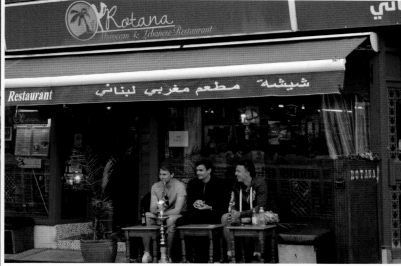

▲ Rotana boasts a shisha terrace, popular with everyone from Arab students to Brighton geezers

▸ **Mohammed outside Rotana on the Street of a Thousand Restaurants**

When Mohammed first arrived in the UK he did not know a lot of people. For the first few months, he did not have any friends but now he has a wide circle of acquaintances. When he does meet up with his friends, one thing they do is cook together. "We cook, yes, of course. We have to cook when we meet because Arabic is not like different countries. We have to cook. Is not like we buy something from outside. When we stay together, we have to cook. The first thing you miss when you come to a new country is your friends and the second is food, and the third is weather... I miss sun and summer."

Adjusting to his new life took some time. "Anyone he comes like in the different place, he have the difficult thing. Like, you know, rent. Because Brighton is popular and is very busy and everyone have that problem about the rent and he search for a house or flat or for a studio. Another thing is that I think here the weather change for one day four times, but in Morocco I think it's just the same, summer is summer, winter, winter."

Mohammed says that he would like to stay in Brighton for a much longer time if he could but that after another five or six years he feels he will have to move to Morocco. So anyone thinking about visiting Rotana or trying their mixture of Lebanese and Moroccan food is advised not to dawdle in case they leave it too late.

Rotana Moroccan and Lebanese Restaurant, 10-11 Preston Street, Brighton, BN1 2HN

Cafe Venus

▼ **Sina, the chess-playing owner of Cafe Venus**

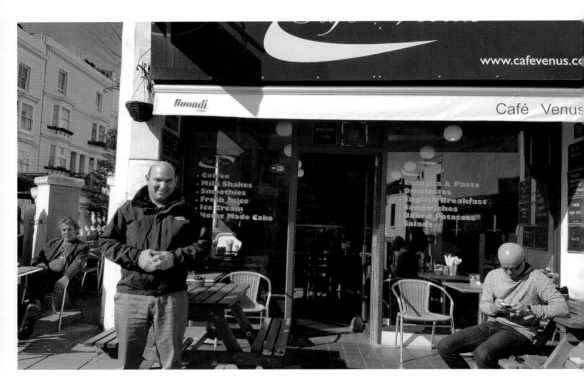

You can find Café Venus halfway down Western Road, opposite the Duke of Norfolk pub. It is a cheerful corner, with a few outdoor tables to make the most of the afternoon sunshine and there are always people sitting outside, tucking into late breakfasts or just people-watching.

The place is owned by Sina, who grew up in Tabriz, Iran, and it is managed by Jura who originally comes from Kaunas, Lithuania. The menu covers a modern range of Mediterranean and English dishes from lasagne to falafel. There are also some Iranian specialities like Pomegranate Tea and their own house-blend of Venus Tea, which is flavoured with saffron. "I just bought this place two years ago but the shop was four years here," Sina told us. "I bought from another Iranian. Previously it was a greengrocers called Golchin, which means, 'flower picker'. I'm just working to make it nice and improve it. To be honest, I don't change a lot. I like the style and I added

Iranian traditions around the shelf but the main thing for me is that I like cooking. I like it a lot. Since I was a kid. If you give me anything, I can cook. I was inspired by my father. He has a textile factory and he has learnt from his father who was a supplier of wholesale fruits. The first thing I remember cooking was kofta kebab. We don't really sell kebabs here, though. We tried to do some Mediterranean but mostly we do English and Italian. We try something from every region to make it different."

Sina still likes to cook in the café sometimes but he remembers that his early attempts at cooking were not always successful. "The first thing I ever cooked completely on my own was rice. It was a mess! I remember it raises, so I pour one cup and I say, 'No, that's not enough', so I put two, then I say, 'No, that's not enough', so I put three cups. When I went away, I came back few minutes later and I found rice all over the floor, all over the place!

"The Iranian style of cooking rice involves slightly burning the bottom of the rice in the pot to make it crisp. Obviously, when you touch the bottom of the pot, when you feel your hand it burns instantly, it's gonna be ready. If you leave it five minutes more, it's gonna be burned. So you have to be present. We call it tahdig style. If we have ghormeh sabzi, we have special kufteh tabrizi. My favourite is carrot with rice and lamb, khoresh havij. But if you want to go close to Iranian culture you gotta go to Iranian restaurants."

I was curious to know what Sina was doing before he opened the café but at first he did not seem to want to tell me. Eventually I found out why, as it may not be the most popular job in the world. "You are not interested in what I was doing before," he laughs, "I was a traffic warden. Seven, eight years. But I was feeling that I wanted to do my own business. I figured that most people like Spanish and Italian food in Europe so we had a go. I love everything here. My favourite thing to cook is breakfast. I like the burger… I just had one! Sometimes I have to tell my staff to stop me eating too much. Now I have to go and eat at another place because when you have a café or restaurant, you have to update yourself. Some customers spot you in another place and say 'What are you doing here?' That's no good!"

But this former traffic warden is a shrewd man and is not likely to be caught out so often. As he is always thinking one move ahead, it comes as no surprise that his other great passion is chess. "When I was a child I taught myself how to play from a book. After the revolution we had in Iran in the Seventies, they banned chess because of fears that it could be associated

Tahdig- crispy rice
Ghormeh Sabzi- vegetable stew with fenugreek
Kufteh tabrizi- Azerbaijani meatballs
Khoresh havij- carrot stew
Kofte kebab- Lamb kebab
Fesenjan- pomegranate and walnut stew
Chelo- rice with butter and saffron
Zereshk Polo- mixed rice and barberries

with gambling. It was banned for seven years. I couldn't play it during that time. I didn't know really what was the punishment but you couldn't buy chess sets in the shops." People say that it takes guts to play chess in Iran. Even these days the game attracts controversy and is in danger of being banned again. But Sina believes that Iran is a country that has had a big influence on the historical development of the game and even invented some aspects we know today. "Chess has some terms from the Farsi language of Iran. Like the word 'chess' or 'check' comes from the word 'Shah' which means king. And the word 'mate', as in 'check-mate', comes from the Farsi word 'matt' which means 'shock', like when you freeze. So 'check-mate' means 'the king is frozen'."

After speaking to Sina, we met the manager of the Café Venus, Jura, a bubbly spirit who really loves her work. Jura grew up in Kaunas, the second biggest city in Lithuania, but she has spent much of her life working in kitchens across Europe. "I've done this all my life. It's not like work, it's like a hobby for me. I like it. I like when customer smiles, when they happy with food, when they happy with service. I like it. I enjoy it. I've been here three years. Before that I was in Germany, I was in Holland, I was in Belgium, but England I like a lot and Brighton I like most. It is my favourite city. I don't wanna move nowhere! It has a lot of students. A lot of young people. It is a nice young city. Brighton has lots of cultures, lots of people. Everyone treats you nice, not like someone looking to you because you are different. In other places the people treat you differently when you are from another country. Someone they are saying that my spelling is not right, my English is not clear and the ask me 'From where you are?' and always I am saying Lithuania, but when you coming to Lithuania and you don't know Lithuanian, no-one is asking 'From where you are, why you not speaking Lithuanian?!'"

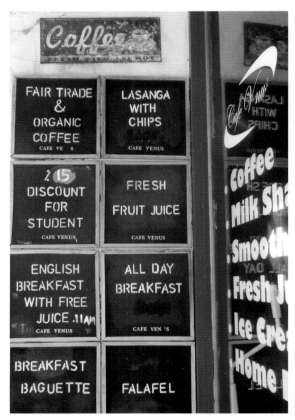

In Brighton, Jura says that customers ask her about Lithuania and they ask Sina about Iran not because they are discriminating but because English people are curious about different cultures and intrigued to find out more. "Almost all our customers are regulars. And you know names and you see customer and know what food he will have." Having worked in so many different kitchens around Europe, Jura has picked up a lot of different styles. "I don't have a favourite, I am mixing them. From one kitchen something, from another something and you can make a very nice food." But she laughed off the suggestion of writing a cookery book, "Not yet," she said. "I am not so old for write books!"

One thing that she would like to do is to open her own place eventually. "Yes. Yes. I am thinking about it twenty years. I will, one day!" she laughs, "It won't just be Lithuanian, it will be mixed. Because we have here mostly Polish people, lots of Lithuanian peoples, lots of Russians, and those are similar kitchens absolutely. There was a Lithuanian place in Brighton before. It was called Oxygen. It was open on Sunday, Saturday but now they are closed. They don't get a licence or something like that. But they was having Lithuanian food on Sundays." Given enough time it is possible that the menu of Lithuanian food would have had crossover appeal to the night-time punters as well. "Yesterday I cooked some Lithuanian

food for customers. They said they liked it. I think our most famous dish is Cepelinai. It is potato and mincemeat inside. You even can't understand. You taking raw potato, grate them, taking hot water, making ball, opening, putting meat inside, closing and cooking, just boiling in water with salt for one hour, it's very strange but if you will go to Lithuania you will need to try it. It is famous Lithuanian food. You serve it with bacon, small things cooked in butter and with sour cream on top. It is very fattening!"

Cepelinai are named after the Zeppelin airship due to their shape and are practically the national dish of Lithuania, even though they are a lot of work to make. Lithuanians say that they need something filling and hearty, as the country is on a northerly latitude, and these kind of dumpling recipes are popular in neighbouring countries as well.

The thing that Jura misses most about her homeland is not the food, though. "I miss that smell. From trees, from grass, from ground. Really if you will go you will understand what I am talking about. After the rain in summer there is that smell of ground, smell of trees, smell of grass. This one. I miss this one. And forest. Mushrooms! Berries! In June I already booked tickets. I am going for mushrooms."

Jura has an infectious laugh and an easy manner. As well as picking mushrooms in the Lithuanian forest, she spends her free time swimming in the local pool (but never the sea). She wears a ring on her hand but she says that it is not a wedding ring. "I was married, I am divorced. In Lithuania, we wear a wedding ring on the right side but the engagement ring on the left. I am single now. I am married with café!" She says that she is so busy working in the UK she does not have time to think about exploring another country, "Not yet but you never know. Maybe. I am planning but for next year. But every time I think 'From January I will start living for myself'. But January never comes, I think."

On the subject of January, we asked Jura a standard question for overseas visitors about how she coped with the British weather but her answer surprised us. "I am very comfortable with British weather," she said. "Try to be in Lithuania: thirty degrees below in winter time! And when you're standing at bus stop your bones even painful! In Lithuania it's raining nonstop, it can be five, six months. For me England is a paradise. It has very good weather."

Now that is not something you hear every day.

Café Venus, 132 Western Rd, Hove, BN3 1DB

Venus is the Roman goddess of love, beauty and desire. She is most famously portrayed in Botticelli's painting, the Birth of Venus, where she emerges from the sea in a scallop shell. The Venus de Milo is not actually a statue of Venus at all, but most likely depicts a Greek goddess such as Aphrodite or Amphitrite.

Venus is also the second planet from the Sun, and the only planet that rotates in a clockwise direction. It is referred to as the Evening Star. When viewed from the Earth, it moves in a strange loop across the sky known as the Pentagram of Venus.

Makara

Theo from Arcihpelagos told us that TripAdvisor announced Makara Charcoal Grill & Mezze as the second-best restaurant in Hove every year for the last four years. So we decided that we had to pay it a visit to find out why.

There we were greeted by Gulsen, who grew up in the west of Turkey and worked as a teacher. She told us that when she first arrived in London six years ago, she tried to continue in the profession, giving private lessons in German and Turkish, but she found it unsatisfying. There were not as many students as back home and it was just not the same any more. At that point, she started thinking about other things she could do. Fortunately, she was able to adapt to her new environment quickly. "Actually, I am not a very, very rigid person. I can quickly adapt to anywhere because from my childhood I was always alone and I was always working hard. My family were with me, but in reality I was working alone, I was spending my life by myself, that's why it wasn't very difficult for me to adapt. The thing just I worked a lot, because I was a student here so I had to earn

money. Just this was a little bit hard for me to because I had to work even harder than in Turkey, otherwise everything was OK for me. Because I came here to see the life in the world, how is happening, not just in my country, but everywhere. You can read lots of things about anywhere in the world, but if you go there to live, it's different. You have to feel it, you have to be inside the life. So, it wasn't very hard for me."

At least it was mostly simple, anyway. "Actually, the first month, I tried to find some Turkish products!" she laughed. "After that, slowly I start to eat other countries' foods. And whatever I liked, I tried more things. And I like to live free, without judgment or complain about any lives, or anybody opposite me. I don't care, because this is their life, so I like free life. Especially, after London, Brighton... when I came here, I said: 'OK, here is my town and I will live here'. Because I like the lifestyle of Brighton. Everybody, even if they are opposites to each other, they are peaceful, they are always together and respect each other. This is the most important thing for me."

"Also, it's very social! I like festivals. I like seaside, because I am from seaside, I can't live without sea. Even if I swim or not, I want to see it. And everywhere is walking distance. I don't have to use any car or bus or anything. I love walking, it's less stressful. I don't like big cities, that's why I like it here."

It was in Brighton that Gulsen and her partner, Faruk, decided to open the Makara restaurant. Even though she loved teaching, Gulsen decided it was the perfect place to change her line of work. The new chapter in her life started in May of 2012 but it would be another five months of hard graft before the restaurant could even open. "Before us, it was a fish and chip shop and it was all white, no decorations or anything. We started from the ceiling and changed everything, and it took a long time. Faruk did all the creative things. Two of his friends helped with the construction and the basement, but Faruk bought all the specific items. He is good at it."

The two of them have evolved a careful split of roles and responsibilities. "Faruk is really social. I am more on the back side with my staff, but Faruk is mostly front side with customers to talk to them, sitting with them, drinking and talking. So, he did this bridge between us and the customers. I am always on the back side, I prefer to be back. I look after the kitchen, cleaning, accounts, paperwork things and my staff, the rota, their private problems, all of them," she laughed again and added, "I'm always saying he is owner, but I am boss!"

"I am from the west of Turkey and we love eating vegetables, olive oil and things. So, I am not a very big meat-eater but I love vegetables. So I am good at desserts or vegetable mezze, but Faruk is good at meat cooking, fish cooking."

The fresh vegetables of her home region are one of the main things that Gulsen misses from Turkey, but another is the memory of sunny days, especially when she was a student. "Yes, I always miss it, because student's time is the best time of your life. Because you are young, you are free and you can do lots of things, you can improve which side of your life you want, you can do everything. I was in East Turkey as a student and it was a very good experience for me. Then I had a chance to see all the sides of my country, it was a really good time of my life. Actually, I am happy here now, this is my country as well, but half of my heart is there, my family is there, my friends, and I love my country." This kind of nostalgia also fuels some of the migrant-to-migrant business in the UK. "We have lovely student customers from Turkey. We enjoy sitting together with them, drinking. Sometimes it takes until morning, we don't care about the time! They like to eat here because students coming for a short time don't want to change their routine food or their routine lifestyle, so they come to find Turkish food."

The main customer base comes from locals, who Gulsen estimates make up eighty percent of the clientele. There was a big risk when they first opened as they were moving down from London and had no contacts in Brighton but they relied on word of mouth from customers rather than spending money on advertising. "We focused on our customers: if they enjoyed, if they are satisfied, they are gonna tell people other people, it's like a wave! This is the best advertisement for us. That's why we didn't do anything and we weren't in a rush. Step by step, slowly, slowly, until we had set up the business, until we had made sure all our staff were concentrated and doing their best. We didn't want all the people

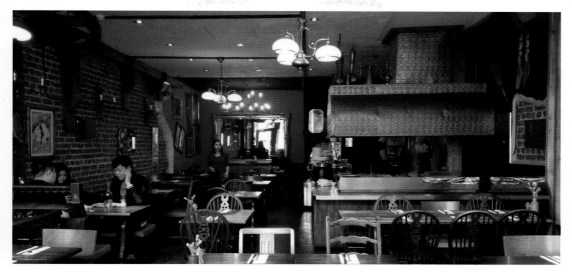

coming straight away here, so, slowly, slowly start. It was good for us. And we are happy now, because our customers are really lovely people and they are locals, most of them. When they come to eat here, they will order some food or drink to other tables because they know each other. Very nice people! Some of them are even friends now, not just customers. We are going out together as well. We are like one of them, we are like locals."

There is an ongoing exchange of culture and knowledge through business and travel that is encapsulated in the experience of Gulsen's restaurant. She herself has been through a process of emigrating from Turkey and then coming to feel like a local in Brighton, just as the locals have embraced her recipes and the transmission of what social scientists would call,

"foodways". There is also a converse flow of knowledge that she was surprised to discover amongst the local customers both through the fact that they chose to eat at the restaurant and through the way that they ate at the restaurant. We might picture a more static system with people coming from outside the UK to deliver something foreign either to an exclusively foreign client base or to a domestic audience seeking exotic novelty but in reality there is a constant reciprocity of identity politics. Our models must be animated. "Lots of customers have visited Turkey for tourism or for business. Sometimes I am surprised because lots of people know Turkish food: it's not very, very specific. Lots of people know French cuisine, Italian cuisine and Turkish cuisine as well, it's very general in the world. That's why they know everything about Turkish food." She went

on to add, "Lots of them know Turkey better than me! Because they are going for holidays or some of them have properties, so they know better than me. So now I am asking them for advice! 'If I go Turkey: where I should go?' And they saying lots of details. Because I am from Bodrum but I've never been in Marmaris! And last November, when I went to Turkey, one of my customers was very surprised when he heard I've never seen Marmaris. That's why it was so shameful for me, it's very close to my hometown and I've never seen it! Then, when I went to Turkey, first I went to visit Marmaris.

"The main recipe the customers ask about is our dessert. We don't have a dessert menu but just a very simple dessert we are doing every day, one tray we doing and when it finishes, it is finished! So they ask for recipes for this, and some of them told us they tried to make it home but it's not the same taste, and I said we're putting our love inside, not just recipe! Especially for dessert, because other things they know they can't find the products, or they can't do because they're not able or anything. That's why they first asking for the dessert."

Another misconception that we might have is that people from Turkey who come to the UK will struggle against stereotypes British people might have about them. In fact the main problem for immigrants like Gulsen is the stereotypes that Turkish people back home have about their life in the UK. "They asking lots of questions about here. Cos, if they didn't leave their countries, they don't know what's here, it's very different for them. And they feel like there's a magic stick and they just touching you, and you done everything in here. It's very surprising for them. They asking lots of questions! They think it's very easy when you have come here: in one year you can make lots of money and you can do lots of good things in your life. But in reality it's not that easy: you have to be patient; you have to work a lot. But they think it's like magic, everything will be better than in Turkey. But no, you have to be patient and work hard. This is not just for here, all the world, wherever you go, you have to do this." This kind of stereotyping cheapens the amount of effort required to establish a new life in a new country in a way that probably reinforces nationalistic identities for those who don't emigrate. It takes emotions like envy and resentment and cooks them up with big ideas about, "Turkey" and, "being Turkish" and what that means for people. It also undermines Gulsen's image of herself and of the value of her work ethic. "At the moment I don't have lots of time for myself, but whenever I have time, little bit time, I want to spend it for good things to improve myself, not just for nothing. I don't like to sit without

nothing," to which she added with laughter, "And I am very hard worker. I don't like to sit and being lazy-people because life is too short for nothing. That's why I think every moment should be spent for good things. Even whatever you like for your hobby or anything, but I like to spend my time here in the restaurant, because here is my home." When she is actually at home, though, Gulsen does not enjoying cooking. "Actually, I don't want to cook after all day... I prefer to read a book. It makes me calm down and not to think about business because I can't sleep very easily. And it's my hobby from childhood, every night I am reading books."

Gulsen first learnt to cook from her mother but it was just another hobby for her as she was always so busy. Her partner, Faruk, grew up in a family restaurant and he had always loved cooking and eating so he was able to teach Gulsen what she needed to know. She believes that if you love something it does not matter whether you have a lot of prior experience because you will be motivated to improve your skills. Now her favourite dish to prepare is mucver, a vegetable pancake from her hometown that she likes to cook with courgette. "I tried it over here and many of our customers liked it, it's very popular. But I miss it in its original style. You grate courgettes, you add some fresh herbs and eggs, and the flour; then you mix it all together and you fry it on the pan." On the subject of vegetables, we asked Gulsen for her advice on healthy eating and healthy lifestyles for people of Brighton and Hove. "Actually, you know doctors always say, 'Don't eat at a late hour' or, 'Don't drink a lot' but... it's not good to say, but lots of our doctor customers are eating kebab here! Yeah! So, in our culture, you know, always they say for the advices: 'Always listen but don't care about to do it!' And the doctors are eating late. Yeah! Around 10-11 pm! But for me, if you enjoy, it's more important. If you don't have any specific health problem, I don't think so it's gonna be a problem, because you enjoy it, this is more important. Little bit from everything, it doesn't make problems. My advice would be: after eating night-time kebab, it's better to go walking in the morning! I think if you drink alcohol in your limits and you don't smoke and if you do your exercise, from the food, I don't think so it's gonna be unhealthy or anything. Everything should be in balance. Whatever you eating, whatever you doing, should be in balance. I've discussed this with the doctors when they come here to eat kebabs and just they don't say anything, they just laughing."

Makara Charcoal Grill & Mezze, 28 Church Road, Hove, BN3 2FN

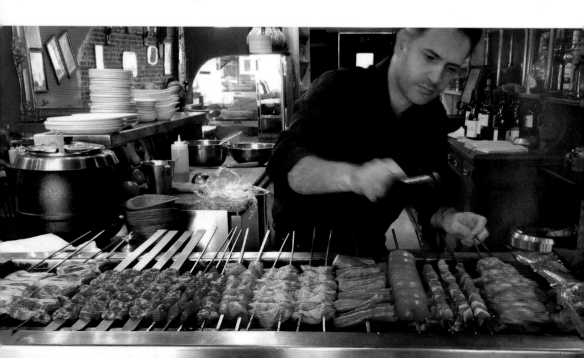

The Blue Man

The Blue Man is a groovy bar with a North African theme that specialises in Algerian cuisine. You can find it at number eight, Queens Road, a street that is something of a let-down in between the thrill of arriving at Brighton station on a daytrip and the joy of splashing into the sea a few blocks later. What should by rights be a sum ertime boulevard of diversions and tourist traps, Queens Road is largely taken up with double-parked buses, sketchy pubs and boring office blocks.

The footfall is a strange thing on Queens Road, too. It tends to bunch up on the east side by the interminable junction with North Road and nobody ever crosses to the quieter west side. And then only a few blocks later it bunches up on the narrow west side pavement and nobody ever crosses to the wider east side. It is as if there is some weird psychogeographic barrier around Brighthelm Gardens that spits pedestrians out sideways. Originally a graveyard, the Gardens are now given over to street drinkers and a nursery, both of whom compete for noise-abatement levels during the day. Although recently revitalised by a street-food market and a community gardening scheme, the Gardens still live up to their nickname of Boracic Park. In a typical example of inner-city juxtaposition, the Gardens are situated opposite the Masonic Centre, where you will often see middle-aged men in black suits self-consciously lugging their suitcases of ceremonial aprons and nooses to their freaky rituals.

Queens Road only really starts to get interesting in the final furlong, which is where the Blue Man awaits, tucked in between the tattoo parlours and bong shops, just before the clock tower. In this context, the Blue Man is an incongruous slice of North Africa in a very English pie. The mysterious painting of the Tuareg nomad on the fascia informs you that this is something out of the ordinary. The muted brass dome awning over the door recalls both the Brighton Pavilion and the post-Byzantine domes of Islamic architecture. And as you step inside, you enter into a different dimension. The upstairs bar is adorned with Moorish furniture and the ceiling is hung about with silver teapots. The walls are covered in fezzes, slippers, plates and framed photos of Algerian camel riders amid desert landscapes. Downstairs, the ceiling is covered in old vinyl records, guitars and Moroccan lamps. Even the loos are plastered in comic books. It feels like someone has taken the usual pub-décor eclecticism of a typical Brighton bar and fired it through a North African bazooka.

This is entirely a deliberate policy that helps to set the Blue Man aside as a respite from the lager and Lynx-drenched dancefloors of the nearby clubbing district, as the manager, Jess, explained. "We are very close to a street called West Street, which you may have heard of, and it doesn't have the best reputation in Brighton, shall we say. So often, if people are coming past on their way to West Street, they sometimes take a few steps in the door but they maybe get a little freaked out by the fact that it doesn't look exactly English and then they leave. And that's fine with us, because in our experience often those people tend to be the kinds that will maybe get a little bit louder and ruder the more alcohol they consume. So honestly it makes it easier for us that we look like a different culture because you're less likely to get that kind of person that will even come in. And if they do make it up to the bar itself, we don't sell Fosters or Heineken or something like that, so again, we don't have what they want and then they leave anyway so it's never much of a problem."

Jess grew up in what she calls an unconventional environment. Her maternal grandfather was an electrical engineer who travelled around the world with his work, so her mother was raised in places as diverse as Mexico, Australia, the Middle East and Canada. This experience meant that Jess was brought up with the idea of different cultures in the house being a normal thing. She started working in, Silver Service waitressing at the age of sixteen, a tradition of formal tableservice dating back to the stately homes of the nineteenth century. This led on to running bars in London before a soul-destroying stint in corporate customer services. Her lucky escape from this demanding world came in 2012 when she teamed up with Maj to join him as a partner at the Blue Man.

Maj is a chef and entrepreneur from Algeria. He came to the UK in the early 90s and launched the first Blue Man in 2001. At that time it was a little café on Edward Street opposite the big American Express building, selling tajines and Algerian food. After it proved successful, he moved to new premises on Little East Street, a pedestrianised parade of restaurants near the Town Hall that eventually proved to be a little too far off the beaten track. The current incarnation was installed in Queens Road four years ago with the intention of providing the same quality of food but in a more informal and relaxed bar-style atmosphere, which is where Jess came in.

She says that Maj is an amazing chef. "He was taught to cook by his mother, Fatima, who is known in his local area as the best cook around. She would cook at every Christening, wedding, funeral and if Fatima wasn't cooking then it wasn't an event worth going to. So he learnt to cook from his mother, from the age of about fourteen and when he moved to England he classically trained up in North London in the French style. Both on the job and in school as well." She also says that Maj is incredibly creative and was responsible for all of the interior décor, including sticking all of her family's old records to the ceiling, which she seems remarkably sanguine about. She does admit that he is keener on bringing

his creative inspirations to the kitchen and the embellishment of the furnishings than on the paperwork and admin. Together, though, their skills combine into one package both as a professional partnership and in the romantic relationship that accompanies it.

The concept behind the Blue Man is a tribute to Maj's own heritage. "It was named the Blue Man because I think it was something that Maj always wanted. Part of his heritage is Tuareg, and the Tuareg are a nomadic tribe that basically belong to the Sahara. They themselves don't have what you might call the same borders that Europe gave the continent of Africa in the last say, three, four hundred years after they invaded Africa and did what they did to it. The Tuareg have their own area of the Sahara. So the reason that Maj called it the Blue Man was because it's part of his heritage, he always wanted to do something that would give a nod to some of that heritage that's in his blood. And the Tuareg men wear these big blue scarves that are wrapped all around their heads and look little bit like turbans, I guess. They keep their heads and faces covered up completely from the Saharan sun, and the robes that they use are dyed blue and indigo, and the colour of the dye seeps into their skin, which gives rise to the name L'Homme Bleu in French, which translated into English is the Blue Man. What's really interesting actually is that a lot of people mistake the Tuareg for being Muslim which they are not at all. They don't really have a religion. Their religion, I guess, is the Sahara desert, and what's really fascinating about their history is that the women wear these long, flowing things that almost look a little bit like saris, so they don't cover their heads or their hair for any other purpose but to guard from the sun basically. In Tuareg culture, the women are very, very much in control and back, maybe I don't know, a few hundred years ago, it was very, very common for Tuareg women to take lovers that had to be in and out by sunset and sunrise. They have their own property, they have their own livestock or material things the family owned, you know, they were very much in control and so the Tuareg people

are, I would say, incredibly equal and forward-thinking and I think it's part of the reason Maj is so proud of that part of his heritage."

Even though the space is driven by a Tuareg and Algerian heritage, visitors to the Blue Man could be forgiven for mistakenly thinking it is a Moroccan-themed bar. As Jess says, "Most people, when they think of North Africa, they think of Morocco and then, after that, they think of Tunisia. Algeria isn't as well-known because it doesn't have a big tourist industry for example, so most people come in and they think it is a Moroccan bar. We like to just say well, actually, it's more of a North African theme as that gives us the freedom to offer twists on specials like baked camembert, rather than limiting it to traditional food. For example: if we do, I don't know, butternut squash and carrot soup, then we'll add something like Ras el Hanout in it, just to give it that North African flavour. One of our dishes is called Battata Harra but that's basically spicy wedges, so we use fresh potatoes and we chop up the potatoes into wedges and we shake them in chilli and sea salt flakes. It's not particularly North African but then who doesn't love potatoes and fries and wedges and things like that? It's all about giving a little twist to either a European or a British dish and then giving it something extra that makes it a little bit more like North African. It's not pure North African and that's important. Maj has talked to me in the past about the idea. For example: in Tunisia their tajines are much spicier, their food is much spicier and that's where Harissa comes from. In Morocco for example, Maj says that they use a lot of fruit in their tajine, so they'll use much more dried apricots and prunes and dates and things like that, so we have dates in our lamb tajine, and that's a nod to Morocco which is a cousin to Algeria basically. Algerian tajines are not as spicy, and don't use as much fruit, so again that's somewhere in the middle. So everything that he does, he gives a little nod to somewhere in North Africa and it doesn't have to be pure, it just has to be really tasty and he's happy... although his couscous recipe is very much his mother's! That's quite set. He is quite strict about that. If he's training someone to cook and the couscous isn't good enough, he makes them start again and he does it all again and show's them how. And the way his mother

makes couscous is with some butter and a little bit of salt and, oh my God, it's delicious!"

This approach to the menu is a refreshing alternative to hidebound national cuisines and is even an alternative to the postmodern idea of fusion cuisine. The concept at the Blue Man is more free-roaming, like the nomadic Tuareg who roam the vast Sahara regardless of national borders. On the shifting sands of the desert, these borders exist only in the mind.

The customers at the Blue Man are themselves a very diverse and shifting bunch. "We seem to attract all different age groups, all different nationalities, which is great. I think it would be boring if we have just one kind of customer, if that makes sense. And I think the main thing for us is, because we love service, we recruit staff that love service, so even though they may not have every single skill that you need to work in a bar, they can learn that quite quickly because the attitude is the most important thing and to work at the Blue Man you have to love serving people, otherwise it's pointless because you have to be how to be able to deal with different types of people every single day. I mean, for example, right now upstairs there is a guy called Dean who is very, very English, and works at Gatwick airport. He's an engineer himself and he's been coming in here for about two years now. He comes regularly every two weeks, eats loads of food, sits and reads his papers, always comes by himself. I mean he's brought his family in before but he tends to just have like his own 'me time'. So he comes in, eats loads of food, drinks loads of ale and, yeah, he's just really happy to be here."

Beyond the menu and the décor, the other attractions include the quality of the coffee and the extensive assortment of alcohol. At the last count there were ten different gins, fifteen single malt whiskeys, twenty rums and fifty beers to choose from. "It's quite funny because a lot of the staff, sometimes if a customer comes up and they look at what we've got and they go: 'Tch, aw, you don't really have what I want' the staff are like, 'Come on now!' You know? 'There's so much here, how can you possibly not fancy something behind this bar? We've got everything! It's impossible, you know?'"

The downstairs function room at the Blue Man serves both as a space for private parties and as a venue for comedians and bands. I have played there once or twice myself and it is quite a challenge to squeeze a few guitar amps and a drumkit onto the small stage, not to mention a band as well, but the atmosphere is always friendly and it has a good energy. Euro-Mernet have been using the venue for their regular film nights and it is popular during the Brighton arts festival in May. "It's the people that come in who make it special, because I've made a few friends now who were performers and they really seem to absolutely love it. As an example we have a comedian called Sameena Zehra who does a night called, "Cult of Comedy". It's almost like a variety show, and she just absolutely loves it here, as does her husband who is a Blues singer. He plays here too and they became really, really good friends and I think that's the most special thing."

Unfortunately, not all of the customers will become friends, however. Difficult customers get everywhere, and the Blue Man is not immune. "One time, it was a couple of years ago now and I was stood in the little gap between the bar and the main floor, and this woman who was sat near the bar, stood up and she waved her empty pot of houmous in my face and she said: 'Houmous? HOUMOUS!' at me, and I said, 'I'm sorry Madame, can I help you? Is there something you need?' cos the way she spoke to me, I immediately felt quite cross but trying to be polite and she said: 'I need more houmous!' and then I said, 'Ok, that's fine, that would be an extra pound please for the extra food that you want.' 'Well I'm not paying more money for it!', and then I said, 'Well, then you can't have any more houmous, if you won't pay for it'. She said, 'I'm vegetarian, I know how much houmous costs!' And then I said, 'Well that's great, I'm really glad that you are a vegetarian, well done, but what you're not thinking about is how much my staff cost, how much the electricity costs, how much the business rates costs, how much it costs me to have a pavement license, how much the heat costs, how much the air conditioning unit costs me to run…' and I could have gone on. I didn't. And I could see in the corner of my eye a couple of my staff members giggling in the

corner, trying not to be seen, because they think it is hilarious, because they are much younger, they are mostly around twenty-five and I'm thirty-five now you know, so I'm polite but, at the same time, I will make my point if I have to, whereas obviously they don't have the same sort of experience that you are really able to do that, so they were giggling in the corner, and she then just immediately backed down and bought more houmous, because I guess I made my point, and actually she was being nicer since then. And actually what's been nice is that a lot of that I learned from Maj. I joke with him sometimes that he trains customers a little bit, you know? You set a place and this is how you run it, and this is what you do, and, yes, you're here to serve people, but at the same time you can't have people take advantage of your kindness either, and that's a really fine line between giving too much and taking too much from someone, you know, and I think he's taught me quite a lot about standing up for yourself and knowing what it is that you're offering and being quite firm about that. Polite always, but firm. And you can afford to take the mickey a little bit as well and I think she got that."

Jess describes herself as a feminist and is deeply involved in campaigning against sexism in the media. She also applies those principles to the working environment. "In terms of the Blue Man, our staff aren't here to entertain, if that makes sense. Yes, they're on a stage when they're on the bar, but they're not here for the gratification of others, so it's very important that our staff stick up themselves and don't take any rubbish from people, especially if they're women, the second they start. And it's the same for boys as well. You know, feminism means equality for both sexes so I would never expect any staff to put up with touching, rude comments, any kind of harassment whatsoever. If it happens: customer leaves and is not welcome back… zero tolerance. So that's just us and it does just mean that you get really good staff because you're there to look after them and you will back them up. So that's really important for us. Both Maj and I feel very strongly about that."

One of those vlaued members of staff is Alex. She grew up in a small country town north of Brighton and struggled to find work when she first came to the city. "I was going up and down the Lanes looking everywhere for a job and I almost walked past this place, as so many people do because it's easy to walk past but as soon as you look in it makes you stop because you see all the bright lights, all

the fairy lights, the colours and everything and I walked in and it's almost intimidating the amount of alcohol that is on the wall, and like everything is so vibrant here you know? So it made me stop and I came in and I met Jess and Sarah and I gave my CV and then you know, the next day I had a trial shift and then another shift and another shift and another shift and then here we are!

"Working here, your life kind of centres around the Blue Man. You know everyone is a big family, even on your day off, if you come at about 5 o'clock most of us is gonna be here just chatting, some of us on one side of the bar, some on the other side of the bar... yeah, it's like a big family and yeah, we are always in here just having a laugh basically." Whenever you walk into a business and everyone there is miserable or grumpy then you know the boss is probably a bit of a bastard. The converse is also true, and the driving force of this sociability at the Blue Man is clear, as Alex told us: "If all the girls were talking about certain subjects and I wouldn't know the context, Jess would just kind of whisper in my ear the context so I could join in and that was really nice. And everyone is so lovely and welcoming and you know, even

after work and it's two in the morning and everyone still wants to have another drink and keep chatting and everyone's, yeah, really, really lovely and it's really easy to make friends here which was really nice because I didn't have any friends when I moved here!"

It is so friendly that fellow staff member, Sarah, even found herself living with two of the girls that worked there, and then later on with one of their brothers, George, after she started working there herself. She listed all of the things she liked most about the Blue Man. "I think the fact that everyone feels comfortable here. It feels like a living room, everyone comes in and feels just comfortable. So yeah, that's my favourite part, that anyone feels that can come in, it's easy to walk in and nobody thinks that you need to fit in a certain mood, it's my favourite part."

Another member of staff, Eben, left her home in Dublin at the age of nineteen to study fashion at university in Brighton. She originally discovered the Blue Man when her mother came to visit from Ireland. Eben found that her mother liked it so much they ended up going every time she came. It was a combination of the atmosphere and the eccentricity that

▸ **Alex & Sarah**

attracted them. As she told us, "Everything about it, it's just like it doesn't look like it's supposed to make sense but it does." After Eben graduated from university, she realised that she wanted to remain in Brighton and drifted fairly seamlessly into working at the Blue Man. For her, the inclusive vibe of the bar is consistent with the town as a whole, "I like how liberal it is and yeah, I definitely think people are a lot more accepting in Brighton than where I come from. I just like that, even if you wear the craziest clothes or you look a certain way, nobody cares in Brighton. You can kind of just do what you want and look whatever way you want and it's a lot more left-wing, which I agree with."

Sarah concurred, "Brighton is really easy-going. Everyone is accepted. I mean especially in the Blue Man, anyone can come in here and we have a real range of ages, backgrounds, jobs, people with a lot of money, people with no money. Anyone comes in here and I think that's quite true in Brighton as well, that everyone comes, you know, whatever nationalities, whatever language you speak, you can still live in Brighton and do pretty much anything you want. I really like that." Sarah grew up in Devon and moved to Leicester to study but found it to be uncomfortably busy. For her, the Blue Man always represented somewhere to just chill and hang out. She found herself working there within a week of first visiting the bar.

Sarah's flatmate, George, is a musician in his early twenties and comes from Mexico. He travelled to the UK to study music and, in his words, to become a rock star. "I have just been working since, doing music, trying to get my band going. How I came across the Blue Man? My sister used to be the manager and so after a year of drinking here, they eventually gave me a job!"

George also says that Brighton is different to his home town but, unlike the others, not because it was conservative or provincial. In fact, George grew up in Mexico City, one of the biggest cities in the world with a population of over twenty million people. "It's completely different, especially to Mexico City cos it's massive. Yeah, let's see, how I can put... you can't really compare, because it's two completely different countries, different cultures. I'd say Brighton is more culturally diverse, just cos in Mexico obviously it's mainly Mexicans, people speaking Spanish, but Brighton there's just a very large, I think, variety of culture. You get people from all over the world, and it's quite an open place, very accepting of people's cultures. I came here, like, seven years ago. I don't really see myself going anywhere."

The two main questions asked by customers are: "Do you speak Mexican?" and, "Is it really hot there?" Unfortunately the answer to both is no. "Mexico City is one of the highest cities in the world, surrounded by mountains in a valley so like the weather is very similar to England, so it isn't very hot." As for speaking Mexican, that's a bit like asking someone from America if they speak American. "I miss speaking Spanish obviously, because everyone here speaks English, so I just speak English all the time. I miss the food, too. Because obviously you get loads of Mexican restaurants here, but it's not the same, it's a lot of Tex-Mex, so I do miss the food."

Luckily for George there is a lot to keep him going at work as the Blue Man menu is so varied. Alex told us she goes through waves. "So for the first six months I couldn't get enough of the spicy wedges. On our staff do, I was named the 'Wedge Stealer' because I would always steal the wedges! I've kind of gone off those now because obviously they are not healthy but I love the spicy chicken wrap dipped in harissa mayo, it's really good. It's making me hungry! But then you've got the classic favourites

◀ Self-confessed Mexican rock-star, George

halloumi and merguez sausages... but there is nothing really on the menu that I don't like, except for salads. I don't really like salads," she laughed, "But that's just me being unhealthy."

Sarah said that she loves baking at home. She does have her favourites at work but does not always get to indulge as much as she would like, "My favourite is the lamb tagine, always, but I eat it rarely. I always get my hands slapped if I go into the kitchen so I rarely get some of that!"

For everyone else, there are now even more opportunities to enjoy Maj's kitchen as the business has expanded to include a second venue, Village, situated in the old Horse and Groom pub in Hanover. As Jess explained, the principle is similar to the Blue Man but this time the theme is English, rather than North African. "One of our staff said that when she goes in there it feels like she's in her granddad's living room in his converted barn in Devon because there's lots of old Toby Jugs, which are a very British thing, you know, the big ceramic jars that have got faces on them, they're really, really English. There's horseshoes all over the place. So even though Maj opened the Blue Man and it's a North African theme and he's Algerian, he's very much an entrepreneur and he could open anywhere I think. If you asked him to go and decorate something to make it a Chinese restaurant, I think he could find stuff to do it. I really don't think he would have a problem. I think the main thing is that Maj knows how to make somewhere feel a bit like a second home, so when you walk in you feel at home, and you feel comfortable, and it feels warm and inviting. So I think that the principle with anywhere that we'd open would be that theme, as in making a place where people feel at home and looked after."

Blue Man, 8 Queens Rd, Brighton BN1 3WA

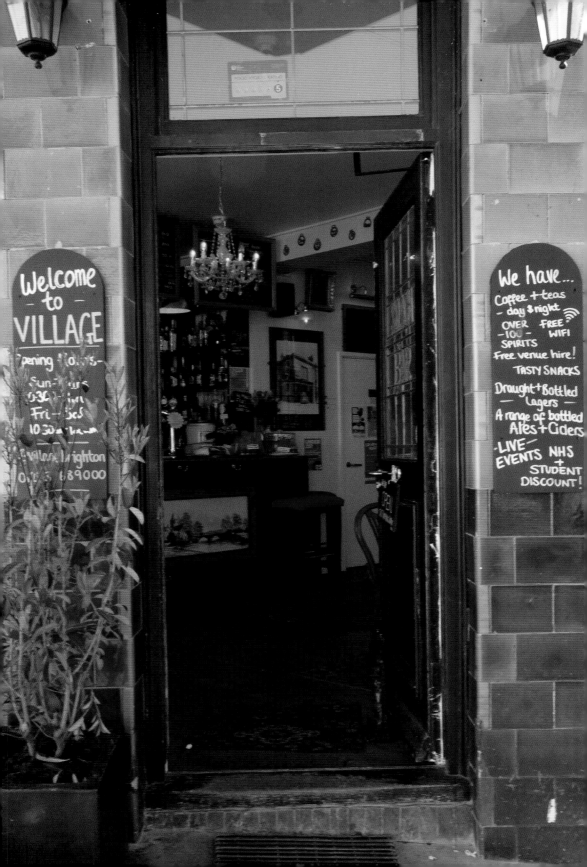

Welcome
- to -
VILLAGE

Opening Hours-

Sun-Thurs
10:30am-11:00
Fri + Sat
10:30am-1:00am

Village Brighton
01273 689000

We have...

Coffee + teas
- day & night
OVER FREE
- 100 - WIFI
SPIRITS

Free venue hire!

TASTY SNACKS

Draught + Bottled
- Lagers -

A range of bottled
Ales + Ciders

-LIVE-
EVENTS NHS
 +
STUDENT
DISCOUNT!

Village

"I am not just a blue man. I can do anything and everything. People love putting a sticker on you, you know, but we are all different, we can do all sorts of things. This is why I've made the Village so different, very different from the Blue Man. The only similarity in here, you will feel the welcomes, you will feel that beauty that the Blue Man have. But every single bit of it, I didn't want it to actually look like the Blue Man."

The Village Café Bar was Maj's next adventure after the success of the Blue Man on Queens Road. The Village can be found halfway up the steep Islingword Road in the Hanover district of Brighton which is known as Muesli Mountain due to the vertiginous angles of the hills and the liberal, organic-friendly residents.

The venue is on the site of the old Horse and Groom pub and retains the green glazed tiling and faïence work on the exterior, which was a feature of the Brighton architect, Stavers Hessel Tiltman, for the now-defunct Portsmouth and Brighton United brewery. It is still a gorgeous building, spread across the corner of Islingword and Coleman Street, and marred only by the presence of Brighton Council's unsightly communal bins in the street outside. When the former owners moved to convert the building into an office block, there was a public outcry and locals campaigned to secure it as Asset of Community Value which would protect it from development under the Localism Act. Now it is a popular café and bar with free wi-fi for the cool kids working on their laptops and a nappy station for families. The tradition of holding live music events also continues.

"I lived in this area for quite a while. I think I've been around for the last twenty years. I always liked this area, and I always thought something would have worked in this area, a little café, a little bar... And the beauty as well is trying to get the neighbourhood in here, to come in this place. If I did the Blue Man, it would be too in-your-face. I think you have to be very, very clever and get the surroundings completely right for people to come in and to relax. It feels like their own house. When I first walked in here there was nothing. There was no ceiling, there was no electricity, there was no plumbing, it was absolutely nothing. Every single bit that you see in here, from the sofa, from the tables, from the lights, from the books, from the shelves, from anything... I put everything together. And I wanted to make a point of not having Jess in here for me to make it just on my own. For the people to understand and to know that someone from a different place make things like that, you don't have to be English to do these things. Anyone and everyone can do things like that, you just need the vision and you need just the know-how. And you can create the warmth. This is what I was saying about the Blue Man, it's not about the tea-pots on the ceiling, it's about the feel of it. And I think in here it's all about the feel and the beauty about it. You just had a mint tea, but this is a completely English surrounding. But you had a mint tea and the people coming to have a mint tea, have houmous and bread, and they won't worry about it, because they are conformable."

When the news went out that Maj was going to be taking on the pub and renovating it, there was some concern in the local area as to whether he would be able to continue it as a traditional venue, perhaps inspired by early promotional language that it would retain 'a very British feel'. "I think at the start this place was gonna turn in offices and flats. I heard that the community around here wanted to put a stop on it. So I managed to find the owner of it and ask him if I can purchase the place and I will return it to be a bar and a cafe and everything else. So, a lot of people when they heard that, I'd say 90% were very excited, very happy, cause they know me, they know I have been around for a long time, they know I can actually do things, and know that I am

a professional. I think there was a little bit of a concern that I was gonna bring the Blue Man in here, so about 90% people loved the idea of the Blue Man in here, but there is 10% that, as you know, my name is north African so, when they put it out in the newspaper, I had people commenting on the newspaper saying, 'His name is not very English, what does he know about English pubs?' But the thing is, I know what I know! Actually, the controversy was really, really good. As you know there's no such thing as bad news or bad publicity, it's always good to get people talking about you, and about what you are doing and how you do it, and I think it was really, really nice to hear a lot of supportive people, and I wouldn't actually live in this area if I didn't think this area is beautiful and we've got a lovely, lovely neighbourhood. We opened it and we open first thing in the morning and I think we are the only one that we are open in the morning and people love it. And I think it's gonna be only getting better and better and better!"

One of the key pieces of evidence for this is the number of old pub regulars that still come to the new café. "Yes! There's loads and loads of people that actually use to come in the Horse and Groom for a long time. I mean, I was a resident of the Horse and Groom myself as well, so they know me, they knew I was OK and, like I said, if they get to know other people they'll be fine with them as well. We got loads and loads of regulars and they absolutely love it. Love the fact that it celebrated this building rather than made it tacky and know you can see you have children, people working from here, people having parties, weddings, all sort of things and that is a very, very Blue Man sort of vibe, actually getting people all together, that's the warmth of the Blue Man coming in to Village without calling it the Blue Man.

"I think there is a Horse and Groom in here, there is a cafe in here, there is a bar in here, there is a venue in here, there is a stage in here. I think we have put everything together, from early morning having French lessons, to parties in the evening and having live musics. I think we're only gonna make the things better, and I think it takes someone from somewhere outside to actually make these things, because he's got a different vision. And I think one thing that the Blue Man or me or Jess or everybody that works for me, I

▲ Maj and Phil enjoying the sun outside Village

won't take all the credit myself, because I've got a team and we're all together run it. One hand does not clap. There's not just me. I think this place it's a fantastic beautiful space to have.

"And we want to continue the community spirit. Massively, yeah, I think so. I think the community are liking it day after day after day. We see people coming in all the time now, they come in once and they'll come back again and again and again. The beauty is that we tried something different. We're not boring. The one thing that we're not, even the staff, even me, even everybody that we got working with us: we're not boring. We try different things and if something doesn't work, we change it."

Maj spends more time these days at the Village than at the Blue Man but it is still an important part of his life. A lot of restaurateurs we have interviewed have told us sad stories about overwork and marital breakdowns, but Maj insists that even with all of the shuttling

between two venues he still has enough time for himself and his hobbies. "There's always time, there's plenty of time. I played football yesterday and I am gonna play football on Friday. I think people think they can't find any time but there's always time. I'll give you a funny story about time. I was in Algeria last week, and I got a brother that is quite lazy, and he doesn't do quite a lot of things and no exercise and the older brother asked him: 'Why don't you do any jogging? Just go and run! Do some exercise!' Straight away the younger brother said, 'I'm so busy, that's the last thing in my mind, I can't do anything, I am so busy. I can't do any training, I can't do joggings, I can't do anything for myself. I'm really, really busy.' So my older brother looked at him and he said, 'I was watching TV yesterday and I saw Barack Obama doing some jogging… Are you telling me you are busier than Barack Obama?' So there is always time! You see all these massively important people, you see them playing golf, you see them with their

family and how they're gonna find time. There is always time. You can always find time for yourself and for your family and your friends."

"Everything that you do it is yourself, it's you the one that are stopping you from doing something. No-one will stop you doing anything. All you do, all your actions, it's you that actually allowing that thing to happen."

Maj had travelled to Algeria for the wedding of one of his cousins. But he observed that wedding parties in Algeria were very different to the kinds of British wedding parties that are hosted in the Village. "I think the only similarity is that of joy and happiness, but there's no comparison at all for the other things, because in Algeria we'll stay forever, a week, two weeks, three weeks for one wedding! There is the groom's wedding and then there is the bride's wedding, and then the sister and then the Henna, so it just goes on and on and on. It's just traditions. It's nice to see that

tradition is kept alive, they feed the local people, everyone is welcome, there is no structure and that's the beauty about weddings in Algeria. I don't like structures on the wedding day, I don't like people sort of telling me I have to sit there and not take any pictures… in there it is chaos, absolute chaos, but it is nice. I like it.

"I think it's a good idea to have a long wedding. They proved that, haven't they? People stay longer with each other and they stay longer forever and ever and ever. Maybe sometimes it's not a good thing but you know 90% is a good thing. You see the rate in England about divorces, it's, you know… really, really big! But if you see the rate in Algeria, it's not a lot. So I think with longer weddings, at least you get to know your brothers-in-law, and their aunties, and everything else, not just one night when you are really, really drunk and it's all comedy! You know, it's one night and you're really drunk and you can't remember anything. And then you just realise that person is a really bad person. But I think you can actually catch someone if you are around them for a week or two or three, you know who they are."

The brunch menu at the Village offers a mixture of traditional British and Continental breakfast options but there are some things from Algeria that Maj would like to introduce. "I think that the signature dish from Algeria is couscous, you know, and everybody knows couscous. It's a wedding meal, a family meal, and you know if they give couscous to you in Algeria they would never give it to you in one plate, you would actually have a big bowl in the middle, and then you all have to share. And that's basically just welcoming you in their environment and couscous is really, really good but is a good couscous, a real couscous, and there is a good way of cooking good couscous, and there is a really bad way of cooking couscous. And that's the other thing about couscous, it's so good that they named it twice, 'cous-cous'!

"There are different kinds as well. There is a couscous with honey and watermelon that they serve in the Sahara because of the heat, to make freshness you know. There is a couscous from the mountains, there is couscous from the

Mediterranean… You have to remember that Algeria has got a big Mediterranean Sea and it got really, really big Atlas Mountains and it's got the big Sahara as well, so we are very, very different people. Algeria is the biggest country in Africa, and there is something about ten or twelve languages in one place and they still live all together and they are still happy all together, and I think it's really, really important to remember that there is not just English in the world, there is so many other languages."

On the subject of couscous, some North African people we have spoken to were upset by the new styles of hybrid couscous invented by the local supermarkets, but Maj took a different approach, one that is influenced by his own identity and sense of a wider heritage. "I think it's nice, I like it. I think as long as it's couscous, I think it's nice actually to introduce other things and you know, maybe some people prefer it with peppers, some people prefer it with chickpeas and I think it's like I said earlier: the palettes and the difference of tastes is different, and I think it's nice for people to know where is from, but to actually change it around? I've got no problem with it at all, you know, it's nice to change around. Yeah, I think the beauty about North Africa as well, you got to remember that you got Tunisia on the right and Morocco on the left you know. The Moroccans, they use a lot of dried fruit and sweetness, with Tunisia they use a lot of chili you know. It's really, really hot. I think Algeria is a little bit of a middle thing, and I think the culture comes in from the French, from the Ottoman empire as well, so we have loads and loads of Turkish food you know and stuff, we got Roman food… we are very, very different, that's what it means being Algerian. You can see me, I've got curly hair, my nose is Roman… we're really, really mixed up and different, and I think this is the way that the future will be, because we're all gonna be mixed, because we're all one person and one people, so that's the beauty about where I am from, because we accept everyone, because, you know, my middle name is Kamal, which is Turkish, you know, so it's a lot of different stuff that we got from the Ottoman empire, we've got loads and loads of stuff from the French, we've got loads and loads of stuff from the Romans.

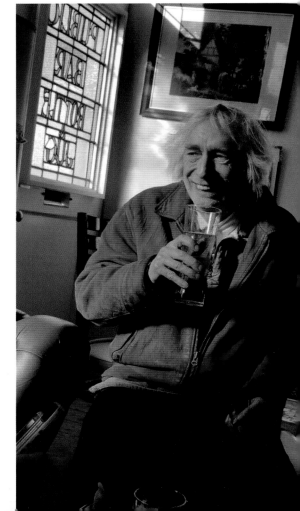

The other thing is that everybody thinks Algeria is an Arab country and everything else, but we've been colonized by the Arabs the same way we've been colonized by the Turks, by the French and everyone else. So I think when people start to actually know where everybody is from, then there wouldn't be any confusion. So this is now the problem with Shiites and the Sunnis and everything else, because there is a lot of ignorant people, I think people have to start to read history, because history is really, really important."

Local history is also important to former Horse and Groom pub regulars like local resident, Phil Webb. He told us about the changes to the area over time and how this has impacted on the community of Hanover. "I've been coming to the Horse and Groom for possibly twenty five to thirty years, when it was the Horse and Groom, and now I'm coming to it as it's called The Village, and I like it! We were all disappointed when we heard the Horse and Groom was closing down and so the community got together to try to keep it alive. That was done through the Council and now it's got a special category with the Council as a 'community place', and I'm so glad that happened, and that it stopped. Because another favourite pub of mine down the road, the London Unity, was converted into houses,

and when this wasn't converted, I was so pleased! And I come here because I enjoy it.

"The Village is different. It's got more of a sort of a 'non-pub' feel, but I like that. I like it because it's casual. It's nice. So I don't really miss anything from the old Horse and Groom. I don't want to say anything bad about them. And well, they had bands on but we still get music here, and it's just a very nice place to have an afternoon coffee or an evening drink.

"As for Maj, well I have known him off and on, you know, for quite a few years, so I know about Maj and he's done a good job. And I'm not just saying that because he's sitting next to me! It is true"

"So far everything is really, really good. The only thing that I don't like is the Council bins just outside the door, and you know if this is being recorded and listened to by the Council: 'Could you please get rid of those bins?' There you go! They should put them somewhere else, I don't mind where. I mean it's outside a place that serves food so I don't think it's good. In the summer I've been with them and it gets really smelly in the summer, so that's the main thing, get rid of the bins. But the inside of the place, I'm very happy with it.

"My favourite thing on the menu? I mean I love the chocolate cake! And I buy pieces of chocolate cake and take it home for special treats and I'm waiting for the kitchen to open because it hasn't opened yet, but we will see. We will see."

With the ringing endorsement of faithful locals like Phil, it is clear that Maj has proved beyond a doubt that he is more than just a blue man. Not only has the pub been saved from demolition, it has also found a new lease of life as something more than just a pub, a very modern kind of business for a progressive area.

Village Cafe Bar, 129 Islingword Road, Brighton BN2 9SH

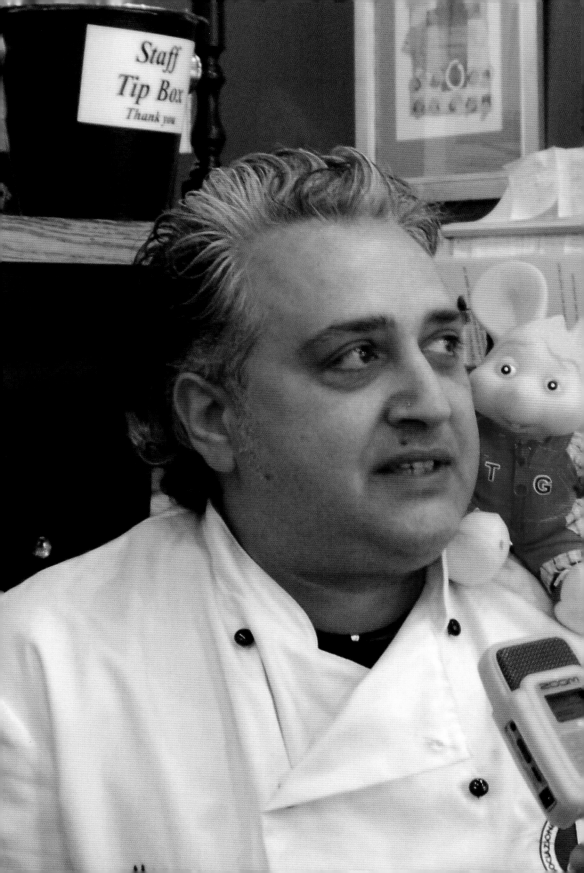

Topogigio

Something about Marco reminded me of Marlon Brando when he played Superman's father, Jor-El, in the big seventies movie. Co-incidentally, I first visited Topogigio with Umit Ozturk, a journalist and community activist from Turkey who looks like a more dashing version of the actor, Ed Asner, who once played Superman's boss at the Daily Bugle newspaper. Umit even brought along a squadron of Lois Lane-lookalike Italian interns who proved invaluable with translating some of the language and with eating some of the pizza, so Superman was something of a theme.

Marco is an award-winning chef. He first achieved success in Italy before moving to England and developing the concept of Topogigio. He was awarded a Diploma from the London-based Associazione Cuochi Italiani for his services to Italian food last year and is currently the organisation's ambassador for the Brighton area.

Marco introduced us to his sister, Masina, who works with him in the kitchen. "The first person who said to me to come to this country is Masina. She come in before me and she said: 'Marco come', she know where I work and what I do. She said, 'If you come in this country you got more opportunity to be more professional'. Because in my country the job is gonna be little bit miserable.

"For example, if I want to have a promotion or a better position, you need to wait. If you are a second chef, example, and you want to be the first chef in the restaurant, you gonna wait and not go take your pension... you have to wait for the chef in front of you to die first!" he laughed. "Because if you go to pension he is still working! Because Italy is like this, you know? In this country, no, it is different. This country is very good place where there is more respect for the people, doesn't matter what you do, where you come from, which colour you are, what you do.

It's important to give respect in this country, they give back to you a hundred per cent. And here they give opportunity to be more professional, they give chance to say if you're qualified for do that, they give you what you are. They don't say: 'No, because you not do that, you cannot do this'. No, they respect you, what you do in for the work."

This idea of having more of a future overseas is a recurring theme among Italian expats, but Marco admits to some nostalgia for home. "We need the breath for life. What I'm missing from my country is oxygen. Our perfume, our taste, our people. Everything. But we cannot survive for on air, there is too many things missing in our country, but we can find them here. What is missing is respect for the people, for life, for people going to school, you know what I mean? There is too many things you do and you don't see the result. Like, you pay a lot of taxes, is one example. You say 'Where go my money? I paid taxes, where is going?' there is nothing that gets fixed properly. In this country is different, everything you do, you see.

"I come from Naples where they invented pizza, mozzarella. There is a saying: 'Vedi Napoli e poi muori'. In English it means 'See Naples and die'. But English people think, 'I don't want to go anymore in Naples, because if I go there and after I need to die I prefer no go!' you know? But it's just a proverb. I suggest to everybody just go for one weekend and see what I want try to say, what you be missing from my city. Matteo who works in the kitchen comes from Roma, where you feel history. When you go Roma maybe food go up and down, not like Napoli," he laughed. "But you can feel history. So, everywhere is worth watching, is fantastic. Masina come here from very nice place, Quarto. Everywhere you go is something to see. Italy is like a museum. Where they come from most of the famous people in the world, like Marco Pollo, Leonardo Da Vinci... you see!"

Marco runs the restaurant with his cousin, Vincenzo, who manages the executive side of the business. Vincenzo started in the trade at sixteen and has always loved catering. He is obsessive about the quality and provenance of ingredients. He tours Italy visiting specific gourmet regions to sample their produce at the point of origin and nearly jumped out of his chair when he realised one of our interview team came from a town that produces a rare mozzarella. He is very proud of his family, including his brother who cooks for the Pope, and his cousin, Marco, who he holds in high esteem despite his frequent teasing. Vincenzo loves Brighton, but his life is spent shuttling between England and Italy to visit his children every month. "I miss being far

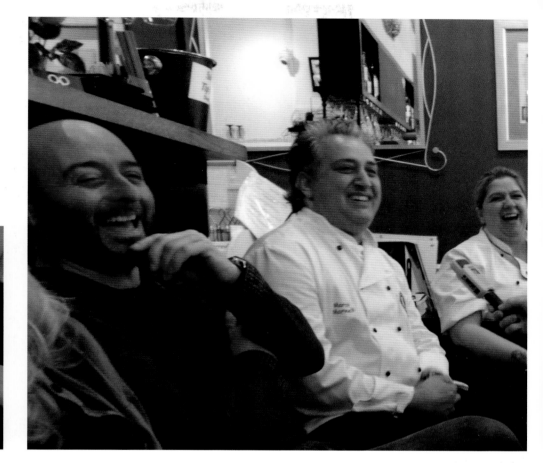

◄ **Masina serves up some
"Three Wow" pizza**

from Italy just for one reason: because part of my heart is there and I think is just this the reason. So, I mean, I got my son and my daughter there, because they live with my ex-wife because I'm separated, I'm single here."

At this point in the interview, my colleague, Umit, grabbed the microphone and shouted, "Dear listeners, he is single!" And, when Vincenzo tried to interrupt, Umit continued, "Dear listeners, I have his number and he is single!"

After the rest of the restaurant had finished laughing, Vincenzo was able to continue. "So this is the bit missing for me, because I don't really miss the people, I don't really miss the tasting because, thank God, I can, you know, eat this kind of things like mozzarella, pizza, whatever. Even here now you can eat nice mozzarella, pizza. Not like how we do, but is many place even here!

"Vabbè, anyway... I don't miss nothing more than that because Italy is not good time now. From the beginning, every time I was here, I was going back. The life here is more easy. So you working, you pay taxes, any problem that you got, you can sort it out. In Italy is not like that, no? So I mean that's the reason why we escaped from there because how we work, how we give the heart, you expect something different. And the last my two year and a half, before I came back here I was in Rome and we used to have the business, you know? And it was so hard to pay the tax and to realize that money, it was like gone and never come back. So I mean that's probably why I decided again to come back and grow again

because every time you go back is like to close the book and you have to open again. Now I'm happy because we're so busy. So it's just why I can't see myself again in Naples or in Rome or in another part in Italy, to start again everything. I don't have family here... so, I got family but I don't got nothing to look after seriously, so I prefer to work more than that so that's why I put all my heart. And that's all."

Unable to resist, Umit grabbed the microphone again to announce, "Dear listeners, he doesn't have a family, he wants to form another family! He is single and we have his number!"

When the laughter subsided, Vincenzo protested his innocence. "It's not like that." He said with a twinkle in his eye. "It was something what I said. But, anyway, if someone call... I never say no."

Vincenzo studied at hotelier school back in Italy and in the summertime he always tried to get practical experience. At that time, Marco was working for a big restaurant and he helped Vincenzo to find work there. He started off at the bottom of the ladder, doing the washing up and then working as a kitchen porter. "It was the best experience because I was running upstairs to wash the big dishes and to look at them and Marco give me the chance to do some decoration, you know? In one month he was like the most powerful influence on my experience. After that I just carried on to work in the kitchen

▶ **Vincenzo runs the restaurant with his cousin, Marco**

and in the floor and move in different parts, you know, to the backroom. And in the beginning I came to England first and then they followed and after that we started working together."

The cousins' working relationship is characterised by mutual respect. Vincenzo insists that Marco is not a stereotypical chef. He never shouts and is always polite and calm. Marco has always recognised the importance of remaining calm in the kitchen. "I think that if the chef is shouting too much," he said, "It's because doesn't got enough… come si dice? Yes: 'self-control'! He's scared because he's not ready yet for that job. But if you got everything in your brain, what you can do, so you got calm because you never take your stress out on the staff. Because if he loses control in the kitchen, he is gone, finished, people doesn't eat anything, because you gonna be mess. Another thing is that Vincenzo works with me because already we were friends before, after we tried to do something together. Maybe you can find partners but it is not easy to find the people you can trust. The trust-people is not easy to find. Because we can find anybody, like you, like her, anybody and say: 'OK, we're gonna work'. But I need to trust people, especially when you go and turn your back, you must to be able to say: 'OK, behind me there is Vinnie, Tommasa or Matteo'. No Brutus behind you!"

It is clear that they all defer to Marco as the visionary behind the business and that he runs a harmonious kitchen, but this is not to say that things are never tricky between any of them. "We really started to work all together four years ago," said Vincenzo, "And he was building the kitchen and we tried all together to plan everything like the seating and how we process the orders, because you know it looks easy but that is a hard job to make sure everything they have to work all together, from the moment the order comes in, you have to be ready on the floor. So, I mean, it was easy for us it doesn't matter because we're cousin, or related, but, you know, I think that basically we're more professional to other people, so I mean we know what we're doing and in that moment it was like easy work, in the moment he came here it was easy. From that moment we work all together but we work with the heart so, I mean, we trust each other. We fight sometimes, because is normal, because you have to fight."

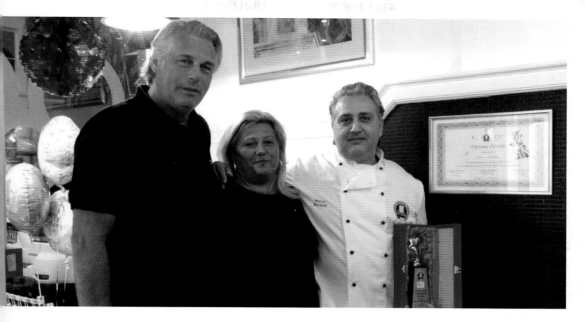

"Argue, not fight," said Marco. "Argue."

"No-no, we fight, is a really fight!" Vincenzo laughed and added, "Maybe because sometimes I'm so rude..."

"The most important thing is… in this job, you need the love," said Marco. "Because it's one of the most stressful jobs, you can't find a worse one, believe me. Because especially when you work with too many people, too many customers. In Italy is different way. For example, people stay in the table for three hours, four hours, six hours… it doesn't matter. You start with a little bit starter, then you got pasta, after you got maybe bread with the sorbetto, something and after maybe fish or meat, and fruit after cake. Look, you gonna be very big, massive! But here the meal is done in a short time. English people like to eat one starter, one main. It doesn't matter it's a fish or pasta, maximum in one hour. Imagine when they come in everybody together, in one hour they all want to eat, so is not easy, it's gonna be stressful. That's why you gonna keep your control,

you gonna be good. If you lost your control you gonna be the worst hour in your life."

"Probably because we do slow food," said Vincenzo. "It's not not fast food. But sometimes they want to do like a party and all the people they have to eat in one hour. It was like a challenge in the beginning because we didn't know each other and I was just working with Marco but I never worked with my cousin, Masina, or with Matteo or whatever. But it was good from the beginning."

Matteo is the only person working at Topogigio who did not appear to be related to everyone else. With his big, strong arms and his black frame spectacles he looks like Superman disguised as Clark Kent. His softly spoken manner similarly belied his ambition and dedication. Perhaps because he is not part of the family, he was not sure about leaving Italy permanently and has returned several times, only to find himself drawn back to the UK again. "The first time I come here in England I was very young. I was twenty-one. Now I'm thirty-two, so time is passing by. I came just looking to see if I could find more teachers in the kitchen and even to learn the English language. In our work, if you want to work in a worldwide way, you have to learn that language, for sure. And I came here for three years, working in London. That opened the doors for many, many jobs all around the world and even in big companies that they require people who can speak international languages. But after eleven years turning around and come back at home and working in Italy, I saw that it was

very difficult to reach the next level. As Marco was speaking about before, you have to wait that the people that is in charge of you, you have to wait that they don't just left the work, they have to die before you can take their place!" he laughs at how absurd it sounds but he explains that it is not said with any malice.

"I came back with my young girlfriend cos was she doing the same work as me. She is a waitress. She want to learn English and we want build our future doing something here, and put all the experiences, the money, and the possibilities that the country can offer to us, to evolve our little family, that's it. And even cos my future will be in my own restaurant and I need the last teachers that can teach me not just how to cook new recipes but I need the philosophy of a real chef. I need to learn how to manage people and a kitchen, not just the food, but how to manage a real kitchen and the people who are working there. So Marco will be my teacher for this, in the next years I hope so if he wants me by his side, and so I want to steal, it's not the proper word, but I want to steal the way he is managing with the people, with organisations, with orders and the quality of food and leading staff. He can just to refine my experience as a chef.

"My idea is to open a restaurant is very risky but I want to do it in Italy because, as they told you before, the people you can really love and be very close to yourself is your family. And my family luckily is full of chefs and pastry chefs and barmen and waitress and stuff like that. We have already the team but we don't have the restaurant, so my mission is to open the restaurant for my family. All my family cooks so all my friends make the queue to come in my house!

"There are two different ways to approach my travel here. Eleven year ago, I was very young and I want to say, sorry for this word, I was stupid! So, you know, not too much ready to take responsibility and lead staff but I was just trying to enjoy my life outside of my house and trying to make my own experience. And the difficult part was the language, first of all, and even the experience, because I was not so sure about myself, the self-control we were talking

before. But what I found here was the positive thing, is the way that if you can do your work properly, here you have the possibility to be recognized for what you are. So, if you are good, people give you more responsibilities, let you grow and they are happy about that, they want to participate about your growing in their establishment, in their kitchen. I think the last part of the road, the evolution of a chef, the last part is that you have to be comfortable with managing staff. And that's what I want to be very focused on. Because I've got already my style, I think that my kitchen will be appreciated. Every chef in the world is proud about the way he cook, the way he have the style of the dishes, and we chefs are always open about new recipe, new style, new staff, because you have to build your style, taking all the things from other teachers such as Marco. For example here, working here, when I finish, I hope in two, three years, what I will show is, the best thing I do here, is learning to make the real good very Italian pizza. Because they made it in a fantastic way and I'm not so good doing it, so I try to learn now this kind of thing. Because I'm not a pizza chef, I will be

after Marco teach me and working for him."

We asked Matteo if it is difficult to make an authentic pizza if he is not a pizza chef? But Matteo laughed, "Ahaha no, we, me and Marco, even Masina, we know how the product is when we make it. So we don't have to try it because if everything is done with love, with heart, with passion, we know that."

"If you follow a proper recipe, you never make mistake," said Marco. "There's a lot of chef just make ingredients like this, today I make good, tomorrow is different, after I do in another different way… No, recipe is this. If you follow you never make mistake, this is important."

Even in this day and age, it is common for people working in Italian restaurants to come across clichés about everyone belonging to the Mafia or always eating pizza and pasta. "I always heard about that," said Matteo, "Every time I go around I heard 'Ah, Italian, ah, pizza'. I know it is a stereotype that is usual for us to hear. But anyone who visits Italy can see that is not just this. About pasta, though: is true! We have pasta

every day and most of our lunch or dinner is based on pasta, OK. That's right. But it's just the same I can say as couscous for North Africa, or potato for German people, or stuff like that for other country, so I don't think is a good thing to say. I always feel bad when I heard this. Because Italy is much more than this."

Ironically it was at this point that the interview was interrupted by the arrival of pizzas to the table. "Mangia, mangia!" called Vincenzo. "Eat, eat!"

Umit joked, "Let's have some non-stereotypical no-mainstream pizza!"

But Marco drowned him out with a cry of: "Fa presto! Si mangia tutta la pizza, vedi! Hurry! You eat the whole pizza, see!"

While the team tucked into the pizzas, Marco's sister Masina told us her story. Masina left Italy sixteen years ago and moved to the UK for the greater opportunities it offered her to improve her quality of life and to give her children the chance of something more than they would have had back home. "Naples is unliveable, even if it is a beautiful city but is true! When I came here I worked in a school, always in the kitchen. Two years ago I worked in a home for elderly people as a cook and then my brother gave me this opportunity. He is my master in the kitchen. When I worked in the nursing home it was a good experience for me because I learned how to cook the old English cuisine. Instead then I came here and my brother, Marco, gave me opportunities to learn more. Although I can cook already, this is different from catering or cooking at home, the speed and more people and everything. This has been my experience.

"I have never lived in any other cities in England apart from Brighton. Although it is not as hot as in Naples, we do still have the sea. And the people here are amazing. I love the Brits, their respect of people. My children grew up here. Even though we are respectful people, in Naples we are not reciprocated as we should be. But I love this city. I love England and I do not go ever!"

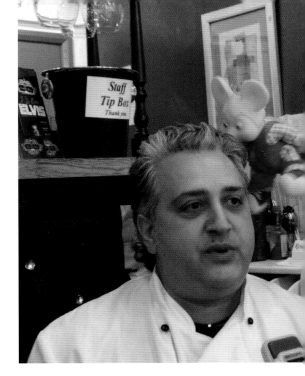

▲ **Masina teases Marco with the restuarant's mascot, Topo Gigio, a famous puppet from Italian television, films and cartoons**

Talking to so many people who have migrated to the UK, it is easy to become blasé about the upheaval it involes. But Marco was keen to point out that it was a big step, especially for his sister. "You have to have enormous courage when you take all your family and say: 'I leave everything and I start from scratch'," said Marco. "And she did so with a child, her husband and everything and started over again. It went well... well, well. I am pleased too!"

Throughout the process of visiting different restaurants and cafes, we have been mindful of gender politics and the differences between men and women in the kitchen, especially with respect to people coming from more traditional cultures. A question arose as to whether, as a woman, Masina had democratic input into running the kitchen and determining the menus but Marco believes that the process is more nuanced than that. "It's not a democracy. I make the menu because is my job, OK? I'm executive chef and I do everything. But I never say that because she's a woman. I respect her like I would do myself. Like somebody else. And doesn't matter if he can be man, or woman, or whatever, OK? If she got a nice idea, she says me: 'Marco, look, I like this dish, what you think?' OK, we prove together, we cook, try. Taste is good? Looks good? We put in the menu. I never say 'No I am the chef, you shut up and go away'. Never. For me, I respect woman like I respect kids, the same as everybody. Doesn't matter if you are ninety years old or you like ten years old. If you respect me, I respect you. Like you give to me what you get you back again. What you give you back again."

Masina agreed, "It's very enjoyable to work for Marco and Matteo. Doesn't matter is man or woman. When you like cook, we cook. I don't care everybody in the round. You cook."

"Especially if, for example, because I'm the chef, OK?" said Marco, "I got a lot of people around me, they working, they wash up the plate and clean kitchen. If I've nothing to do, I take off my jacket and I help them. I wash the plate and pans. I can swab the floor. Doesn't matter. This is team work. Because if I need help, I know if I call, you come straight away to help me. This is very important. If I want

to do like in Italy, "Do that!", say, "Shut up, no speak!" and, "No break! Why you take a break now?'… No, this is no good. If one day you need help, or you need somebody here, you no find nobody. Ok? This is the way. You have to keep all your problems in the back, leave it on the side. Family stress, work stress. I love the chatting, make people happy."

The restaurant is named after the puppet, Topo Gigio who has starred in television and cartoons since the late 1950's and is famous in Italy, America and around the world. The decision to name the business after him was very deliberate. "It's been funny because this is an attractive name for all family, no only just for grownups. Like most other restaurants say: 'No, after six o'clock no kids around'. No. We are open for the family, with the kids, from eleven, when we are open, till we close, doesn't matter. So people come in to here, enjoy, then pick and play with Topo Gigio as well," he laughs, pointing at one of the Topo Gigio dolls in the restaurant, "Vincenzo with the big ear he gonna make the Topo Gigio stuff!"

Marco believes that the Topo Gigio doll is not just fun for the children but that it also helps to awaken the inner child within the grown-ups when they visit. "Yes, yes they do. It's like a funny time, you know? With the kids as well. We don't have one of the usual names like you find, for example, like Leonardo restaurant or Da Vinci restaurant or Otello, Orsino, or Bella Napoli. If you go there and ask them as well 'What do you mean Orsino?' they doesn't know! 'Who is Orsino?' Nobody has known. 'Who is Leonardo?', 'Leonardo… I think that do maybe the helicopter, I don't know'. He doesn't know, people doesn't know, just put the name. But the name Topogigio is funny. I like to put funny name in good restaurant, where people say, 'Ah, it's funny name!' where can find too many things Italian properly and funny like… Already you come inside and you can see Vincenzo's face and say 'Oh, what a funny guy!', you know?"

"Yeah I'm like an attraction for the people…" Vincenzo said. "So…"

"For the woman!" Masina adds.

"I always try my best," laughed Vincenzo. "I always try to be friendly and make everyone

comfortable and I'm really good on this because people, when they come in, sometimes they are happy, not just for the food. What I'm doing usually is to give the plate, not to sell them but to suggest them to eat our food, you know? And they trust me, is good."

"One more very important thing," said Marco, "is when you go in the restaurant, before serve the food, you eat already with your brain. You must be teacher. For example: 'What you suggest me?', 'I suggest you eat this, because the chef buy this in the market this morning and will cook this in this kind of sauce with these products', but the smell coming, you know, already your brain, already you feel taste in your mouth before you eat. After, you gonna enjoy yourself. This is what I try to teach them. Because it's easy to bring the plate, 'Ok this food is for you'... Pa! Put plate in the table! Food must be come in from here, which country, which dishes, which city, ingredients. This is very important.

"First comes presentation and after you gonna eat. You know what you eat, you know what you expect, you know the taste after you try. Maybe most of the people, when have the food, they see in the menu, for example salmon with asparagus, OK? They expect to have something different, they try maybe not like it and say, 'It's not what I expected!' But if you, before sell probably food ensure them what they want to eat, then try to say, 'Look, this is an ingredient combination with fish, we put a little wine, a wine coming from Toscana, a wine like prosecco or this', you know, introducing all ingredients in good way, already you eat, already you feel taste in your mouth before you try the food. I like.

"For me is important for people when they come in, first impression. They sit down and say 'Wow'! First 'wow' because, for the restaurant. Second 'wow' when food before coming and third when they see and they eat. Three time. When customers say to me three time 'wow' is good, is bingo! For the rest, doesn't matter."

Topogigio, 6 Church Road, Hove, BN3 2FL

Marrakech Lounge

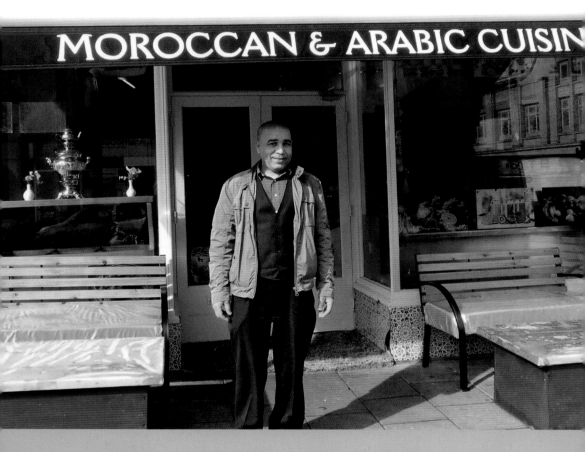

MOROCCAN & ARABIC CUISIN

Shisha Bar and Restaurant

"The world has become very small," Riaz looked at me and explained. "We have become like one country. The bus to Liverpool takes longer than the plane to Tunisia. This world will become like family. We have to accept that. We have to".

Riaz is the waiter at Marrakech Lounge Shisha Bar and Restaurant, just across from Waitrose on the busy corner of Montpellier and Western Road. Marrakech is the first of a mile-long procession of Middle Eastern and North African restaurants and takeaways that stretches from the Taj international grocers all the way down to Hove Town Hall. It is the most diverse part of town and Riaz clearly loves it. "All of us here in England is multiculture. All of us, when we do this job, it's like we're ambassadors, you know, we bring our food down here to England. Sometimes you feel like you are somewhere in Iran or North Africa or you are in India but you are still in England. When you go on the street you find everything around you, from everywhere on this planet and you feel like, OK, I'm in England, but sometimes I feel like I'm the whole of this planet, you know? It's like a big opportunity to all of us. We are here in England and we are so lucky because if you go around you see Mexican, Arabic, North African, Asian, this and that, French, Italian, all around you, which is good. For myself I feel OK, we are in an island, but for me it's like all the world is here in this island. It is a good atmosphere and everybody happy and we knows England is an open country."

Marrakech specialises in North African food. Rather than an exotic rarity, Riaz says that most of his customers are familiar with the cuisine. Interestingly, he attributes this not to the presence of North African immigrants but to the globetrotting habits of the English. "Most English people they knows about North African food. Sometimes you cannot explain to them because maybe they knows better than us! Because they've been around

the world and they're travelling a lot and they knows everything, you know, they knows about Asian food, North African food, Arabic food, you know what I mean? Most of them they knows. And some of them they ask, yes, we have to explain to them what's this, what's that, but most customers that come here they already knows everything. We don't have to explain to them. English people, they go all around the world, they travel a lot, different than other people. They travel a lot and they knows everywhere I think on this planet."

"I have been living here in Brighton fourteen years and it's become home for me. Of course, I love living here. I am here because I love England and I love to work in England. I got my friends here and I got many years here. Is my family here, is my home. I have to be happy. If no, then I have to leave. But I love it to be honest, you know: a lovely city, nice people, friendly people. For that reason I am attracted to live down here. I used to live in London but London is stressful life, you know, very busy city and this and that. Here you got the sea, you got a lovely, lovely city, friendly people and I decide to move down here. Sometimes I play football with my friends. We go enjoy ourselves, go clubbing and go to the pub, it depends. We got a lot of things to do here. Go by the seafront, have a rest. In summertime have a barbecue down the seafront, relax like everyone else. This is life, you know. I lived here for many years now but anywhere I go, I miss Brighton. Anywhere I go, even if I go back to my country, I miss Brighton. I have to come back."

Riaz is adamant that he is not going to move anywhere else. "Sometimes when you pass a few years of your life in a city, you can't move from there, to be honest. When you have all your friends there it becomes like your mum and dad around you. If anything happen to you then you got all your friends around. What Brighton has become for me is like home. I can go anywhere to visit but still I have to come back home to Brighton.

"My country is Tunisia. Everybody knows it is in North Africa, the Mediterranean, you know. A lot of people they knows Tunisia and maybe you know it's a lovely country, with lovely people, open minded and multicultural there. And before, when I grew up there, I feel like the same as I do in England, you know, because everyone there. If you go to the city, it's like England, its multicultural. You find European, African, Arab, you know, from all the world there in Tunisia and they are all more than welcome. Open minded as well, because the people there are open minded."

Marrakech Lounge came about from the owner's desire to promote North African cuisine to the people of Brighton in the hopes that it would prove as popular as Indian food has been over the years. "Marrakech Lounge came from my boss' idea. North African food is like a new idea here and hopefully works and everybody love Arabic food in England. Especially if we see around all like Asian foods are the most popular in England and this North African food we find in France and Italy and Spain, for example they knows about it, but England I can see it's a like a new idea in some places. Hopefully everybody like it and I wish everybody taste and like our food. This is the idea what we had in Brighton. I wish everybody visit us and they are more than welcome at our place."

Maghreb cuisine is a mixture of Mediterranean, Arab and Berber traditions with a range of historical influences from European colonialism and Ottoman expansion. "We got special couscous, couscous lamb, couscous chicken, couscous veg. We got tagine lamb, tagine chicken. We got white beans with lamb meals. We got lot of things which is different North African specialities. We got a shisha garden which is the most customers they are from Middle East you know, from Kuwait, from Qatar, from Saudi and they came for shisha. We don't have a lot of English people or Europeans, coming to smoke, maybe a few of them, but most of the ones who come for shisha are Arab people." The shisha garden is very popular with the clientele at Marrakech, both men and women, but Riaz stresses that it is not part of

Clockwise from top left: Riaz the waiter; Alice and
the Caterpillar; and Hamsa, the Hand of Fatima.

his job. A non-smoker himself, he regards it is as no different from smoking cigarettes and he is not a fan. Nevertheless, the shisha is now a fairly normal sight in Brighton, with several venues available. Also known as the hookah, or even the hubbly bubbly, the shisha is popular throughout the world, from Persia to the Philippines. For many people, it is synonymous with the philosophical caterpillar from Alice in Wonderland.

The shisha garden may not be part of his job, but Riaz is everywhere else in the Marrakech Lounge. "I am serving food. I am the waiter. We got a chef he is the one cooking the food in the kitchen and me I'm serving food. I'm happy. You know, I am patient with everyone. It's my job to be patient, to make people happy and to serve everyone. It's my job to ask everyone what he needs, what he wants, if he don't like that food they can change for him you know because some people they new and maybe they don't like the food, I have to look after them. Always we have to ask our customer before we serve them, we have to ask them what they need, some them they're vegetarians, some them they're vegans, some of them don't like chicken, other ones don't like lamb. We have to ask them before we serve the food. Even sometimes we have to change the food for them because some them allergic to some specific foods, some them allergic to tomato, other allergic to potato, you know. People are all different and we have to make everybody happy, it's our job and my job I have to look after my customer.

"I've done a lot of things in the past. I've done different other jobs. I have been in catering for five years. I enjoy catering. It's a hard job as well at the same time but I enjoy it because you have a lot of contact with people and I am enjoying that kind of thing. Always it is talking with lovely people and it wakes you up. Always when you do your service you feel like you're happy inside you. Which is good. I have done a lot of jobs with indoor work where you don't see anyone and you can't speak to anyone, you know what I mean, and they are different than catering."

Marrakech is named after the French spelling of the Moroccan capital, Marrakesh. And part of the attraction of the restaurant is its ability to transport you to another land. All of the senses combine together to work their magic. "You

▲ **Hamsa, a talismanic amulet that can protect against the Evil Eye. Part of the decor at Marrakech Lounge**

◄ **Debora, Roberta, Riaz, Steve and Rami**

know our food is Arabic and North African and even English people or European people come here they like to hear Arabic music with their food. They feel like they're somewhere else, you know what I mean? When you put on some Arabic music and you serve them Arabic food there's an ambience. They feel like they are somewhere else, like they are in that country. For example, if you serve them, like, Moroccan food or something, they feel like they're in Morocco or in Tunisia or in Iran or somewhere else. And after the music finish, the food finish, that's it. Go back to Western Road. Back to Brighton! Back to reality!"

Marrakech Lounge, Shisha Bar and Restaurant, 128 Western Rd, Brighton BN1 2AD

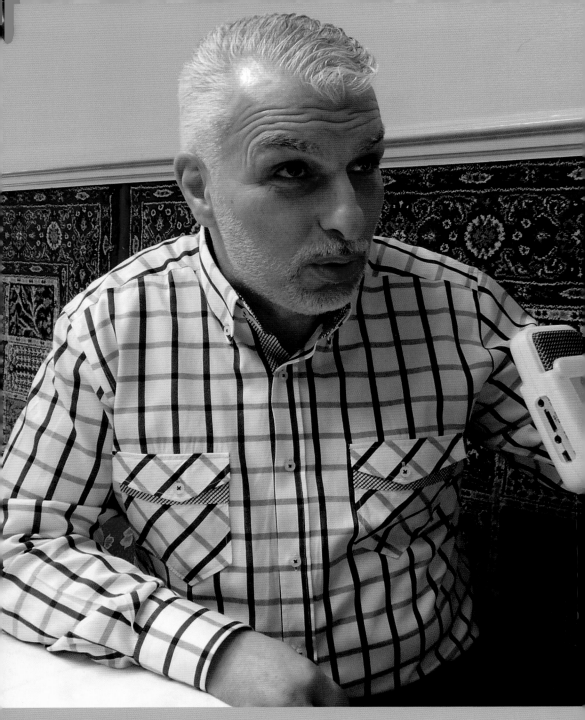

...a

Taste

For some people, the restaurant business is the trade they inherited from their parents. For others it is just a means to establish a new life in a new country. For Sabri, it is a lifelong passion that was inspired by a chance incident on a family outing.

"I remember, I was little and we were in the restaurant, me, my dad, with the family." Sabri explained "And we ordered something and the waiter went and brought the food and it was something wrong with the order. And I remember that the waiter was offended for us to criticise his food. And we said, 'Well hold on a minute, we know what we ordered and this is not what we ordered'. And then I suddenly saw it from a different angle: how he's proud of his food and presentation. You know, now, these days, the customer is always right, but in those days he knew that there is no way that anything was wrong with the order. Our chef here at Sahara, even when we joke now and we say something is wrong about the food, he gets offended. He is so proud! So from that moment, when I was a little boy in Tunisia, I thought, 'This guy loves his job and he takes it with pride. I'd love to have a job to be proud of!' We don't expect in these days that anyone will get up and think, 'Oh gosh, I'm going to work, I love this!' Everybody goes to work to earn a living, but if you work and you enjoy your work, then I think it's a huge progress and it's from that moment I started to learn about the catering industry and working with the catering, until that grew with me. Since I was in Tunisia I learned about catering and it really trigged me. I loved to see people and their passion. Now, this is where I come from basically. I'm a Mediterranean and I worked with the food industry all my life, since I was in Tunisia and when I came in England, twenty six years, it is my field."

of **S**ahara

Sabri took over the Sahara restaurant on the Brighton stretch of the Western Road in 2009 and rebranded it as A Taste of Sahara. "First of all we thought 'OK we started work, what we can now call this restaurant?' We called it A Taste of Sahara. Why A Taste of Sahara and not Sahara, or Sahara Limited or anything else? Because we wanted this restaurant to be for everyone. For the Arabs, for the Muslims, for the non-Muslims. Wherever a desert is, there is a taste of it. So it hasn't an identity. It's not a Lebanese restaurant, it's not a Moroccan restaurant, it is not an Iranian restaurant. Is a taste of every country. We got the Tunisian couscous. Tunisia got a desert, so taste of that desert. Morocco got desert, so got the Moroccan tagine, Iran got desert, so got the kofta of Iran. The Saudi Arabia, the Middle East and the Emirate got desert so got the kabsa. So from every country we got a dish and that's why we called it A Taste of Sahara, to have a taste of the Arab world."

This philosophy extends to the décor, starting with the exterior paintwork, which is designed to match the colour of the sand in the Saharan desert. This is complemented with Moorish arches in the transom windows and geometric patterned mosaics of Zellige tiling along the stallriser. Sabri declined to take any credit for the ambience, though. "No, no, no. I'd be selfish by saying that! It was a collective decision from my wife who actually took charge of the decor. I disagree with her all the time, but she is always right. When it comes to decor, it was her speciality. She is an interior designer and when she was choosing the chandelier I said, 'Oh no, too expensive. Get cheaper ones!' and she persuaded me and when they're up, actually, they look nice! I always see it as a business and I want the cheap option and it's, you know, when is done, she's done that right."

Before the restaurant opened, Sabri invited a group of people, including a number of imams, to sit down and work their way through the menu. Any dishes that did not meet with their approval were removed and the dishes were refined until they were perfect. He also spent time finding the right team. In order to create a menu that could span so many different regions and cuisines, he needed more than one chef. "I have three chefs here and they are proper chefs, not sous-chefs. I have Ali, he is originally Palestinian, he does speciality of the Lebanese food. I also have Said, he is Iraqi Kurdish and he knows all the food of that area. And I have Mohammad who is Egyptian. I'll tell you something: when I went to Saudi Arabia, I was staying in a four-star hotel, the food is absolutely stunning and so I went to the manager and said, 'Can I see the chef?' and when I met him he was Egyptian. And another hotel, I wanted to meet the chef. I just wanted to have some background. Most of the chefs are from Egypt and Saudi Arabia and the food they do there is absolutely amazing. So I'm lucky to have three chefs like that. We have one standard and they all work together to produce the same tagine, the same falafel, the same couscous. It doesn't matter who is cooking, it is the same for everyone. I'm lucky to have someone like the people I have today because they've been with me since Day One, when we opened the restaurant. They have been very loyal to me and I have been very loyal to them. I think the major problem of some businesses is when the chef leaves. If the chef leaves, the restaurant loses balance and this is a serious problem. Thank God my chefs still remain with me."

The modern food-industry is international, and the menu at Sahara reflects that. Sabri spends a lot of time visiting trade exhibitions and expos in places like the Birmingham NEC or the London ExCel centre and he says that the industry is very diverse. "I visit them to learn new things and to network. And it is very mixed. Funnily enough, most of our suppliers are Turkish! All the olives, the halloumi cheese, the vine leaves is from Turkey. So most of our suppliers they are Mediterranean suppliers but it's a big mix. If you think of Tunisian food you think of couscous, if you think of Moroccan food you think tagine, if you think about Lebanese, Lebanese got the falafel, the houmous, vine leaves the tabbouleh. If you think of the Middle East, you think kabsa. When a Saudi sits down, before the order, we tell him, 'Kabsa?' he say, 'Yes!' You know, people they stick to the dish they know. For me it is the couscous. The Tunisian couscous, with all respect, is the best of the North Africa. Libya does couscous, Algeria do couscous and

Morocco do couscous, but when it come to the couscous, the best is the Tunisian couscous. The French, when they come, I know exactly what they can order: couscous royale. You have couscous royale with lamb, chicken and merguez sausages, with potatoes, carrots... beautiful! Lot of spices and herbs. We have, for example, the Moroccan couscous. The Moroccan couscous is white, not red with sauce. It's not bad but not as good as Tunisian. Morocco is very known for tagine, is really nice! Tagine lamb, tagine chicken, beautiful with potatoes, carrots and you serve in the clay tagine and when you open the dish you see all these things coming out and the taste is very nice. So the Tunisian is couscous, the Moroccan is tagine... every country known for something.

"We have four desserts but one of them is for everyone and that is the baklava. You name any Arabic or Muslim country, they have it! In a different way, everybody loves the baklava. English people love the baklava, Iranian, Tunisian, American... you know, everyone see baklava, they order. Even they aren't hungry, they order one baklava to share it between them, to have that taste of the honey and the pastry and the almond. So baklava is for everyone. There are a lot of Tunisian desserts and we have to be careful, as I mentioned at the beginning of the interview, that this restaurant have not got an identity, it's not a Tunisian restaurant. So I don't want to label it or offer too much, you know, Tunisian desserts. We do bouza which is really nice... we do so many different things! But I didn't want to have one identity and people think, 'Oh, you're Tunisian so this restaurant is Tunisian.' We chose the baklava which goes to everyone. We do a lemon meringue which is goes to everyone as well, if you have fish or if you need some lemon taste. And we have an Arabic dessert that is fig and plum tart. We have fig in our country and in all the Arab world. And we have ice-cream. Unfortunately it is not Arabic but everybody like ice-cream and everybody ask for ice-cream so we have honey-pot with ice-cream, is very nice. Which country? It travels around! When it comes to the dessert we not really have an identity of a country except for baklava which is everyone."

Like most of the male chefs and restaurateurs, Sabri learnt the art of cooking from the women in his life. To begin with, it was his first wife. "I used to

cook at home, she was my teacher! I got few things wrong? I got a lot of things wrong! And I kept going until we got the dish right. And then when I got my dish right, I'll hand it in to her and she would teach another dish and then another dish. And I used to phone my mum, you know in those days it cost very expensive, and I would say: 'Mum have you cooked this? How much sauce?' And here I'm in England to get that flavoured food. And I'll tell you something else that's very, very important: it's the spices. I'll get them from home. I'll go, get fresh spices; I'll pick them up and get them to the person who grinds them and bring them with me back. That taste… there is absolutely no comparison. And that does make the difference of the flavour of the food.

"When I came in 1988, it was my girlfriend she was living near Brighton, in Lewes. I didn't have a choice. Then I came and I liked Brighton and that's why I stayed. I did go to London to work, I did go to Birmingham, to Leicester, to Coventry, I did travel and I choose to stay in Brighton, because I feel like at home. Where I come from, the sea surrounds us on three sides, and here I have the Brighton seaside. I'm like a fish. I need to be near the sea. I come from Bizerte, right on the top of the North Africa. And the sea surrounds us from three sides. I need to go swimming every day. People here go to play football whatever, we wake up we go on the beach. We come back, catch crabs, go fishing, that's part of our

childhood so Brighton was perfect for me! He is near the sea, near the countryside, and that's why I stayed in Brighton. I try to stay for example in London, but I hate it. I couldn't stand it, it was too loud, too busy, I went in Leicester, and I didn't like it. Two hours from the sea! I need to breathe, I need fresh air, and that's how I come back and stay in Brighton. Brighton is beautiful, really good. Multicultural society, very friendly people, open-minded, that's why I would not choose another city.

"When I first came here I was working in the Gatwick airport in the food industry and I learned a lot of things. One of them is that customer service is as important as the food. Sometimes you could have a lovely restaurant, a lovely food, but if your attitude with customers is not good, people don't come to you. So, I learned about the customer service and I stayed for a very long time, at least five years in the Gatwick airport. All my friend start with me, they worked and they left after two to three years, open their own business, and I'm thinking to myself, 'Damn, look, what's matter with me? I need to make the move. I didn't have the courage, what's matter with me?' But you know what? After five years well, I made my move, thank God, from that time until now, successful. All my friend who left before me, they all collapsed. I'm thinking the reason of that is the longer you stay, the more experience you had. So you gained the experience, when you are ready to

come out to the real world and have your own business… you are ready, you successful. All my friend, they thought they knew it, when they left, open they own restaurants, and didn't succeed, they down. What I'm saying is, obviously, now, when I open Sahara, we done a loads of networks, a lot of advertising, a lots of friends spread the world. We done a launch and they invite people and gradually has grown. Now we are one of the top restaurant in Brighton. There are over one thousand thirty seven restaurants in Brighton and Hove and we are one of the top ten restaurants. Tripadvisor will do the job for you. We have 99.99% people will write a good review about you because the service is as important as the food. The presentation as important as the quality of the food.

"Now I have loads of regulars. Every weekend I have the honour that I can say: 'That's a regular, that regular, that regular.' I have at least three or four tables every single weekend they are regulars. As soon as we can see them, we know their names, they know our names, we kiss and hug. It is not shaking hands, it has become that kind of relationship where we kiss them and hug them. Christmas? No doubt, all the time. Here we are in March and we have Christmas bookings already. In the twelfths of December we're fully booked. We have the council, they booked with us every year. We have the police, they booked with us every year. We have the hospital, they booked with us every year. We have two schools, they booked with us every year. So this is just off the top of my head, but these people, they are big bookings, at least twenty people in each booking.

"Funnily enough, our plumber was with us as a customer and that's how we get know him. You know, he's a customer, and then we start making deals: listen, if we have a problem, you come do this, and then you got the 50% off food and we give you discount. The electrician is a customer, that's how we met him. All the people. The electrician is a customer, the plumber is a customer, the carpenter, he's a customer. Done all the woodwork that you see. So all these people we built a relationship to become a friend as well. And all the most of work you see here is through customer; we get you know each other and then they love the food, they love the restaurant and they come and we build a relationship."

Sahara has a strong reputation for the warm hospitality of its staff and the stylish presentation of its food. Most reviews describe the restaurant in terms of authenticity and exoticism, finishing with a promise of return trips. But of course, like every single successful restaurant with a lot of reviews online, it is always possible to find one or two negative reviews. In this age of, "Web 2.0" where the internet is dominated by user-generated content, it is just part of operating in the public eye. Most restaurateurs either ignore them or just don't address them, but it is clear that they bother Sabri. "Sometimes what happens when you read a review on TripAdvisor, five stars, five stars, five stars, you prepare yourself so much, and you go eat and your expectation is higher than usual and this is a normal procedure. It's like when you someone tell you about the film, 'It's excellent go and see it.' Everybody talks about the film and you build the picture in your mind so high. But when you see the film, you think actually, 'It's not what I expected.' We had one or two challenges and it doesn't bother me but when it hurts sometimes, you know, someone writes a bad review and it does hurt because you have ninety-nine good reviews, but one bad review it upsets you. So thank God we don't got many of those for the last however many years we've been here, over nearly a thousand reviews we have already. We have less than, you know, ten bad reviews. So I would say we are doing something right. When people do complain it's not about the food, it's not the presentation and it's not the service. It's something else. Like one time, we were fully booked and we did say to the customers 'We are fully booked, we have a private room downstairs. Are you ok with stairs?' and they said yes. But they brought soft drinks with them, and we said 'Listen, we don't allow soft drinks. Bring your own alcohol but we do sell soft drinks.' I think that upset them. They focused on something like that but your review should be based on the quality of service, of the food, or value for money or presentation. Something, sometimes, you know, someone would say, 'I wanted chips with my tagine', and, 'Can I have tagine served double with chips?' You could buy chips separately but it doesn't come with it. This is, with all respect, not McDonalds. This is how it is served. You ruin the reputation of the dish. You could have something on the side but it is a shame that someone takes a different angle and they give you two stars because they couldn't have chips in their tagine."

Knowing the English predilection for chips, it is perhaps something that every restaurant has to endure, no matter how bizarre the request. But fortunately such cross-cultural misunderstandings are rare, even though most of the customers at Sahara are English. "I love my culture, I love my tradition," said Sabri. "That's why I'm carrying my culture, my tradition with me in the restaurant, the look, the food and so on. And English people love that and that's why 95% of our customers are English people, because they love the food and they love the look. They look to us when they go on holiday. Our economy in Tunisia is based in tourism. They come for the sea, the food, the dress, that they love the way we are. Every country is different in their own way, in the way of food, of culture and tradition. Everybody loves their own culture, that's all what I have to say, you know. I'm sure you can say, 'Mine is better', when the other says, 'Oh mine is better', but we're all different and in our own way.

"When I first came here in England, I saw pizza but it was Hawaiian pizza with pineapple. I never heard about that before. You know when you try to get something original and then you add to it and change it sometimes you break it, you ruin it. I'll tell you an example, if I go now to Waitrose and I see a plastic container with Moroccan couscous or Tunisian something... I mean, the Tunisians don't eat that, with all respect, rubbish food, you know? When you see it displayed in plastic thing and they add feta cheese to eat on... is not Tunisian, is not Moroccan. I know that they changed a lot of things and unfortunately they destroy them. It's not how it is originally. If you see a Tunisian or a Moroccan or Turkish or Italian, the best Italian pizza is by Italians. If I go start selling pizza tomorrow, it could be ok but it won't be as good as Italian person make it that pizza because he knows the ingredients, he knows the taste better than me. So, that's when we try to change things unfortunately we damage them. When you see some people who hijack your identity and your food, what do you think? It hurts you, you think it's not very nice.

"I was in France and I have to do my homework to read the person where he is from, and when I find out he is from where he said he is from, I went to his restaurant. But if you find, you know, someone, with all respect, like a Japanese chef cooking Moroccan Tajine in an Arabic restaurant? Then it's gonna be challenging, with all respect, it's gonna be not right. And I'm sure if I open a Chinese restaurant then people won't come to eat there. They'll say to me 'You don't look Chinese, so I'm sure you're not gonna do a very good job'.

"There are a lot of traditional Tunisian recipes, and I wish I could sell them in the restaurant but I have to see it as a business. Just because I like that food or that recipe does not mean that everyone else is going to like it. We have a huge lot of different old recipes and we love them, but to bring it to an open restaurant for a general public, they'll say, 'Mmm, what is it? I'm not too sure, I'll order what I know.' So it's best to stick to what you know is going to satisfy the general public, otherwise you won't sell. There are a lot of things I love but unfortunately we can't sell them because people don't know them, and even if you introduce them, they might be not as big. So you are best to introduce something that's gonna sell for everyone. If I say baklava, everyone likes baklava, if I say couscous, everybody heard about couscous, say tajine, everybody hear about tajine, you say pizza, everybody hear about, you know, this is the thing, you have to target the bigger market.

"The English customers ask about my culture all the time, though. They ask, 'Where are you from?' And they always ask you, 'What is your nationality?' They always ask you, 'What's your favourite plate?' OK most people say to you: 'Listen I don't know, you order for us' and you do that for them, and I know what they will like. I can see people come in and I know who wants what. The men, we get them mix grill because men like meat and for the ladies we order the Moroccan lamb tajine. It's got the sauce and potatoes and they share it all between them.

"My favourite food we do here? I love the lamb chops, I mean I like all the food to be honest. The advantage I have cos I am the boss, I have a little bit of this dish, a little bit of this dish, a little bit of this dish, so I have bit of lamb chops sometimes, bit of couscous and a bit of tagine all

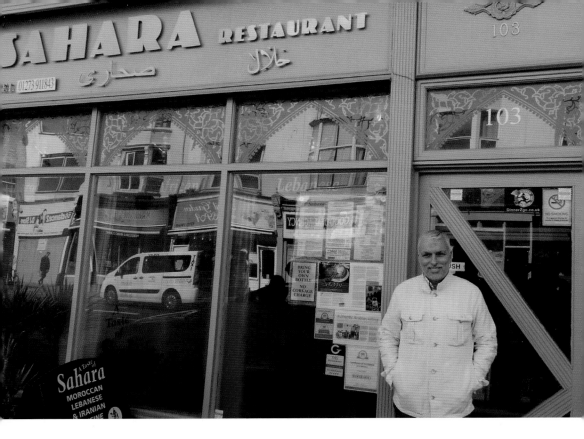

together. So three small dishes in one plate. But the lamb chops, they are my favourite. We use the best lamb chops you can buy in Brighton. When we buy the meat fresh at the butcher, I'll tell him we will pay more money for our lamb chops and just the middle bit, the most expensive bit. The way they cut, we don't have the end bits because they are not really nice. And then they are absolutely delicious and not a single one has complaints about the lamb chops, everybody have lamb chops they love them. The fish it comes every day fresh and they bring them. I can tell you a story, something that happens two days ago, it's funny but it's interesting. We forgot to order the fish, so the guy said to me, 'Listen you pass by, you need to come and pick them up from the harbour', so I went and I pick them up with two fingers basically because fish smells, and I put them in the car and I come here and my fingers smells fish, but I'm thinking you know normally fish stink and it doesn't smell very nice, but you know what, this is smell nice! And what's nice is the freshness of the fish, and I even went up to the lady that works

here and said, 'Smell my finger!' Is stink, yeah?' It's the freshness, because is fresh it smell nice. So the fish here is beautiful as well, because is all cooked in charcoal, and it is beautiful."

Unlike many restaurateurs, Sabri says that he does manage to balance his work life with his family life these days. Comparing this with other places we have visited, this is partly something that comes with age and partly something that comes with the wisdom of a second marriage and a second chance to get things right. "I consider myself very, very lucky. Before, I worked very hard. I worked seven days a week. I remember in the time of my first child, my wife said to me, 'We don't need the money- we need you', cos I used to work hard. Now, I'm fifty-one and I'm taking it slightly easier. I have the time to enjoy myself. The time I'm here, basically, working extremely hard is Thursday, Friday, Saturday and Sunday half-day. Monday Tuesday and Wednesday I just come to check, make sure that everything's OK, and just go away. So I do have the time to see my family otherwise I won't enjoy what I'm doing.

"I don't go to the kitchen at home. I wouldn't dare go in the kitchen! You know, the lady's always in charge in there, at home. They say 'housewife', they don't say 'househusband' so the house is for the lady. She does all the cooking and don't you dare criticize the food, if it's salty or not salty, just eat it! But she's a good cook so I love it. I mean she cooked the couscous better than me, better than we have in Sahara, because when you cook for six or seven or eight people, not like you cook for twenty, thirty, forty people… she spend the whole day cooking one dish. When you run a restaurant, you spend the whole day cooking twenty dishes. No, at home they are in charge… unfortunately!

"My favourite dish at home is the couscous. I love the couscous. Every Sunday I tell her to cook couscous and I really enjoy it but after eating the couscous I lay down because you are so full, that you can't do anything after that. The couscous is heavy but that's my favourite dish. In Sahara is lamb chops and at home is the couscous.

"I think every father wants his children to follow in his footsteps, every father. But I never put pressure. I said to my son: 'Listen, you go to university. I've got people from university working with me, I've got people finished university working for me', I said to him, 'Please'. You know it's part of me tells him, 'Go to university', but a part of me says to him, 'Stay with me, we have a reputation, we have a name, we have a good business. Learn! And take over and develop our idea.' He's working with me now, part time, but you can't say, 'Oh we can't have this, we change this', the change has to come from inside, never from the outside. And every father I think wants his children to follow his footsteps unless the father's job is very hard. But I'd love my kids to follow in my footsteps cos you enjoy it, you meet lovely people all the time, people come to eat out and they come for a good time, so it's nice and they come dressed up and you know to dress nice, you smell nice, you meet lovely people every day, different people, different cultures, different colours. It's challenging, but just imagine if you work in an office, in front of a computer, every day you do that… I can't do that, I can't do that. This is the beauty about it.

"All the time I phone my mum and she said to me 'Close the restaurant for a month and come and stay for a month'. I'd love to do that but, unfortunately, when you got a business you care about the business. You can't do that and that's painful. I want to go and enjoy myself. When I go, I love the sun. When I go in summer, I go only for not even a week. I don't get a tan, I get burns because I don't have time to get a tan, so you need to get burns very quickly and come back. So that's the situation unfortunately.

"There's a lot a food I miss so much and that I can't cook and then you think of your childhood or when I go home, I think it's part of our culture, first of all they ask you, 'You tell us, you are here for five days, what do you want us to cook for you?' I say, 'This, this, this and this,' because you miss so many lovely food that reminds you of your childhood. You miss the family. When you are here you miss your friends, who you went to school with. What they become? But unfortunately life moves on, some of those are in France, some of those in Tunisia, some of those passed away, and some got married but you still always ask, and think, 'I wish I could see So-and-so, I haven't seen him for years, I don't know what happen to him, I heard he is married, he has got children, where's he? I'd love to see him just to see how he looks like.' These things, you know, you always play back in your mind. And you miss a lot of things because they are back in the memory. And as we are foreigners, this is not real home for us, we came here to survive, you know, to develop, and we got married, we have children but we still think home is back there with the people you went to school with, the street you played in, the places you went to, the restaurant, the streets…. that's home, that's the memory you miss all the time in your mind. It doesn't matter how old we grow that's real home and that's real memory we miss."

A Taste of Sahara, 103 Western Rd, Brighton BN1 2AA

**Cakes at the
Shish Kitchen,
formerly the
Waves Cafe**

Victoria
Sponge
£2·90

Shish Kitchen

The Shish Kitchen is run by Esmeray and Ali, a husband-and-wife team from Turkey. Their story is similar to Enza and Eugenio from Buon Appetito, but they faced a whole different kind of adversity before they got to realise their dream of opening a restaurant. It was a struggle that could easily have broken them.

Their key to their resilience lies in the kitchens of their childhood and the generosity of spirit that these experiences engendered. "When I was child, you know, my mum she taught me how to cook," Esmeray told us. "When she started, she said to me: 'Take this', for example aubergine, 'Just peel it and cut it like this and give it to me,' then she's cooking. And she trusted me!" Esmeray laughed as she explained, "And I started when I was a young child and my mum taught me and still I am learning how to

cook and I'm still searching, even now." She admits that she still calls her mother and asks for recipes, "Still, asking still, still, you know, yes. For example: keftedes. It is difficult for me, but I am still trying to do keftedes."

"My job is harder than her because I am eating too much!" joked Ali, the other half of the business. "She is making all these delicious dishes and they are so very nice that sometimes I had weight problem and some years I weighed nearly is ninety kilos, ninety three kilos. Now is okay. I had some heart problem, but now is okay. She is looking after me is very good."

Esmeray added: "He started, you know, eating healthy food, you know, salad, maybe more salad, more vegetables. We are from Mediterranean and we are eating actually healthy food but we love pastry things as well."

"I like pastry," said Ali. "Borek is very nice, if she does not touch them, I am eating two or three borek. Easy."

"We have different type of borek," Esmeray explained. "We are using different pastry. Some of them, they are made from only water and flour, some of them we are making from butter, oil, flour and water. And different fillings. Cheese and spinach and minced beef as well, we do one with the feta. You can do, you know, different ones with potatoes as well."

Ali and Esmeray have both worked in catering before. "I came here in 2001 and I started to work in the café," said Esmeray, "And he used to work in the off-licence and restaurants, the pizza shop as well, takeaway, kebab shop. I used to work in the café with my business partner and we did outside catering for the special occasions, parties, and events."

After that, they took on the Terrace café in George Street, Hove. "We sold it to different persons. Now after us they changed it five or six times, name and menus, and now they changed it again. Now they make it, I think is coffee again and pizza shop, I don't know. Then we opened this place here on Kings Road as the Waves café but I will change it next month

▶ **Esmeray dishes out the homemade borek wrapped in filo pastry**

into a restaurant. It will be called the Shish Kitchen and it will be a Turkish barbecue ocakbasi restaurant. And we will make mezes. Maybe fifteen, twenty different mezes: meat, different meat, fish. And then if we can get a full alcohol license we will be able to serve wine. And we make to vegetarians food, vegan and vegetarian. Vegetarian is, I think is two or three different vegetarian dishes, make to falafel, houmous and some vegetarian kebab."

At the time of the interview, it was still the Waves café but now at the time of writing it is the Shish Kitchen. It is a beautiful, open space with lovely wooden floorboards. The front of the restaurant is a large window giving on to a street just by the upper seaside promenade in between Brighton Pier and the remains of the West Pier. The atmosphere of the restaurant is enriched by the wide selection of fine art, sculpture and paintings adorning every wall. Before they took over the place as a café, it had been an art gallery. The couple retained many of the paintings from that space and added some more pieces,

especially the quirky sculptures and object d'art. "We tried to buy everything, there are not brand here, they're all from the different second hands, you know antique shops, and it was before us, it was the art gallery. Then we tried to keep the arts a little bit."

The future is looking bright for the couple now, but Esmeray explained things have not always been easy. "When I came here, you know, I didn't have family here. I got relations in London, but they are not here. It was difficult for me to make a friends, to meet the people. There is no people around to make a friends, and I had a two years old child when I arrived. When she started school then I tried to find a job and I find a job in the café. Then I started to work and I met a friends and I was trying to get to earn money and it was the language was the problem for me, still, I didn't go to school because I got a child so there was nobody around me to look after her, you know? It was difficult for me but at the moment we sort out everything. I got two kids, one of seventeen, the other is ten years old, she will be eleven soon."

Ali says he did his best to support Esmeray during this time, but things were very unsettled. The family fled to the UK from Turkey

**"My job is
harder than
her because
I am eating
too much!"**

because they had so many problems there. They
applied for refugee status and went through an
uncertain period as asylum seekers living in
Glasgow. So obviously they were very relieved
when the Home Office told them that they
had made a decision on their application and
they would be allowed to stay in the UK
indefinitely. They were moved to Brighton
and they started to build a new life for
themselves but then suddenly out of nowhere
the Home Office told them there had been
a bureaucratic mistake. They were informed
that they no longer had the right to stay in the
country. The bottom fell out of their world.

The sanctuary that they had sought in the UK had been cruelly snatched away from them with no explanation. And then it got worse.

The family were locked up in an immigration detention centre. These are intimidating facilities run by private security companies and are similar to prisons. Except with immigration detention you have not been accused of doing anything wrong and you don't know how long you are going to have to stay.

Ali picked up the story. "First we are refugees. We stayed six or seven months in Glasgow. After Glasgow they gave us indefinite visa, they moved us to Brighton but then, after four years, the government said they made some wrong mistake and we have not any visa! It was a shock. After two years they take us to a camp, a detention centre. Nearly two or three years after that they give us the indefinite visa. We went, I think, five or six times to court and the Home Office lost. After this, our life is came back. Now we are okay but before we had a lot of problems. Now is okay but everything is finish. We wanted to make business again; we started two or three months ago here last year we get the solicitor and everything is finished, two, three months ago we opened and again they had some problems. Now everything is okay. We had a lots of problems before. Psychologically, they's going to very bad. Now everything is going to, we hope, is going to good."

Now that things are more settled, Esmeray says that their children are able to make the best of growing up in a new country and having two cultures. "My older daughter she is seventeen years old, she wants to be a musician. She is playing guitar and she is going to do access to music college and my youngest daughter she wants to be a fashion designer at the moment. She is going to start secondary school next September. And yesterday they accepted our offer to secondary school, she is going to be at Cardinal Newman, so she is happy now. You know in this country it's difficult for us to bring up children, because there is two cultures, two different cultures and sometimes they are struggle, sometimes we are struggle as well, but everything at the

"If she is making it, I like it!"

moment good. I am proud of them because they are speaking two different languages and they are reading and they are writing very well, you know at the moment they feel special as well because in England most of people couldn't speak a second language because English is an international language, they don't need to speak another language and at the moment they feel, before they were shy, you know, if we speak Turkish next to their friends, they say, 'Don't speak Turkish, don't speak', they feel different but at the moment they feel special as well. All the time, situation is changing and their ideas is changing."

Before the Shish Kitchen, Esmeray spoke to us about the menu at the Waves cafe and how it reflected this heritage and navigation of cultures, with a mixture of Mediterrean and international food. "In here we are doing homemade food. We do two type of lasagne, one with vegetable, vegetarian; the other is with beef, beef lasagne. The English people, they like to eat pasta and all the people, they love lasagnes, pasta, pastry things. I just want to cook here, you know, I got lots of recipes but I just want to make a lasagne here, for example chilli con carne, they are my favourite. Yes, I love it. And we make Turkish pizza: lahmacun. But it has to be in a big oven, it has to be in a real

wood fire. Our customers they sit here and are always asking me how to make a borek, how to make the cakes... they are asking me a lot. And I do soup as well: homemade soup. For example, I made it leek and potato soup, my favourite!"

"I like eating kebab," Ali added, laughing. "I like Turkish shop where they make real charcoal grill, they tastes very nice and I like borek, a lot of pastry stuff. If she is making it, I like it! And for mezes, I like the mezes. When we going to London, we going to eat kebab and mezes. Is very nice."

When he is chided for not eating more salad, Ali counters, "Salad is come with kebab! Every time is come with salad. Yesterday, I was in London, I ate the kebab and salad. We not have the salad ordered but because it is Turkish restaurants they bring direct the salad. Before the other dishes, before the kebab, they bring first the salad, and two or three different mezes. In Brighton area, lots of kebab shop they use the gas grill. But in London they use charcoal, real charcoal. Real charcoal is give the taste, is not same as the gas. Is gas give the little bit smell, but you not taste the smell cos they put the sauce on the kebab. In Turkey some place they make it better than here, but is not in all Turkey. For example in Adana and Gaziantep they make the real kebab. If you eat in Istanbul, if you going to five star restaurant, they make the nice kebab, but its price is going to triple, double, very expensive. But in London they use nice meat and nice sauce and they have the good chef. My cousin is a chef in London. When we reopen as the Shish Kitchen, he will come to cook here and we will make the same kebab as London. Maybe is better than London. We try".

"He does very well," said Esmeray. "He is very good chef."

Ali is clearly very proud of his cousin, "He is make the last fifteen years in here as a kebab chef. He is learnt first make the washing up, start, and they learnt slow, slow, slowly and now is working to one very big restaurant in London and he is next month, he is stop from them, and he is will come here and he make the very nice mezes, kebab, and we

make the fish, two type of fish and vegetarian kebab and some different vegetarian mezes."

Esmeray confess that they do miss the atmosphere of family gatherings back home in Turkey, but they cannot think of moving back due to the political problems and the fact that their children are so established here. "They don't want to go back to Turkey. I think they couldn't adapt to Turkey because it's different for them. Their education is here, they got friends, families, like here for them, here is like their own home. They love to live in Brighton. They don't like London as well. Two years ago we were planning to move to London as we got a cousins and other family there, but they don't wanna go. They just prefer to live Brighton. They love Brighton. They find more entertainment in Brighton, they find fun in here. They don't want to be anywhere else. If they are happy, where they are happy, you have to be there. If they are not happy there is no point to move, there is nothing, you know."

When we visited, the restaurant had only been open a few months but they were already starting to attract regulars. "I used to work in a place in Uckfield for two, three years, I got customers we've been like a family, you know, I know them, they know me, I know their kids. Sometimes we are keeping touch, we are texting each other and emailing. They are sending a Christmas card, sometimes, for the kids or Easter."

Ali is also used to making friends with his customers. They always responded to his positivity and charm, even during the tough times. "Yes, good friends," he said, "I was worked in Peacehaven in a fish and chips take away. Every Christmas they give the cards, and when they came to the shop they ask and we talked to each other and is good friend. They said to me, 'Every time you're always smile and you're every time happy'. Sometimes I had a lot of stress but it's good with customer, every time."

Shish Kitchen, 8-9 Kings Road, Brighton, BN1 1NE

"If we speak Turkish next to their friends, they say 'don't speak Turkish, don't speak!'"

Part Two: Social History

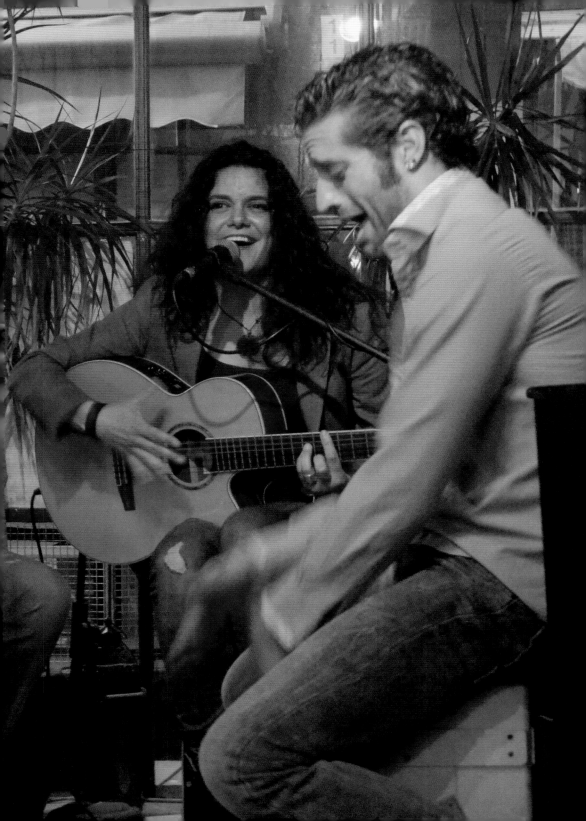

Chapter One
Kitchens & Theatres

In the late 1940s, a Canadian anthropology graduate named Erving Goffman left his student digs in Chicago and travelled across the Atlantic Ocean to the Shetland Islands. He was just twenty seven. He spent the next two years living on Unst, a small island settlement of just a few hundred people and a thousand sheep. Only nine miles long and four miles wide, Unst is incredibly remote. It is the northernmost of the inhabited British Isles and halfway to the coast of Norway. Unst was even used as the model for Robert Louis Stevenson's Treasure Island. It must have seemed a long way from the big city skyline Goffman was used to. Whilst on Unst, he spent most of his time walking and reading, trying his best to socialise with the baffled locals who had no idea what he was doing there. At times he felt the same way. He cut a strange figure, this stocky son of Ukrainian Jewish immigrants, talking in his North American accent and romping over the island in his big knee-high leather hiking boots.

At first Goffman stayed in the island's only hotel, but later on he moved to a single-storey cottage that he rented from a local crofter in the village of Baltasound. Goffman continued to return to the hotel for his meals while he lived there and he liked to help in the kitchen, doing the washing up and eavesdropping on all the gossip. At some point Goffman abandoned the ethnography he was supposed to be writing, just as he had abandoned his home in Canada nearly a decade before, and the chemistry degree he was supposed to have been studying there. We don't know exactly what happened next, but at some point, sitting alone with his books in his tiny cottage on a tiny island and nobody to talk to about any of it, Goffman decided to try something different, something completely new.

He left Unst a year later with a dissertation in his suitcase that would make him one of the most important and influential social theorists of the twentieth century. In his later career, Goffman would go on to influence fields as diverse as game theory and linguistics and he would help pave the way for postmodernism. But his initial target on Unst was more humble. While he lived there, Goffman had become fascinated by the everyday ways the locals interacted with each other, the different ways they presented themselves in different situations and the ways in which all these interactions seemed to be built around practices that helped them to avoid social embarrassment. If he was still back in Chicago, his tutors would have told him to find a new hobby. Face-to-face interactions were seen as trivial to academics at the time. They were important men who were busy debating "grand theories" such as class and capitalism. But left to his own devices on Unst, without any supervision, Goffman was free to indulge himself.

Unst was perfect for the study because it was complex enough to offer a range of different types of interaction between people but at the same time small enough to gather background information about all of the participants. He could observe the ritual of a wedding or a funeral and know everyone there, their personal histories and what they were bringing to the occasion. The island's remoteness worked in his favour. One biographer wrote that Goffman turned Unst into his own "natural laboratory".

The more that Goffman studied personal interactions between the locals on Unst, the more they reminded him of a kind of performance, or theatre. They were like scenes being acted out for different audiences. He decided to call his concept "dramaturgical analysis" and started studying people's relationships as if they were actually a sort of living drama. He explained: "All the world is not, of course, a stage, but the crucial ways in which it isn't are not easy to specify."

A good example is the world of the restaurant in Goffman's hotel: if we think of a theatre with a stage and a backstage area, we can think of the dining room as the front and the kitchen as the backstage. The front is where the "play" is put on for the audience of customers and where the performers feel like they are onstage, while in the back the performers could be more true to themselves, relaxing and gossiping offstage, or letting off steam about the customers. This idea has been immensely useful to our understanding of the social history of Brighton's Mediterranean and Middle Eastern restaurants, and the way that they present themselves to the local public.

Goffman left Unst and married his fiancée, Angelica, the next year. He spent time in Paris writing up his notes into a book that would set out his new ideas. Their only son, Thomas, was born shortly before the book was published. It had a huge impact, winning the prestigious American Sociological Association's MacIver award and landing him a Professorship at Berkeley. Goffman was young for the role and his students saw him as a cool outsider, going undercover in his research like a hip private eye. Goffman's next major focus was on the ways in which psychiatric hospitals institutionalise their patients. He was unhappy with the treatment he observed during his research and formed a campaign to oppose the use of sectioning, where people are forcibly committed to hospital against their will. His 1961 book, Asylums, was one of the first sociological studies of psychiatry. But within three years of its publication, his wife Angelica killed herself after a battle against her own mental-health problems.

Goffman resigned from Berkeley and left the West Coast. He moved to the other side of America and subsequently planned to take the Benjamin Franklin Chair in Sociology and Anthropology at the University of Pennsylvania. But he was not wanted by the faculty and they housed him in a periphery of the Anthropological Museum. He died shortly after, in the same year he was elected president of the American Sociological Association, the same institution who had once given him his first major award, but he was too ill to ever take up the post. Goffman's ideas have

continued to shape the social sciences since his death. Now it is widely accepted that paying attention to the most mundane and intimate aspects of ordinary lives can help us to understand the "grand theories" of the twenty-first century.

In this book we are looking at that most everyday subject, food, and in particular the Mediterranean, Middle Eastern and North African (MENA) takeaways and restaurants of Brighton, as a way of understanding the politics of global flows; the creation of the nation-state; the politics of identity; diversity; class; gender; and nationalism. Brighton is the site of a historic hospitality culture, in which restaurants, along with shops, hotels and pubs have long been central to structuring social life and are a barometer of the city's economy and demographics. Food and drink has always been important to the city. In the past this meant the catching of mackerel and herring for the fishing industry and, later, it meant the drinking of seawater at the health resorts. But over the years these have evolved into an industry of consumption, more interested in fish and chips than fishing and more interested in the drinking of lager than seawater. Brighton's modern urban culture has food at its heart.

Eve Jochnowitz is a Jewish New Yorker who studied dance and performance and went on to work as a baker. She now writes about food culture and says that we can think of restaurants as "great theatres" of culinary performance, as opposed to the "little theatres" of the kitchen at home. They are places where a community performs the values that it cherishes the most, for example displaying attention to cleanliness and hygiene or displaying religious identity through publically honouring halal food. These values are communicated through all of the senses, so that the moment you walk into a restaurant and see the décor and hear the music, you are in what Eve Jochnowitz has called a site of "designed experience." A vital part of the dining situation involves the creation of atmosphere through sound, decoration and contextualisation of place. As the chef of Topogiggio, Marco, put it: "One more very important thing is when you go in the restaurant, before serve the food, you eat already with your brain."

A lot of this performance exists unconsciously in the little rituals of the day-to-day business activities. An Italian chef's routine of flipping dough and spinning pizzas into the oven is a ritual of craft, whereas the shouted orders and production line of a McDonalds is a ritual celebrating Fordist automation. In the restaurants and takeaways we visited, these performances are aimed at three different audiences.

The first is an "inside" audience. Restaurants are important places of contact and conversation for migrants living in new communities. They are essential social spaces in which newcomers seek each other out. The sign advertising the halal food in an Egyptian Muslim restaurant, for example, is at first a direct communication with other Egyptian Muslims. When we have spoken to foreign-born restauranteurs about the customers from their own communities, they tell us that they are coming to their restaurants for, "a taste of home."

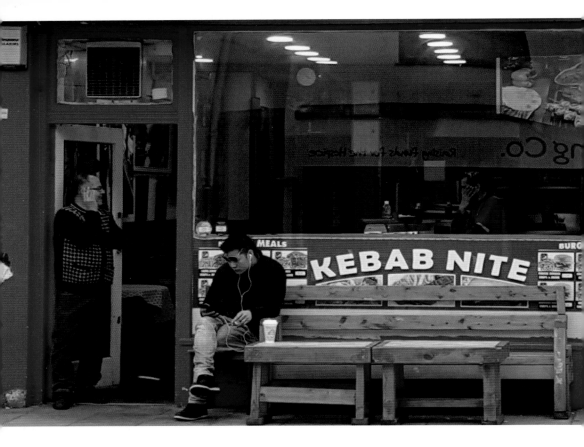

The second is an "outside" audience. An Egyptian restaurant in an English town is by definition a hybrid space. Multicultural restaurants in the diaspora are engaged with recalibrating authenticity and playing with tradition for an audience of natives from the host community who are outsiders to that culture. When we talk to restauranteurs about their local clientele, they describe the motivation of the native customers as a kind of tourism. As Riaz from Marrakech Lounge explained: "English people or European people come here […] they feel like somewhere else, like they are in that country." Like other restaurants, many of their English customers have visited their country in the past and eating in the restaurant is a way of fluently returning for a taste of their holiday.

We might describe the third as an audience that is neither "inside" nor "outside" but is, in some way, "alongside". An example of this is where members of very different Arab communities come to eat together in a place that cannot be presented in any one specific nationality but instead dissolves certain divisions (those of nationality) while rebuilding others (those of religion and language). The culture of disparate ethnic groups becomes simplified or homogenised. It is said that they have become a community in spite of each other.

For the benefit of consumers from all three audiences, the ethnic identities are turned into commodities that you can purchase and, literally, consume. And this consumption is global. Restaurants are global. The practice of eating out is spreading to new societies and some chains have branches in nearly every country on the planet. Restaurants are a big part of this process through things like their role in the global food supply industry but also more significantly in the migration and circulation of workers. To put it another way, in the words of Jochnowitz's editors, foreign restaurants have become deterritorialised sites of ethnicity, spaces for intercultural contact where the foreign is made familiar and the global is miniaturised. They are a central node in the diaspora that creates images and sensory products of that culture both for consumption and for the creation of modern identity politics. A good way of illustrating this is in the idea of the, "taste of home".

The key emotion of the "taste of home" is nostalgia. The word nostalgia comes from the Greek "nostos", meaning return home, and "algos", which means pain. The immigrant seeks out the restaurant that serves the kind of food he or she remembers from their country of origin because they are homesick. But the consumption of nostalgia does not just involve a sense of travelling through space, it also involves a kind of travel through time (in this way, the restaurant becomes a TARDIS, although not all of them are bigger on the inside). Through the lens of nostalgia, many takeaways have become emblematic of the past according to the Hawaiian-based academic, Christine Yano. Their decor draws visually on "traditional" or pre-industrial peasant memorabilia such as oil-lamps or agricultural equipment and the music they play leans towards folk music from their country, rather than the more ubiquitous pop that you are likely to hear if you actually visit that country. They hark back to history and tradition because things that are older seem to carry more weight: because they are old it makes them more genuine, more real. All of the sensory data in the designed space refers not just to an idealised homeland but also often to an idealised past. A Mediterranean takeaway in an English high street is a gap in the normal order of things that produces both an alternative to mainstream English society and also its intensification through marketing a nostalgic sense of home. Some of the ethnic-food businesses do not exist in these exact forms in their own country. Christine Yano writes about okazya, Japanese delis in America that are nothing like any delis in Japan. So the way these business are put together overseas builds a set of transnational images that engender what different people mean by concepts like "Mediterranean" and about who they are now and who they might be in the future. The Libyan emigré who visits the Libyan café is there for the whole package. The act of consuming the culture through food helps them to construct their understanding of their own new identity in the new country. Restaurants provide consumption-experiences that are as much about identity, of places and people, as they are about the serving and consuming of food.

Some anthropologists, like hip-hop researcher, Derek Pardue, for example, argue that within our multicultural world we are practising the consumption of experience

without any durable substance; that we buy scenes, just as we purchase cuisine; and that "exoticness" and "familiarity" are just purchased scenes. But this demeans the impact of the processes at play and is oblivious to the social changes they are part of. This process of nostalgic gastronomy does not simply create a singular hybrid identity in the new country, but actually changes things back home, too. The images and institutions built by migrants in the diaspora are also nodes in the transnational circulation of culture and communication between the homeland and the UK. Studying the way this happens can allow us not just to make an ethnography of the people who work in food-businesses abroad but also to make an ethnography of transnationality itself. In the new interconnected world of mass migration and globalisation, this is as important a topic now and for the future as colonialism is to now and the past. People on the move converge on these spaces as a way to preserve their culture in the flux of modern dislocation. Culture is seen in these contexts as a "thing" that has to be "done", or performed; something that has to be retained and ritually shared or it will be lost. Culture becomes a mediation of history. This is about performing memory to stave off the decay of what the French call dépaysement. When we are dealing with refugees and asylum seekers in particular, they are an audience who cannot return to the homeland and so every taste of it is a taste of the past and every taste is an act of recreating that decaying memory.

It is worth noting that for many of the people who visit the restaurants and takeaways, their nostalgia is not a simple romantic longing for the past but is an ambivalent emotion that also has room for the contradictory relief at having left that past behind. This is especially true for political refugees and dissidents who have been persecuted by the state in their country of origin. The Asian-American writer, Purnima Mankekar, argues that the nostalgic desire of migrants arises from the gap between resemblance and identity. Nostalgia is enamoured of distance, not of the referent itself.

During the project that led to this book, I took part in a series of conversations and interviews with the owners, managers, staff and customers of local restaurants, cafes and takeaways. I was not intending for it to turn into a journey of discovery but that was what it became. One of the main revelations for me was that the central performance of the restaurant is the family drama. This happened most powerfully when I went from interviewing the husband and wife team behind the self-proclaimed family restaurant, Buon Appetito, to interviewing the Kurdish lads who run Mac Doner, a kebab shop on St James Street. None of them are related to each other as far as I know, but I was struck by how much they have created a viable alternative family-in-exile. As they told me, they found themselves alone in a new country without their mothers to cook for them anymore and so they started cooking for each other and then, over time, cooking for the whole community. In this way, the kebab shop becomes a transnational public house, or a kind of postmodern mead hall.

In some languages, the word for family literally means "those who gather around the kitchen area". Food defines family. It is a tie that binds us to each other in a web of dependencies, domestic power and mutual reciprocation. It is the material basis of our familial rituals, our feasts and holidays, our birthdays and funerals. All of the players within the restaurant are like a family of actors staging a play about the idea of home for an audience of diners.

Eugenio Saulle is the owner of the Italian restaurant, Buon Appetito. He sees it as a family restaurant in the sense that people can bring their families there and also in the sense that it is a family-run business. He told me: "My wife is involved, my brother, my brother in law. So we are a big family. Everybody cooking in the kitchen. [...] And all the staff around like to work with me because they feel like their own home. Some them call me Papa." In this way, Buon Appetito is a "great theatre" where the staff perform a

kind of play in which their characters are all related. But just because it is a kind of play does not mean that it is fake or that it is insincere. The father-figure that Eugenio embodies provides both a real source of income to the staff, just as the father does in the traditional household, but he also provides a very real paternal resource to the staff. As he says "most of the staff that work with me, they come from a foreign country, not from England, and they need someone to say, 'Come on, I'm beside you, don't worry', you know, every day you need a sweet word to them. You need respect and passion. Buon Appetito is a family restaurant for the customers and for the staff."

Nowadays, Michael Hernandez runs a social media company in Kansas, but when he was still at university in Illinois he worked as a cook's assistant in Carmen's China House, a Chinese-American restaurant presided over by the matriarchal figure of Carmen Feng. Writing about his experiences at Carmen's China House years later, Michael said that becoming a cook is like becoming a member of a family. "Food is used to create the shared substance that forms the basis of kinship," he wrote. Food is one of a number of possible components (including biology, genes, time and labour) through which people express their sense of interrelatedness. Through learning Carmen's food practices and sharing food in her restaurant, Michael became part of her business-family.

Carmen was a refugee from China, via Taiwan, whose mother and husband both rejected life in Illinois and returned to Taiwan, leaving her behind to raise her three children alone in the restaurant. Carmen had to rely so heavily upon her friends that she modified her concept of family-in-exile to include them as well. She told Michael, "Without my new family, we would not have made it." Michael noted that China House's family structure is constructed and reinforced through Carmen herself. She occupies the role of a matriarch, or mother, rather than an owner/manager, just like Eugenio at Buon Appetito. The people who work for Carmen become her children rather than employees. She rarely uses the term "employee" and referred to them

instead to them as her "kids". Her treatment of her biological sons and her employees is the same, and her expectation of behaviour and loyalty does not change. Interestingly "restaurant" is another word used by none of them. Carmen always refers to the business as "China House", her home and family. This is consistent with the people we have interviewed for this book, all of whom referred to their businesses by their title.

Given the reputation of professional kitchens as shouty, demanding environments, it might seem strange to think of them as theatres where people are performing family values. But in fact the presence of such notorious discipline in the restaurant is the very thing that singles it out as a family structure, as opposed to other workplaces with less noisy hierarchies. When Carmen catches Michael smoking, she gives him hell, just as she did when she found cigarette-butts under the mattress of her son, Ping. She explained that discipline is a severe but necessary means to keep the family together. Rather than driving people apart emotionally as it would in a neutral environment, within the restaurant, as with the family, it actually reinforces loyalty, health and obligation. One of the only other comparable organisations is the army, a structure that relies heavily on hierarchical parental power and deep emotional identification with the organisation. Discipline in these contexts is a process that addresses loyalty and family role adjustment. A healthy level of discipline is not always seen as a negative force; rather, it is performed as a reaffirming action that brings one back into the play of the family system.

When you have a restaurant like the Italian restaurant Topogiggio, in Hove, where most of the workers are family members, the food carries with it the flavour of the family. This flavour is also present throughout the business. For example, Topogiggio's chef, Marco, told us: "Maybe you can find [business] partners but is not easy to find the people you can trust. The trust-people is not easy to find. Because we can find anybody, like you, like her, anybody and say, 'OK, we're gonna work'. I need to trust

people, especially when you go, you know, turn your back, must to be said, 'OK, behind me there is Vinnie, Tommasa or Matteo'. No Brutus behind you!" The workers become your family because you can trust your family, unlike Brutus, who Julius Caeser was unwise to turn his back towards. And this sharing of responsibilities is also flexible at Topogiggio. As Marco says, "I got a lot of people around me, they working, they wash up the plate and clean kitchen. If I've nothing to do, I take off my jacket I help them. I wash the plate and pans. I can swab the floor. Doesn't matter. This is team work. Because if I need help, I know if I call, you come straight away to help me. This is very important." If one needs help, the other fills in, often without being asked. This kind of adaptable kitchen requires mental, emotional and physical co-ordination that is best or most naturally achieved within the family, or within an organisational unit that can comport itself as a family such as the traditional Japanese "ie" or household, that was a model of a corporate household rather than a biological unit. In day to day functioning it included non-kin elements of a household, including outside workers.

Another good example is the concept of the regular punter. When I spoke to Jowanro, one of the chefs at Mac Doner, he told me, "I have a lot of regulars. Eighty percent of my customers are regular. I know straight away fifty, sixty customers when they come in I know how they want. They ask for burger, pizza, shawarma. I know how they want. I see them coming, I put it straight on for them. They say, 'Oh, you already put it on!' I always have time for them." What these regulars gain by their loyalty to the business is the special treatment of an intimate, a family member, or at least a good friend-of-the-family. Jowanro gets their order ready when he sees them

coming, putting it straight on so that by the time they get to the counter, the food is already on the go. This is not the performance of factory-style mechanisation that you find in the more business-minded fast-food chains: this is the performance of the home, of the family. And it only exists at the human level because it is based on a manifest knowledge of the regular punter, garnered through long-term interaction.

But perhaps the most telling example is the story of the brothers, Farshad and Farshid. They came to the UK as young teenagers to escape the dangers of the Iranian revolution but they found themselves following in their father's footsteps and opening a restaurant. They ran it together: the two brothers against the world. Everybody looked down on them and expected their venture to collapse in a matter of months, but Piccolo Restaurant was a local institution for twenty eight years. That is, until the older brother, Farshid, decided to leave the business. Now his younger brother, Farshad, cannot conceive of continuing without him. "Twenty eight years; I'm done. […] Especially as my brother is not here with me anymore, it's too much on my own." Without the family, there is no restaurant. When I last walked past it, Piccolo's was closed, the interior gutted and a sign outside announcing closure for redecoration (presumably by the new owners). It was a moving sight.

If we go back to Erving Goffman on Unst, he first thought of the stage as a metaphor for social interactions when he was hanging out in the kitchen of the island's hotel.

He saw that the workers were like actors: getting dressed up in their costumes (in this case the various hotel uniforms of chef or waiter); performing their scripts (in this case the dialogue prescripted by their roles); and then removing their "masks" when they are backstage in the kitchen again, invisible to the audience and behaving in completely different ways to when they are onstage in the restaurant. Onstage, they have to be more "proper" and presentable. But backstage, they can take off their costumes and drop their front. They don't have to speak their lines anymore and can step out of character to discuss the behaviour of the audience, or customers, without disrupting the performance. Just like actors, they put on a costume and act differently when in front of the audience. It is all about presenting themselves in a certain way to manage the right impression people would form of them, and by extension of the organisation as a whole. We all do this constantly in our social interactions and try to present ourselves to others in the right way, but the restaurant is a more concentrated environment. The backstage is completely separate and no member of the audience is allowed to appear in the kitchen. This is why it was so surprising when we interviewed Theo at the Greek restaurant, Archipelagos, and he told us that in his home town the customers would go straight to the kitchen to check up on the chef instead of relying on the assurances of a Food Hygiene Rating from the local authority. In normal circumstances, the customer is never allowed backstage. Many places that have a kitchen in the restaurant for people to watch the food being made, like Piccolo's, actually have another kitchen somewhere else to prepare certain types of food, so their pizza-kitchen is in itself another prop of the theatre, part of the spectacle. We must be attentive as well to the fact that when

the performers are backstage they are engaged in another performance: that of the loyal team member, and that there is an entire Mandelbrot set of stages within our lives. We almost always have lines to deliver, it is just the size of the audience that changes. Just like the faded Silent-Age Hollywood starlet, Norma Desmond, announces in 1950's Sunset Boulevard: "I am big! It's the pictures that got small."

When the people we interviewed spoke of "customer service", this is what they meant. The concept is less like a set script of lines to be spoken in order but more a set of theatrical instructions and restrictions for an improvised play. Jowanro at Mac Doner told us, "If you work in a fast-food kebab place you always at night get drunk people. You have to be patient and handle it, not argue with people. My old boss said how you gonna work there, how you gonna do? It's more hard seeing people everyday, but it's my place, I have to be nice to people. It's customer service." Even when the customers at the kebab shop are drunk and argumentative, the worker has to remain polite and continue to act in a certain way. They can act differently when they are downstairs in the stock room and can complain to each other about how rude the customer is. They can certainly act differently if they encounter such behaviour outside of work. The patience that Jowanro spoke of is as much about not breaking character as it is about keeping one's temper.

Another crucial aspect of the performance is "tone". Most of the places we visited are positioned as casual dining venues. They offer a mid-range kind of sit-down fun rather than the more proletarian stand-up production-line of the fast-food joint or the more bourgeois sit-down formality of fancy fine dining. Tone, then, is largely about class. And this is communicated in two ways. The first is materially: via the condition of the exterior paintwork and the interior décor; and via the dishes and drinks selected for the menu and the quality of the plates and glasses they are served with. The second is dramaturgically: via the uniforms the staff are given and the level of formality to their script, or customer service. If the sign outside is falling down and the menu is a photocopy with peeling laminate then it would be incongruous to find expensive dishes proffered by stiff-shirted waiters. Likewise, a swanky bistro would be less convincing if it was staffed by cheerful geezers in day-glo polo shirts. The menu is the programme. Any kind of food that is typically not eaten at home but outside the home when travelling or at school or work, especially something robust that can be held in the hand like a sandwich, kebab, or slice of pizza, is comparable to a packed lunch and representative therefore of ordinary "home-cooking". This immediately determines that the frame will tend towards blue-collar food.

With so many of our restaurants branding themselves after specific countries, it is impossible to avoid considering the performance of nationalism. We often talk of food in terms of nationality (e.g. "Going for an Indian") and restaurants of specific national cuisines always cluster together, eventually becoming neighbourhood institutions like Chinatown in London, Little Italy in New York, Kadinlar Pazari in

Istanbul, or the Balti Triangle in Birmingham. This is starting to happen in Brighton and Hove as well. Of course there is the well-known restaurant district of Brighton's Preston Street, and a spattering of rough-and-ready kebab shops around the clubbing zone near the seafront but there are also two discrete clusters of Italian restaurants: one in Hove near the Town Hall and one in Brighton near the Lanes. This could be dismissed as a fairly universal feature of a tourist town, but less dismissible is the growing cluster of North African and Middle Eastern (MENA) restaurants along Western Road. Between the Taj Mahal International Supermarket in Brighton and the Town Hall in Hove, there are dozens of kebab shops, cafes and restaurants strung like a row of pearls through the middle of the Brunswick electoral ward. It seems notable especially as Brighton does not have a significant Black and Minority Ethnic (BME) population. It is certainly lower than the national average, although slightly higher than the South East generally. Nor is Brunswick predominantly a BME area. Anecdotally, it is said to have a higher density of MENA residents than other parts of central Brighton but in no way is this population statistically notable. Many of the BME customers are part of Brighton's transient student population of university undergraduates and language-school pupils but most of the private student accommodation is around the Lewes Road area. Brunswick is characterised by tall, thin Regency houses chopped up into little flats. It is listed in the top ten percent of wards in the indices of multiple deprivation but is hardly a hellhole. A two bedroom flat in Brunswick Square can set you back £500K. There's a Waitrose and a Patisserie Valerie. It's a very mixed area socio-economically, and there is no clear accounting for it. There is the Al Madina Mosque near the Brighton end of the strip, admittedly, but there are two other mosques in Brighton and neither have such a noticeable impact on surrounding businesses. Whatever the reason, in the near future no doubt this area will be given a suitable name. Falafeltown, perhaps?

Through their normal business activities of selling a particular lifestyle, MENA restaurants cannot help but be accidental purveyors of national stereotypes. Some are recent inventions (such as the newly emerging stereotype from the American media about Iranians being flashy and materialistic) and some are playing to existing assumptions (such as the idea of the French being sophisticated). Of course, none of these stereotypes can be accepted as factually correct for the entire population of a given country. From putting the name of a country in the title of the business (such as Shandiz Persian Cusine or Rotana Moroccan and Lebanese Restaurant) to using the colours of a certain national flag in their décor (such as the green, white and red of most Italian venues), restaurants design their sets around representations of ideas about specific nationalities. In this way, they are part of what the Midlands-based social-psychologist Michael Billig calls "banal nationalism". They are not vehicles of a blatant nationalist ideology like the ceremonial hoisting of a flag or a military parade. Instead they are part of a subliminal barrage of everyday national signals that includes the Queens' head on our coins, or the idea of a national football team, or the way we talk about British weather as "the" weather. All of these subliminal propaganda

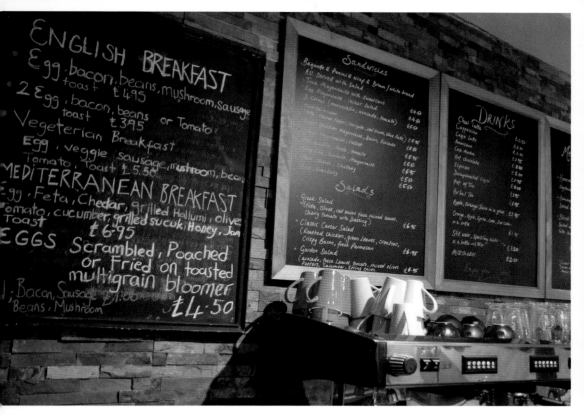

messages reinforce the nationalist idea that the nation is a timeless institution that has always existed, when of course it has not, and the idea that all of the people within the nation are somehow related to each other, or at least more related to each other than they are to the people in other nations, and that we are all somehow on the same team, when of course we are riven with class differences and regional rivalries. The idea that a middle-class Guardian reader in Islington somehow has more in common with a Liverpudlian dock-working Sun reader than with a Parisian liberal simply by dint of them both sharing a mythical brotherhood of "Englishness" is debatable. From a critical perspective, nationalism is a ploy used by the ruling elite to manipulate a population, up to and including the point of sacrificing its own children for wars fought only in the economic interest of that elite. As Albert Einstein once said: "Nationalism is an infantile disease. It is the measles of mankind."

The restaurants we visited can only fairly be considered as accidental performers of banal nationalism but it is still important to understand the processes at work and what that tells us about the constraints of integration on migration. When the manager of a Turkish restaurant engages in an onstage performance of Turkishness, they are simultaneously constructing an idea about Britishness as an opposite set of codes and the two are defined against each other. By contrast, much of this breaks down when the players are offstage and all of our interviewees reported

how delighted they were by the cosmopolitanism of Brighton and how ready everyone was to dissolve those artificial barriers between people. There were two restaurants in particular that displayed what we might consider as performances of multicultural plurality and the different ways that they did so are quite revealing.

The first is Kambi's. Despite branding itself "Kambi's Lebanese Restaurant", it transpires to be much more complicated than that. The original chef was Lebanese but the founder, Sadeq is from the minority Arab community of Iran. Another partner, Haval, is a dental technician from Kurdistan. The current head-chef, Lui, is a bench-jeweller from the Christian minority in Syria. The waitress we interviewed, Anna, was a pharmacist from Poland, and Kambi's has a stated policy of hiring people from different cultures, not just from Lebanon or even just from Arabic-speaking countries. The statue of the grinning genie in the front window and the shawarma on the spit in the takeaway both call to mind Turkish influences. The focus of the menu is on authentic Lebanese-style dishes, but the wide selection of vegetarian and vegan items is characteristically Brighton-friendly. The restaurant is the number-one destination for the hungry congregation of the nearby Al Madina Mosque after prayers every Friday afternoon and the food is strictly halal, but many of the staff are non-Muslim or even Atheist. The fact is that Kambi's is a very modern multicultural institution. That there is still a performative element to this does not mean that it is not genuinely multicultural, or that it is simply

"putting it on", but that it is deliberately coded and communicated on the stage of the Great Theatre and is something that the workers there are happily trying to get across to the customers.

The second example of multicultural plurality is A Taste of Sahara. One of the few restaurants not to have a national theme, Sahara does not even brand itself "Mediterranean" or "Middle Eastern". As the owner, Sabri, told us: "We wanted this restaurant to be for everyone. For the Arabs, for the Muslims, for the non-Muslims. Wherever a desert is, there is a taste of it. So it hasn't an identity. It's not a Lebanese restaurant, it's not a Moroccan restaurant, it is not an Iranian restaurant. Is a taste of every country." As he is from Tunisia originally, we asked Sabri if he included any Tunisian puddings on the menu but he replied: "There are a lot of Tunisian desserts and we have to be careful, as I mentioned at the beginning of the interview, that this restaurant have not got an identity, it's not a Tunisian restaurant. So I don't want to label it or offer too much, you know, Tunisian desserts […]I didn't want to have one identity and people think, 'Oh, you're Tunisian so this restaurant is Tunisian' […] Which country? It travels around! When it comes to the dessert we not really have an identity of a country except for baklava which is everyone."

As Sabri states clearly, this is a question of identity. He does not want to identify the restaurant as "Tunisian" and even goes so far as to suggest that "It hasn't an identity." We might gently suggest that the identity being presented through the construction of the brand could be seen as one of multiculturalism, or at least of Trans-Saharan fusion. For a thousand years after the Arab invasions of North Africa in the eighth century until the apex of European colonialism, the camel caravans of the Sahara were one of the great commercial highways of the world, stretching from the Atlantic ocean, through ancient Marrakech and Tunis, through to Cairo and the Levant. Trans-Saharan trade brought gold from Ghana to the Mediterranean and slaves from Sub-Saharan Africa to the Arab slave markets of North Africa. It is an identity that is as simultaneously distinct and yet fuzzy as that of the Silk Road, which is itself bound up with images as diverse as Imperial China and ancient Persia.

Fusion cuisine is about the deliberate combination

of different culinary traditions. It has been at the forefront of innovation within nouvelle cuisines and originated in the combination of French and Asian cooking. The American style of Tex-Mex is a popular, if less-imaginative example. In this way, the anti-national non-identity fusion Sahara is still an identity, just one that is not beholden to obvious identity politics. This is possibly motivated more by commercial goals than humanist conviction or anarchist theory, but it does serve to present Sahara on a continuum of broadly left-leaning cultural unity. The notion of the "world citizen" can be traced back to Diogenes the Cynic, the fourth century BC philosopher who lived in a tub in the marketplace of Athens. In a Greek world built on the proto-National concept of city-states, Diogenes was subversive enough to announce: "I am a citizen of the world!" This notion was later taken up and popularised by the radical English-American activist, Thomas Paine, who had the public-relations advantage of not sleeping in a barrel.

A manifestation of the cultural relativism of the "world citizen" can be found in modern-day fusion-cuisine, and the creation of new hybrid products. In part, this also happens by accident. The immigrant tries to recreate a familiar recipe in a foreign environment but does not have easy access to the original ingredients, cooking equipment or expertise (as so many of our chef respondents talked of not being able to easily call their mothers for the recipe), and so accidentally creates something new that is neither wholly foreign nor wholly native. At the same time, a similar process is at work in the other direction where the adventurous eater is trying out a new cuisine as part of their culinary tourism and is trying to find something familiar in the unfamiliar. They seek out and popularise the most accessible dishes on the strange new menu, especially favouring the ones that have some recognisable ingredients or connection with more established foods.

The resultant hybrid does not fall slap-bang in the middle between the two cultures, however, and is subject to movement and negotiation. Take, for example, Essam who runs the Almas Lebanese and Middle Eastern Restaurant and Bar in Hove. The idea of "Lebanese" food in this context is already broadened by the inclusion of "Middle Eastern" in the title, but it goes further than that. Lebanese food, to Essam, represents a hybridised kitchen that incorporates the historical Caliphate of Bilad Al-Sham and transcends the modern-day political territories of Syria, Egypt, Palestine etc. It is also a direct enactment of his own hybridity, being the son of a Syrian mother and an Egyptian father.

Although these hybrid forms would seem to embody the values of the World Citizen, their most popular manifestations are in fact sneered at by the average urban sophisticate. If you raised the question of England's ten thousand Chinese takeaways in the presence of the well-educated and well-travelled chattering classes, they would doubtlessly dismiss the food as pseudo-Chinese cuisine bastardised to satisfy uncultivated Western tastebuds, citing Chow Mein as an example. This snobbishness

seems strange, as these dishes could just as easily be viewed as symbols of how cosmopolitan we have all become, rather than how naff we all can be. What is so bad about new food integrating to a new environment? What is so bad about people who enjoy this kind of food? And even if it were provable that they were somehow "doing it wrong", does it matter if the food tastes nice? There is an element of class politics at work in this dismissive attitude, but there is also the broader concept of authenticity.

One example of the issue of authenticity is the Italian restaurant. When we spoke to Farshad, the Iranian-born founder of the Italian restaurant, Piccolo, he told us about the discrimination he faced in the early days. "It was hard, hard. Very hard. Cos it was the neighbours. They could see we were not Italian. They thought we were Arabs or Indian and they looked down on us. [...] It was so funny, everyone saying, 'Two Indians, Two Arabs, they come to open Italian restaurant. Give them two months. We give them three months!' I think that was one of the reasons really made us to work harder to prove that can happen. And, all of them after a few years they were all eating here, you know!" Of course most Iranians are not Arabs and there must be very few who are Indians, but this was thirty years ago and people were less attentive to such things. Nowadays people are more discerning and seem to be able to specifically single out Iranians as another group of people who they feel should not be making Italian food. One Italian-run restaurant that we visited complained that Iranian-run restaurants were harming their trade because they devalued Italian food. For them it was obvious that an Iranian would not be able to make it as authentically as an Italian and therefore

not only would it have less worth but that this would infect the entire notion of the worth of Italian cuisine. As with performances of multiculturalism, this attitude can be explained as most likely motivated by commercial interests ("they are challenging our USP") rather than a political position (for example, a disparagement of foreigners).

The idea of authenticity also came up when we were visiting Sahara, a restaurant which paradoxically was a grand theatre of hybridity. The owner, Sabri, told us of his surprise at discovering Hawaiian pizza, the Exhibit A of inauthenticity for Italian gourmands (but probably more of a prime example of American-chain globalisation than of anything else). Sabri stated that the best pizza is by Italians and added: "I'm sure if I open a Chinese restaurant then people won't come to eat there. They'll say to me, 'You don't look Chinese, so I'm sure you're not gonna do a very good job'." In this case the policing of authenticity is presented as an action of theoretical customers, rather than the stated opinion of the restaurateur.

Interestingly, Sabri criticised the hybrid couscous on sale in the local supermarkets. "When we try to change things unfortunately we damage them. When you see some people who hijack your identity and your food, what do you think? It hurts you, you think it's not very nice." His use of words like "hijack" and "damage" show both that he sees this as a fairly violent process and that he is passionately concerned. This brings to mind the idea of a nostalgic packaging of culture, as discussed above, where culture is a thing that has to be performed to prevent it from becoming lost, except that, with the threat of inauthenticity, culture becomes the victim of a hurtful attack.

Hidden within this is a legitimate business concern about rival products of an inferior nature that will drive down the perceived worth, and therefore actual financial value, of your own product. And when that product is in itself predicated on the performance

of a specific nationality or trans-national culture, then a critique of that product finds a natural locus on the nationality of the rival as a gauge of their ability. What becomes knotty, however, is that the articulation of this business concern is therefore metered by a form of nationalism that is at once inherently built on the construction of the foreigner, or non-national as the "other", and this is an incontrovertibly political position that is the basis of divisions between ethnic groups, tribal wars and Berlin Walls. This is paradoxical, though, as the people caught up in the disputation are all themselves immigrants and are the most ardent supporters of multiculturalism. As Sabri himself says, one of the joys of being a restaurateur is that, "You meet lovely people every day, different people, different cultures, different colours."

Supermarket couscous is a revealing subject, especially in the way that people react to it. Rather than the "authentic" recipes on sale in the restaurants, the supermarkets are making their own hybrids with unusual ingredients. The issue came up again when we spoke to Maj, the owner of the Blue Man and the Village. He told us: "I think it's nice, I like it. I think as long as it's couscous, I think it's nice actually to introduce other things and you know, maybe some people prefer it with peppers, some people prefer it with chickpeas [...] But to actually change it around? I've got no problem with it at all, you know, it's nice to change around." This difference of approach could possibly be grounded in his own sense of identity as an Algerian. "I think Algeria is a little bit of a middle thing [...] You can see me, I've got curly hair, my nose is Roman... we're really, really mixed up and different, and I think this is the way that the future will be, because we're all gonna be mixed". This ability to identify as an intermezzo, or "middle thing", gives permission to be open to cultural hybridity and even inter-ethnic procreation which is perhaps the ultimate expression of this hybridity and the unspoken concern of those who would oppose it.

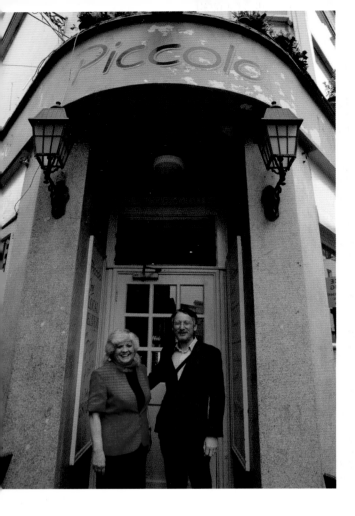

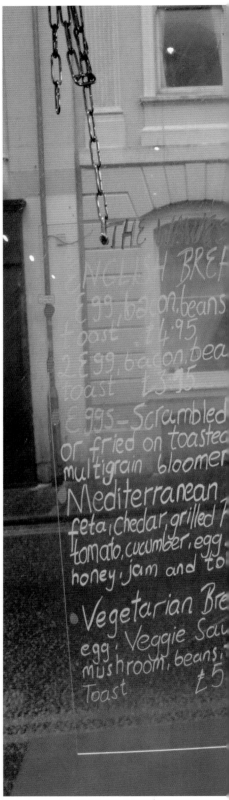

THE

ENGLISH BREF
Egg, bacon, beans
toast £4.95
2 Egg, bacon, bea
toast £5.95

Eggs - Scrambled
or fried on toasted
multigrain bloomer

Mediterranean
feta, chedar, grilled
tomato, cucumber, egg,
honey, jam and to

Vegetarian Bre
egg, Veggie Sau
mushroom, beans,
Toast £5

The word "authentic" evolved from the same root as "author", and initially meant that something was an original creation, not a counterfeit painting or a fake coin, say. When it comes to cooking, it is fair to question the idea of authenticity existing at all. Every meal is a copy after all, following a recipe or tradition to endlessly recreate a dish, so the idea of an "original" meal seems more symbolic than anything else. After all, people are not frozen in space and food is not frozen in time. And even if the original dish did exist, it is not beyond all possibility that it could be replicated by a foreigner. The alchemical power of fire transforms everything. Cooking is always chemical, and foreign food must surely be easier to replicate than transmuting base metals into gold or synthesising cyclobutadiene. It is no more impossible for someone to grasp a foreign cuisine that it is for them to grasp a foreign language, although it may indeed be more difficult and it may indeed take more time. For example, it seems uncontroversial to state that Japanese whisky is not authentic Scotch, but Nikka's Yoichi single malt still won "Best of the Best" at the annual Whisky Magazine awards and the godfather of Japanese whisky, Masetsaka Taketsuru, was able to find work at all of the best Scottish distilleries. It may be more reasonable to understand authenticity as an element of the performance, and an important one in the context of MENA restaurants in the UK, even though it is identifiably part of an ideological process that potentially works contrary to the integration of MENA culture into the mainstream.

Some may see modern fusion cuisine as one side of the coin, with authentic national cuisine on the other. But both of these approaches are equally based on the presumed existence and borders of national identities, it's just that fusion cuisine likes to play with combinations, but it does not dissolve them. Perhaps the real alternative to national identities is a Tuareg-style culture that has no use for the concept of countries at all, as epitomised by the menu at the Blue Man, something that overrides lines on the map unconsciously, like a camel across the trackless desert.

All of these ideas (and indeed this entire book and the community project that spawned it) go back to Erving Goffman, tramping around on the island of Unst in his knee-high leather hiking boots. The people of Unst saw him as a crazy college student from Chicago. His fellow students at Chicago saw him as a Canadian chemistry drop-out. His parents back in Canada saw him as a Ukranian Jew. But he was just an observer and a traveller who enjoyed hanging around in the kitchen, eating food and gossiping. And that is all we have been doing. In the next chapter, we will look at the history of our eating habits and the two very different forces that shaped them.

Chapter Two
Poverty & Purity

STEVE SILVERWOOD

"Tell me what you eat and I will tell you what you are."
-Jean Anthelme Brillat-Savarin

In 1793, the French lawyer and revolutionary, Maximilien Robespierre, unleashed the Reign of Terror. He put over sixteen thousand heads in the guillotine and slaughtered another forty thousand people for good measure. Amongst those he had executed were the King of the French, Louis XVI, and his wife, Marie Antoinette. The revolutionaries stormed the royal Bastille prison and overthrew the monarchy. But it was a time of great repression rather than liberation. The country fought civil wars and crushed any dissent with outbursts of terrifying mob-violence. It was also a time in which Robespierre delighted in settling old scores, including a grudge he had against another lawyer who once embarrassed him. This man had been foolish enough to argue publically with Robespierre about the death penalty. His name was Jean-Anthelme Brillat-Savarin.

Brillat-Savarin was denounced as a royalist and counter-revolutionary. Roberspierre put a bounty on his head. Brillat-Savarin's property was seized and he was forced into exile. He fled, clutching a Stradivarius violin that he managed to smuggle out of France, and made his way to America. He washed up in New York, eking out a living by giving French lessons and making a name for himself amongst the other French refugees as the lead violinist in the Park Theatre Orchestra.

Meanwhile, Robespierre had executed all of his enemies (and half of his friends) and declared himself President at a festival designed to launch his new Cult of the Supreme Being. He had even built a mountain in the Champ de Mars, appearing at its summit like Moses before the crowd. Appalled at his attempts to create a weird new religious dictatorship, the remaining revolutionaries had him arrested and thrown in a cell. Robespierre realised that it was the very same cell he had used for Marie Antoinette. Knowing what was coming next, Robespierre tried to escape by jumping out of the window, only to break both his legs. Having failed to get away, he then tried to shoot himself to escape the guillotine but succeeded only in shattering his lower jaw. Broken and bleeding, he was screaming when the blade finally fell the next day.

With the gory death of Robespierre, the fire went out of the Reign of Terror. In the French Revolutionary Calendar, the month of his overthrow was known as Thermidor, from the Greek word for "summer heat". Within a short period, the flames had all but died down.

Brillat-Savarin was allowed to return to France. The bounty was lifted and his name was cleared. He came home to find a different place to the one he had left, but he was able to settle back into his old profession and eventually he even became a judge. Having been exiled for so long, he spent the rest of his life in thrall to the French cuisine he had missed so much, especially the simple food of the provincial middle-

classes, and devoted several years to the composition of that hymn to the sensual lifestyle: The Physiology of Taste. Anonymously self-published just two months before his death in 1826, the book has never been out of print since. Brillat-Savarin was interested in a hedonistic pursuit of pleasure in food and wrote about the importance of food to human happiness. He is the grandfather of the gastronomic essay and a byword for the pleasures of the table. He is everything an Englishman is not.

"The limits of pleasures are as yet neither known nor fixed, and we have no idea what degree of bodily bliss we are capable of attaining."
-Jean Anthelme Brillat-Savarin

It is said that finding or growing food has been the major preoccupation of our species throughout history, yet few societies on Earth have ever consumed all of the edible plants and animals available to it; there are almost always restrictions of some kind and these go to the heart of how that society likes to think about itself. We have few better ways of understanding a culture, what it values and what it fears, than by its attitude towards food. This chapter will look at the the social history of our food, the way it has evolved and the meanings we attach to it, in order to ground our understanding of the modern food culture surrounding takeaways and restaurants in the UK.

The history of food in England and Great Britain is a story shaped by poverty

and purity. But these are only set in motion by the fundamental force of colonialism. And not just British Imperial colonialism, but also the times when Britain itself was colonised. Firstly, the Roman colonisation obliterated the existing oral culture and introduced a huge range of new foods to Celtic Britain, including staples such as apples, pears, carrots, cabbages, peas, turnips and leeks. They brought herbs like rosemary, thyme, basil and mint. They even brought the idea of chickens and rabbits as farm animals. The mass of Celtic peasantry, though, saw little difference to their diet at first.

Five hundred years later, the Anglo-Saxons brought a love of bread and beer that continues to this day. They also brought a lot of vegetarian recipes because only landowners were allowed to hunt deer or wild boar and most Anglo-Saxons were too poor to even farm cattle. Later, the Norman Conquest replaced beer with wine, and, as the medieval era progressed, the food became richer and more varied. The Crusaders were exposed to new foods in the Levant such as rice and dates, and they started to use sugar, although initially it was used either as a medicine or as a spice for meat dishes. Sugar later became the engine of the transatlantic slave trade. It became known as White Gold and accounted for a third of Europe's entire economy. It also helped alter world history. If King George III had not invested so many of his soldiers in protecting the sugar islands of the Caribbean from revolt, then he would have had the manpower to hold onto the American colonies. Instead, they slipped through his hands like, well…like icing sugar.

Bread was still the main staple of the population. Its importance is evidenced in the number of laws governing its manufacture, even in Medieval-era London. When distant volcanic eruptions led to bad grain harvests, the ensuing bread shortages left a third of the population dead. Gravediggers gave up even trying to bury all the bodies. The dire situation was only relieved by donations of wheat from Germany and the beginnings of large scale food imports. Bread was crucial as it was used to bulk up a small meal and also to form sandwiches, which were regarded by Charles Dickens as "one of our greatest institutions".

Before Dickens, though, Britain found itself the birthplace of the Industrial Revolution. This was partly because of the abundance of accessible coal but also because of British imperialism. The colonies offered significant overseas markets for manufactured goods and provided essential raw materials; in synergy with this, the rise of industrialisation ensured that Britain had the infrastructure to exploit the new colonial opportunities. As a consequence, the country urbanised far more rapidly than anywhere else in Europe and this had a devastating impact on the survival of the kind of rural gastronomy and provincial specialities that European cuisine prides itself upon. Whole communities were uprooted and entire local identities were wiped away. During the Nineteenth Century, the population doubled twice from nine million to thirty six million, with an irreversible shift of the poor from

agrarian to urban. The sporadic malnutrition of the historic rural peasantry was replaced by the unending malnutrition of the urban poor. The emerging working classes of the industrial cities experienced great poverty, especially during the Hungry Forties. It was a time of slum housing and child labour, with children as young as four working in dangerous environments such as mills and coal mines. Indeed, conditions for Victorian child labour were worse than those in the developing world today, where ninety-seven percent of the work is either in the home or alongside parents, mostly in light agriculture, whereas the majority of children in Britain were employed outside of the family in industrial environments. With the big shift towards industrialisation and urbanisation, farming declined and the nation was no longer able to feed itself, becoming dependent on food imports from the colonies and new methods of preservation such as canning and refrigeration.

By the beginning of the early Twentieth Century, the poor had better access to food due to imports of wheat from North America, frozen meat from Australia and dairy products from Europe. There were exotic novelties like rhubarb all the way from China. They were also increasingly able to get hold of relatively newer products such as white bread, margarine and condensed milk. But these impoverished their diet as they contained less vitamins and nutrients than the alternatives (the whiteness of bread, for example, is fairly proportionate to its lack of nutrition). When they did get real milk it was watered down. And when they did get sweets they were so cheaply made that the sugar would be substituted with plaster or powdered gypsum, and toxic chemicals were used to give them a bright colour, sometimes even including arsenic. Many recruits for the Boer war were rejected on the grounds of poor health.

In the modern age, the impact of centuries of relentless poverty is still manifest in the food culture of the British working classes. Not only are foodstuffs like margarine, white bread and condensed milk still consumed, but what is prized above all else in a meal is that it must be cheap and that it must be filling. The idea of food being a sensual pleasure, in the style of Jean Anthelme Brillat-Savarin, does not even really come into it.

But the French table has long stood as a symbol for "getting it right" among the upper classes. There is an element of this Francophile elitism inherent from the early days of the Norman Conquest, but it truly established itself in the mid-Nineteenth Century when professional kitchens started importing male French chefs. The word "chef" is an abbreviation of "chef du cuisine" that dates from this time and is concurrent with the then-unfamiliar French concept of the "restaurant". All homes except those of the labouring classes had servants at that time, and many had their own cooks, so it is no surprise that the upper class households started vying with each other to obtain the best French cooks. It was a competition that would further devalue the already diminished notion of British food.

The growth of the cities led to the emergence of a new middle class bourgeoisie

(from the French word meaning "town dweller"). Combined with the boom in industrial progress from the new steam technologies and international trade from colonialism, a whole new social stratum was born of managers, clerks, civil servants, teachers and other white-collar workers. The culture of this new class was conservative with a small "c", and their food culture was no different. In order to differentiate themselves from the working classes, they renounced drunkenness and indulgence. Simplicity and plainness were the new goals. Cookery books emphasised cheap family meals of roast beef and mutton with plain boiled veg. The use of leftovers was not driven by poverty but by virtue. Children especially were given plain food such as simply cooked eggs and "nursery puddings" of semolina and rice.

"The modest virgin, the prudent wife, and the careful matron, are much more serviceable in life than petticoated philosophers, blustering heroines, or virago queens. She who makes her husband and her children happy, who reclaims the one from vice and trains up the other to virtue."
-Isabella Beeton (From Mrs Beeton's Book of Household Management)

"I'll have the blandest thing on the menu!"
-Kulvinder Ghir (From the "Going for an English" sketch on Goodness Gracious Me)

The idea of plain food being morally superior continued during the wars of the Twentieth Century and was reinforced as a patriotic virtue through the national policies of rationing and austerity. The older generation who grew up during this time still prefer to use every scrap of food and have an almost physical inability to throw food away. The younger generation, raised in an era of disposable technology and prosperity, find this frugality somewhat embarrassing. In fact there is a generational morality gap at work. If the emphasis on plainness and parsimony seem somewhat puritanical then it should come as no surprise that the roots of this morality lie in the Protestant Reformation. Gluttony had always been seen as one of the seven deadly sins in Christianity but the new Protestantism, especially Calvinism, elevated temperance and the rejection of physical luxury to the highest degree. It was like a perpetual Lent. Coupled with the Protestant work ethic, this avid control of excess and expense was a huge driver in the capitalist boom of the industrial revolution and colonial expansion that created the middle classes as we know them today. The taboo on gluttony and drunkenness found spiritual outlet in the debate over Transubstantiation. The Roman Catholic Church taught that the sacramental wafer and wine of the Eucharist ritual were miraculously transformed into the body and blood of Jesus when placed on the tongue of the believer. This was problematic for the emerging Church of England who removed the use of the word "Mass", changed the wafer to plain bread and insisted that the transformation was purely symbolic. Around the time of Oliver Cromwell, Mass was outright banned. Shortly afterwards, the Great Fire of London began (tellingly) in Pudding Lane and ended in (ahem) Pie Corner, where it was commemorated by the erection of a golden statue of a small boy, beneath which the inscription still reads: "This Boy is in Memmory [sic] Put up for the late FIRE of LONDON Occasion'd by the Sin of Gluttony 1666".

Other more telling examples of the wider Protestant food taboos and aversion to gluttony include the strange inventions of one John Harvey Kellogg. A committed Seventh-day Adventist, Kellogg was the chief medical officer of the Battle Creek Sanitarium (sic), where he forced patients to undergo a regime of vegetarianism and yoghurt-enemas. He believed that sexual activity was scientifically unhealthy and promoted sexual abstinence, but he was convinced that the greatest evil in the world was masturbation. According to Kellogg, the "solitary-vice" destroyed physical, mental and moral health. It also caused cancer, epilepsy, madness and death. "Such a victim," he wrote, "Literally dies by his own hand." Kellogg used various bizarre means to prevent masturbation among his patients, including physical mutilation; caging the genitals; and electric shock treatments. He believed that food was a principal cause of the problem and that a bland diet would decrease excitability amongst people, especially the young. And so in 1878 he invented Kellogg's Corn Flakes.

In this sense, controlling the desire for food was not just similar to controlling the desire for sex: it was the same thing. The repression of gluttony is not always so

overtly linked to the repression of sexuality, of course, but the connection is always there subliminally, from the "forbidden fruit" of the Garden of Eden through to the titular pastry in American Pie. Some cultures perceive certain foods like oysters or chocolate to be aphrodisiacs, even though there is little scientific evidence for such claims. At other times, certain foods can act as ribald symbols for body parts, such as phallic bananas or mammary melons. Food can even play a role in sexuality, including reified fetishes such as the geisha-house tradition of nyotaimori, where sushi is served on the naked body of a woman. One can even buy edible underwear.

In the 1980s the British company Lyons produced a series of television advertisements for cream cakes featuring celebrities famous either for their camp value or their perceived sexiness such as Carry On star Barbara Windsor, gameshow host Larry Grayson, Frankie Howerd and a cross-dressing Les Dawson. These all emphasised a lack of self-control and featured the slogan "naughty but nice", coined by a young copywriter named Salman Rushdie who would go on to inflame passions of a different nature with his controversial Satanic Verses.

In most English homes it would be considered awkward for a guest to arrive in the middle of a meal. They may well even expect to wait for the meal to finish while sitting in another room, as if it were a taboo ritual. There is certainly an overlap between the notion of the dining room and the bedroom as a place where we enjoy the pleasures of the flesh. Both offer the possibility of enjoying forbidden things, or of withholding from the pleasure of indulgence.

So the quest for plainness in English cuisine can be understood as part of a deliberate anti-hedonism that has a spiritual dimension. The use of the term "English cuisine" is quite deliberate here.

"On the Continent people have good food; in England people have good table manners."
-George Mikes

Many people will scoff at the idea that the English, or the British as a whole, even have a food culture, let alone an actual cuisine. A recent study in Lewisham found that the older inhabitants see British food as plain, wholesome, nourishing and healthy; but those under fifty see it as a dying concept: bland, boring and unhealthy. They reject the idea of meat and two veg in favour of a creolised cuisine of Italian, Chinese and Indian food. Young people view English cuisine as something like the Tooth Fairy: not only does it not exist but, once you give it some thought, it's actually better that way.

In part, this attitude can be seen as an example of a cultural blind-spot, similar to what we might call the accent-illusion, where a speaker is convinced that they do not have a regional or national accent at all and that their voice is normal while it is everyone else that has an accent. So partly we don't think we have a cuisine because we are

so used to it that foreign cuisines just seem that much more… "cuisiney"? Another part of this attitude lies in the unwitting support of European nationalism through the performance of cosmopolitan sophistication. What is meant by this is that the same desire to appear elegant that led the upper classes to recruit French chefs into their stately homes now leads the aspiring middle classes to extol the superiority of European cuisines, only nowadays this is being done in the context of a more mobile Europe so that the conversation often takes place in the company of French or Spanish or Italian visitors who are only too keen to agree about the relative quality of their food, especially at the humorous expense of the English. The delight with which this is accomplished is presented as a gentle riposte to the otherwise supercilious English but it is really just a reinforcement of patriotic nationalism and pride in their own heritage. The English victim rushes to agree, so as not to seem like a provincial buffoon, but the denigration is unfair. Plainness and simplicity are subtle virtues that can be appreciated as deeply as piquant excess to the cognisant palate. The English do have a cuisine and British food culture does exist. It just does not like to shout about itself, that's all.

Countries like Italy, France and Spain are known for the rich diversity of their regional ingredients and recipes. Adherents often point to these as examples of their pre-eminence over English cuisine, but England possesses a range of regional specialities, as well as those with the same level of Protected Geographical Status enjoyed by delicacies such as Champagne and Camembert. For example, blue cheese can only be called Stilton if it is produced, processed and prepared in a specific area, using full-fat milk from cows grazed only in that area. Similar restrictions apply to things like the Melton Mowbray pork pie, Cumberland sausages, Cornish pasties and Wensleydale cheese. Even the title of the humble Jersey Royal potato can only be used for spuds grown on the island of Jersey and even then only those grown using traditional methods.

The contested yet meaningless title of English national dish belongs to the Sunday roast "with all the trimmings", namely roast beef served with roast potatoes; boiled vegetables; Yorkshire puddings; proper gravy; cauliflower cheese (controversial); and horseradish sauce or mustard on the side. Roast beef has been emblematic of Englishness since at least the seventeenth century. It was so widespread and popular that foreign visitors described the English as "entirely carnivorous" and it even became the source of the French racial epitaph for the English: les rosbifs. The beef is the central focus of the meal but the Yorkshire pudding is the real star. A crispy batter pudding enriched with dripping, it was originally served before the meal in order to dull the appetite so that the diners would not eat so much of the expensive meat to follow. This is a fine example of the heritage of thrifty cooking born out of historical poverty. In hard times, the Yorkshire pudding would be the only course. It is also a fine example of regional specialities, many of which still bare the names of their birthplaces.

In the case of Scouse, the name of the dish has actually become more synonymous

as the name of the people who invented it and their dialect. Scouse is not just a colloquial term for Liverpudlians but is also the name given to a beloved local stew. Some more unusual British delicacies include: Cornish Yarg, a semi-hard Friesian-cow cheese coated in a rind of stinging nettles; Welsh laver bread, made from boiled and pulped seaweed; Haggis, a savoury pudding made from minced sheep-offal and traditionally served with onion and suet inside a sheep's stomach; black pudding, a sausage made from pork blood, sometimes boiled and served with malt vinegar; and Stargazy pie, baked pilchards, eggs and potatoes in a pastry crust with the fish heads actually protruding through the crust.

The regional cakes and biscuits of England are national treasures. The Bakewell Tart from the Peak District town of Derbyshire is justly famous for its shortcrust pastry and delicious filling of jam layered with syrup, egg and almonds. The Devon cream tea offers an unpretentious plunge headfirst into a chibi paradise of scones and butter, clotted cream and jam served with sweet milky tea. These are part of a long list alongside the Chelsea bun, Eton mess cake, Eccles cake and more.

In keeping with the tradition of puritanical morality, a lot of the more elaborate dishes are only eaten on special occasions. The full-on version of Stargazy pie, made with seven different types of fish, is mostly reserved for the festival of Tom Bawcock's Eve on the 23rd December. Pancakes are conventionally eaten on Shrove Tuesday, also known as Pancake Day, in order to use up perishable ingredients before the fast of Lent. Gingerbread Men are ginger-flavoured biscuits from Market Drayton in Shropshire that are baked in the shape of little people around Christmas. Parkin Pigs are a Yorkshire variant that are made of gingerbread cake and baked in the shape of a pig for Guy Fawkes Night.

The month-long palaver that is Plum Pudding, also known as Christmas Pudding, or Pud, is similarly restricted. A dark cannonball of a desert that perversely contains no plums at all, a traditional plum pudding should have thirteen ingredients to represent Jesus and his twelve disciples. These are typically egg, suet and dried fruits flavoured with spices like cinnamon, nutmeg and ginger. It is only eaten on Christmas day but should be made a month ahead on the Sunday before Advent (also known as Stir-up Sunday). The mixture should be stirred by each family member from east to west to symbolise the journey of the Magi. Lucky charms and tokens are then added, originally just a dried pea but later evolving into things like coins and more complex tokens that could tell the fortune for the year of the person who finds them on their plate such as buttons, thimbles, rings or bones. The pudding is then drenched in some kind of alcohol, normally brandy, and steamed for several hours, after which it should be hung up to dry in a cloth bag until Christmas. When it is served, the pudding should be topped with holly before being doused in brandy and set on fire. Yes, really.

"Only dull people are brilliant at breakfast."
-Oscar Wilde.

Perhaps the greatest marriage of simplicity and substance is the Full English Breakfast, or fry-up. Individual elements vary but the mainstays are fried eggs; fried sausages; grilled back bacon; fried tomatoes; fried mushrooms; and fried bread. Other popular items are baked beans, black pudding and hash browns (although the latter are as divisive as cauliflower cheese on a roast dinner). The Full English is served with plenty of salt and pepper; splattered with tomato ketchup or brown sauce; accompanied by a cup of white tea; and complemented with hot, buttered toast. Various regional variations include the Ulster Fry (soda bread), the Scottish (tattie scone) and Cornish (hogs pudding). The breakfast is a stalwart choice for the working class labourer who requires something heavy in protein to help cope with the punishing physical exertion of the day. As recently as the 1950s it was the daily breakfast for half of the population. Less popular now due to health-concerns and changing habits, the breakfast is more often than not eaten at the weekend, usually to help soak up a hangover.

You are allowed to read a newspaper with your breakfast (something that would be greatly frowned upon at any other time), a tradition that dates back to the lengthy pre-hunt breakfasts at Victorian country houses. This may have been the origin of the Full English: the characteristically wide range of items was just a means to display the wealth and diversity of their estate. This is said to have transitioned through the aspirational middle-classes to the working classes, most of whom would not prepare the meal at home with family but would consume it at a "greasy spoon" or café with their workmates. Which is where things get interesting.

"I went to a restaurant that serves 'breakfast at any time'. So
I ordered French Toast during the Renaissance."
-Steven Wright

Eating out in Britain originally meant a meal at an inn or monastery as part of roadside lodging during a long trip. It is unlikely that any inns predated the Romans. These were supplanted by the railway hotel and then the motorway service-station and airport lounge as transport evolved. In the meantime a whole world of alternatives to the inn appeared across the country. This started just before the industrial revolution in London with the creation of the chop-house. These were basically men-only steakhouses for office workers and were located in places like Bread Street in London. Around the same time, coffeehouse culture was being created in Oxford by Mediterranean migrants.

Coffee was first drunk in England by Nathaniel Conopios, a Greek Orthodox refugee from Crete who came to study at Oxford University around 1637. He was expelled shortly afterwards by shadowy "Parliamentary Visitors", presumably because he could not prove his loyalty to the Roundheads due to his religion. The first actual coffeehouse in England was opened in Oxford's Angel Inn by a Lebanese immigrant known only as Jacob the Jew. His first business rival was another Levantine immigrant, a Syrian Jew named Cirques Jobson. In addition to coffee, they also first introduced the public to drinking chocolate, both products of Jewish traders and confectioners. What is especially notable about this foreign contribution to British culture is that their shops predated Cromwell's revocation of the Edict of Expulsion where all Jews were forced to leave England and suspicion of being a Jew was at that time an arrestable offence.

The first coffeehouse in London was established in St Michael's Alley, Cornhill, in 1652. They spread quickly, despite complaints about the "evil smells", and within fifty years there were over two thousand in London alone.

Coffeehouses were hotbeds of gossip and scholarly debate where people would spend all day discussing politics. They were critical nodes in the establishment of the free press and the tradition of the daily newspaper. After the Restoration of the monarchy, they became firmly established as democratic spaces frequented by a wide demographic of people from all social classes and backgrounds. This was their greatest strength as social institutions but it was also their weakness. Because of the inherent snobbery of the upper classes, the democratic coffeehouses were gradually eclipsed by the growth of the exclusive, members-only, gentlemen's club. These clubs offered a second home for upper class men where they could relax and dine together, safely ensconced from the lower orders. As they were all boarding-school educated and so less comfortable around women and children, they were also seeking to escape from their wives and families. It is worth noting that most of these clubs still persist today, as does elitism, snobbery and sexism.

Coffeehouse culture soon devolved. The Folley was a famous floating coffee house situated in a boat moored off the stairs of Somerset House. It had

started off as a fashionable spot but began to attract a more disreputable clientele until eventually becoming what London biographer Peter Ackroyd called "little more than a floating brothel," to which he adds wonderfully: "Not being on land, it had no tenacity of purpose."

Working class dining developed into regional institutions such as the tripe restaurants of Lancashire (there were hundreds in Manchester alone) or the pie and peas shops of Yorkshire. Most famous among these institutions were the Pie and Mash shops of London. These originated in the practise of live eels being sold by female street vendors who would skin the eels on the spot as a cheap filling for pies. The Pie and Mash shops that developed from this were known for their ornately tiled and mirrored interiors, their luxurious marble tabletops and their elaborate shop fronts, quite distinct from their pedestrian surroundings. Originally the pies themselves contained eels, but these morphed into minced beef pies with mashed potato drenched in "liquor", a green parsley sauce made from stewed eels. The eels came from the River Thames as they were one of the few forms of fish that could actually survive in the polluted waters. The Thames has boasted eel fisheries since at least the eleventh century and probably earlier. As a boy I can remember my uncles going fishing in the Thames and bringing home these slippery river monsters to be made into jellied eels with vinegar and pepper. Sadly, the eel population of the Thames has fallen dramatically in recent years and those sold in the remaining Pie and Mash shops are now all imported. These days there are only a handful of the shops left, mostly in the East End and South-East London. For the majority of ordinary people, however, dining out meant a Friday night takeaway from the fish and chip shop.

As noted in the chapter on Almas Lebanese and Middle Eastern Restaurant and Bar, the cooking of fried fish and fried potatoes evolved separately. Fried fish, or Pescado Frito as it was known, was introduced by Sephardic Jewish refugees from Portugal, while chip shops were popping up around London at the time of Dickens. A man named Joseph Malin, the son of Jewish rug-weavers from Eastern Europe, is recorded as opening the first ever fish and chip shop in 1860. By the 1920s there were more than thirty five thousand chippies in Britain. Historians even say that a diet of fish and chips helped win the First World War. While the German home front suffered hunger, the British government prioritised the safeguarding of fish and potato supplies to ensure that the nation was well fed on a diet rich in protein, fats and carbohydrates. In George Orwell's essay on the northern working class, The Road to Wigan Pier, he states that fish and chips (alongside the Football Pools and strong tea) helped keep the masses happy and avert political unrest. He wrote: "They have neither turned revolutionary nor lost their self-respect; merely they have kept their tempers and settled down to make the best of things on a fish-and-chip standard"

The chip has been described as quintessentially English. It is simple and straightforward, and about as unpretentious as you can get.

Yet there is something about the chip that is rare in English culture but is hugely important. And that is the habit of sharing.

"Sadder than destitution, sadder than a beggar is the man who eats alone in public. Nothing more contradicts the laws of man or beast, for animals always do each other the honour of sharing or disputing each other's food."
-Jean Baudrillard

"He who eats alone chokes alone."
 -Mediterranean proverb.

We underestimate the social importance of sharing food but it is critical to human bonding. This is borne out in our language through the word "companion" which comes from the Latin words com (together) and panis (bread) i.e. one who breaks bread with another. As it occurs in the Bible, the phrase "breaking bread" describes a common meal as an act of fellowship and then later as a symbolic communion at the Last Supper. Co-operative food sourcing and production is the foundation of all human society and the intimate sharing of food is the glue of those societies. But traditional English food offers little opportunities in the way of the Spanish tapas or the Nordic smorgasbord or the Mediterranean meze. One exception is the chip. Opening a bag of chips is one of the few times we expect everybody to help themselves and for us to share without obligation. "Pinching a chip" is a victimless crime as there are always plenty more in the bag.

In the bleak austerity of the Second World War, fish and chips were one of the few foods not subject to rationing. The wartime cabinet had learnt how valuable they were to home front nutrition and morale. This cheerful source of energy was considered a vital part of the war effort. Winston Churchill reputedly called fish and chips "the good companions". In fact, fish and chips are now one of the symbolic cornerstones of British identity. One example of this can be found in the Citizenship Ceremony and the Life in the UK Test, both by-products of the Second World War.

In the aftermath of all the bloodshed and horror of the War, a series of international protocols were drawn up between world governments, known as the 1949 Geneva

Convention. These established rules for humanitarian treatment of wartime prisoners and prohibitions against biological warfare. Nearly two hundred countries signed the convention as a reaction against the years of warcrimes and atrocities. Following this, the 1951 Refugee Convention established the right to claim asylum. By the turn of the millennium, however, record numbers of asylum applications and inflammatory coverage in the tabloid media had led to widespread anti-refugee sentiment in the UK. The government responded with protectionist rhetoric and proposals for new legislation, leading to an unprecedented number of Immigration Acts (about one every two years for the past twenty years). The 2002 Act was drawn up in response to those who criticised new immigrants for not speaking English and for not integrating into society. Like all of the other Acts, this appeared to have been drawn up by unelected civil servants within the authoritarian culture of the Home Office and waved through by the Home Secretary in the perennial bid to appear "tough" on immigration. The Act established the demand that all immigrants wishing to naturalise as British Citizens would be required to pay around a thousand pounds, take an English language test, pass another test on British history and then attend a Citizenship Ceremony.

The "Life in the UK" test was dismissed by some academics as a "bad pub quiz" full of trivia questions and factual inaccuracies. Some studies found that the majority of British-born young people could not answer most of the questions. Still, over a million people have taken the test since it was introduced and most of these have eventually gone on to take part in the Citizenship Ceremony. An incongruously modern invention, the ceremony has none of the authentic pomp or elaborate costumes found in other national rituals such as those of Westminster, the Crown or the High Court. You are required to attend the Town Hall in smart clothing where you will swear an oath of allegiance to God and/or the Queen before having your photo taken in front of a picture of the Queen. You will also receive a gift (such as a set of ballpoint pens with the local authority crest on the side) and listen to a speech by the mayor or the registrar. During the speech, the available dignitary will attempt to explain, without the prop of antique language, and for a foreign audience, what it means to pledge yourself to "British values". At every ceremony I have attended, this is always defined in terms of the Second World War and fish and chips.

But this lazy version of what it means to be British was already under question from those who championed multiculturalism. In a famous speech in 2001 by the Labour government's Foreign Secretary, Robin Cook, a new dish was posited as the nation's favourite, one that was invented by a Bangladeshi curry house in Glasgow to suit the demands of a local bus driver. "Our economy," Cook said, "Has been enriched by the arrival of new communities. Our lifestyles and cultural horizons have also been broadened in the process […] Chicken Tikka Massala is now a true British national dish, not only because it is the most popular, but because it is a perfect illustration of the way Britain absorbs and adapts external influences. Chicken Tikka is an Indian dish. The Massala sauce was added to satisfy the desire of British

people to have their meat served in gravy. Coming to terms with multiculturalism as a positive force for our economy and society will have significant implications for our understanding of Britishness." The speech created controversy in the press and sparked debate about the concept of Britishness. Almost immediately afterwards, Robin Cook was demoted from the Foreign Office back to the House of Commons. Two years later he resigned from the cabinet over the invasion of Iraq.

Robin Cook's speech was made at the tail-end of the Asian Underground movement, itself a multicultural reaction to the whiteness of the Brit Pop scene and Cool Britannia paradigm that had dominated the 1990s. In 1998 the Indo-dancehall fusion band Asian Dub Foundation were nominated for the Mercury Prize, the Asian indie band Cornershop went to Number One with the Fatboy Slim remix of their ode to a Bollywood playback-singer, Brimful of Asha, and, in 1999, the Mercury prize was won by Talvin Singh. It was suddenly hip to be Indian, and the syncretism of Punjabi culture seemed tailor-made for fusion.

The idea of chicken tikka masala as the national dish was problematic for many commentators who were resistant to what they saw as a politically-correct attack on traditional British identity. For others, it was problematic on grounds of taste. The academic Elizabeth Collingham rejected the idea of chicken tikka masala as evidence of groovy multiculturalism, adding that it was in fact "not a shining example of British multiculturalism but a demonstration of the British facility for reducing all foreign foods to their most unappetizing and inedible forms." In the context of this chapter, Collingham's opinion can be set to one side as part of the snobbish Continental disdain for British working class food choices, but it does show that the rejection of Robin Cook's idea was not just simply jingoistic.

Robin Cook died two years after leaving Parliament, but his idea persisted. In 2009, the former Governor of Punjab and then-MP for Glasgow, Mohammed Sarwar, tabled an Early Day Motion in the House of Commons asking that Parliament support a campaign for Glasgow to be given Protected Geographical Status for chicken tikka masala. The motion was, apparently, not chosen for debate. As opposed to something like Stilton or Wensleydale, chicken tikka masala was too much of a hybrid product for any one town to claim ownership.

Whether or not it is representative of modern British culture, there is also a politically-driven debate as to whether chicken tikka masala is even the most popular meal. Some surveys have found that dishes such as Cantonese-style stir fry are more popular, although their sample sizes are far from statistically significant. The right-wing Daily Mail newspaper, described by a former reporter as "institutionally racist", seems to have a particular disapproval of Indian cuisine, repeatedly claiming that Chinese is the nation's favourite takeaway. This may or may not be the case.

Actual estimates vary, but research suggests that there are still ten thousand fish and chip shops, followed by nine thousand Indian and eight thousand Chinese outlets. The real question is what is being eaten and where. The most reliable figures come from the industry's main market research company, the NPD Group. They recently listed burgers as the top takeaway item, with over seven hundred million portions served per year. Indian and Chinese food put together only amounted to five and a half million. The nation's former favourite, fish and chips, is roughly half that amount. When it comes to takeaways eaten at home, however, Chinese is the clear market leader and even fish and chip consumption outstrips Indian food. Whatever the exact split, it is clear that eating-out has become diverse.

"The finest landscape in the world is improved by a good inn in the foreground."
-Samuel Johnson

These habits date back around fifty years to the postwar introduction of supermarkets and the proliferation of Chinese restaurants. At that time, less than one in ten people had a fridge, so shopping was a daily task and there was little variation in eating out. The only "ethnic" options besides French restaurants in London were Italian ice cream parlours. Chinese food was something completely new. The increasing level of Chinese migration to the UK in the 1950s was a legacy of British imperialism in Hong Kong that brought new opportunities for the British to sample Chinese cooking. It proved such a novelty hit that it was even included on the menu at Butlins holiday camp in the late 1950's as "Chicken Chop Suey and Chips", another chicken tikka masala-style dish that was invented in the diaspora. Within twenty years, anyplace bigger than a village would have at least one Chinese takeaway, and Chop Suey was always on the menu.

The first Wimpy Bar was opened in 1954 by Lyons, who already owned a national chain of Corner Houses and teashops. The British public were amazed by the speed at which the food was delivered at the new Wimpy Bars where they could order their food and be eating it within ten minutes, an amount of time that would nowadays result in a heated complaint. The first McDonalds opened in Woolwich twenty years later, trumping Wimpy with their model of superfast counter-service. Times were changing.

In 1961 the first convenience meal was launched in a blaze of advertising: Vesta packet curry. The box contained two packets: one with the dried bits of sauce that needed reconstituting with boiling water, and the other containing the rice. It was fairly inedible by modern standards (think of a Pot Noodle without any of the gourmet elegance), but ushered in a new fad for Indian food. As opposed to the conventional narrative that this new boom was entirely the result of postwar immigration, the rise of the curry in the white working class culture can only be understood through the amber lens of that other new

product: lager. To paraphrase Churchill, these were the real good companions.

*"Burgundy makes you think of silly things; Bordeaux makes you
talk about them, and Champagne makes you do them."*
-Jean Anthelme Brillat-Savarin

Before the late sixties and early seventies, British men would not drink lager.
Due to the fact that fridges were still rare, it was only sold in little bottles at room
temperature and was seen as a "girl's drink". This changed when the big breweries
moved from cask to keg, a technology which favoured lager over the more
traditional ales. Suddenly having the lager on draft meant that it could now finally
be enjoyed chilled. This was coupled with a rise in travel to Continental Europe
where people brought back the habit from their holidays. So all at once there was
the perfect drink to wash down the hot new spicy flavours of the Indian meal, as
well as the perfect meal to round off a night's drinking. It is impossible for us to
imagine the widespread Saturday night outing of "Going for an Indian" without
lager, and Indian lagers such as Cobra and Kingfisher are rising in popularity in the
UK, even though most of the beer in India itself is spoilt by the use of glycerine
and other preservatives. Nevertheless, Indian food and lager have experienced
a symbiotic growth, just as colonialism and technology have always done.

In a similar way, the rise of the Italian restaurant in the 1970s was synonymous with
the rise in availability of good wine. The removal of the Resale Price Maintenance
restrictions on supermarket wine sales, plus improving trade links with European
producers occurred alongside the increasing consumption of alcohol by women
in the same period, possibly as a correlation with the spread of feminism and the
loosening of social expectations. Brands such as Blue Nun and Mateus Rose were
considered as desirable accompaniments to a plate of spaghetti bolognaise, although
they are now deemed a bit naff. In a related development, the pizza became an
everyday item through the now-ubiquitous household ownership of a deep freeze.

By the 1980s, if an Englishman was condemned to death then his Last
Meal would be a Berni Inn starter of prawn cocktail, followed by steak
and chips or Chicken Kiev. And for desert he would have a slice of Black
Forest gateaux. Times, and tastes, were continuing to change.

One key indicator of these changes is olive oil. When I was a boy in the 1970s,
olive oil was only available at the chemists. It was sold in small bottles for the
medicinal purpose of pouring it into your ear to help alleviate congestion and
discomfort. In fact, when I first came across it as a foodstuff I was reluctant to try
it in case it tasted like medicine or, worse, that it might even taste of earwax.

All sorts of foods unheard of fifty years ago are now part of our daily life like yoghurt

or French bread. Other foods have been more faddish, going from everyday purchases to something more occasional like the flash-in-the-pan kiwi or the nine-day's-wonder sun-dried tomato. These days the average café will offer things like ciabatta bread or coriander soup alongside the usual tea and bacon sarnie. We're also eating out more.

Dining away from the home takes up an increasing percentage of household expenditure, even though overall spending on food is down. Up until the 1950s, we spent a third of our income on food. By the 1980s it was down to a fifth and today it is down to a tenth. But over the same time, our expenditure on eating out has doubled from ten percent to twenty one percent of the household budget. Obviously this is more so in London and the South East where wages are higher and restaurants are more expensive, but the trend is up across the board. So what happened?

"Give me a frothy coffee without the froth."
 -Tony Hancock (in The Rebel).

Eating out in Britain in the 1950s meant taking a deep breath and hoping for the best. The restaurants were dreadful. The service was notoriously grumpy and the food was a lacklustre selection of gristly mince and soup out of a tin. Even the opening hours were limited and inconvenient. The trend seems to date from at least the 1870s, when the American novelist Henry James wrote a letter to his father during a visit to England: "I was seeing arrive the day when London restaurants, whose badness is literally fabulous, would become impossible, and the feeding question a problem so grave as to drive me from the land."

Some blame the British indifference to food, but this is something of a dull cliché. In British culture, sensual pleasures (like food and sex) are traditionally seen as private and personal. It is not necessarily the case that the British are being indifferent about food (or even puritanical about its delights as such), more that they are just a bit embarrassed about it. Meg Ryan's fake orgasm in When Harry Met Sally was filmed in Katz's kosher deli in New York. It would never have happened in Newport Pagnell.

A more pervasive influence was the hand of the state. When services are controlled by the government, the British expect them to be terrible. People even find a perverse delight in disappointment. "Tut," they say. "Typical!" And food had come under increasing public control in the twentieth century. The wartime Ministry of Food oversaw food supplies way past the end of rationing. Even by the late fifties there were still remnants of "British Restaurants" across the country. Originally known by the cheerless title of "Community Feeding Centres", these were communal kitchens created during the war that transitioned into civic restaurants run by the local council.

Until relatively recently, the majority of lunches eaten outside the home were provided by institutional caterers, many in the public sector. These included canteens in the workplace and in hospitals, as well as things like university refectories and messes in the armed forces (remember that national service was still compulsory until the '60s). Ever since the Eighteenth Century, and especially in the Colonial period, nation-states have intervened in food production and consumption: from controlling prices, monitoring agriculture, restricting fishing, subsidising farming and correcting public nutrition. These institutional caterers are just one modern manifestation and the biggest branch is the mini-industry of school dinners.

Just the mention of those two words will foster a queasy combination of nostalgia and repulsion in many readers. They conjure images of Olive the cook from the Bash Street Kids, with her rancid food that could burn holes in walls or perhaps, nowadays, Lunchlady Doris of Springfield Elementary. They are part of the national psyche and contributed to set notions of what is and what is not "proper" food within the banal framework of crypto-nationalist conditioning at work within all state apparatus. Most recollections of school dinners are negative, with the general exception of the desserts which are often fondly remembered. Many children qualified for free school meals until the neo-liberal cutbacks of the Thatcher era reduced the percentages of families that were eligible. The 1980s also saw a relaxation of nutritional guidelines by the state and the green light was given for subcontracting. This was part of a huge socioeconomic shift. Privatisation represented the biggest transfer of wealth since the dissolution of the monasteries and created a culture of complaints and a new sector of call centres to field them. Before privatisation, the canteens and kitchens that fed Britain were non-commercial. There was no competition and no need for them to try. There was also no point complaining. You got what you were given. But there was also no need for them to pander to consumer demand and the

food they slopped onto your plate was often healthier than the pizza and burger-heavy diet of the modern schoolchild. Even despite the limits of rationing, school dinners of the 1950s were actually healthier and more balanced than those today.

Things started to change well before Thatcher, though. One of the early grapeshots was Raymond Postgate's Good Food Guide, first published in 1951. Followed by the Egon Ronay Guide a few years later. These were independent guidebooks that shamed bad restaurants and drove up standards. Egon Ronay was a Hungarian restauranteur who befriended the TV chef Fanny Cradock and helped to plug French cuisine as an alternative to the masses. Meanwhile, Raymond Postgate was a British columnist who founded the (delightfully titled) Society for the Prevention of Cruelty to Food and helped encourage ordinary British people to write their own reviews of restaurants, a democratising process that continues today with TripAdvisor. Interestingly, Ronay's daughter, Edina, went on to become an actress in the 1960s Hammer Horror and Carry On films which have become touchstones for British pop culture, while Postgate's son, Oliver, became the much-loved creator of Childrens' TV classics like Bagpuss and the Clangers, themselves emblematic of English whimsy. It is as if the two families were unconsciously bound up with reshaping and packaging British national identity.

Both of the new guidebooks helped create an interest in food as a leisure pursuit at a time of increasing affluence. New forms of kitchen equipment and "labour-saving devices" like fridge-freezers, modern stoves and food mixers became a means of expressing cultural capital, while the time-poverty caused by families working the longer hours they needed to afford all the new gadgets led to a rise in demand for food prepared by others. This was especially true of women, who were working outside of the home more than ever. New supermarkets, too, meant weekly shops instead of daily trips and ready-made foods instead of cooking from scratch. By the 1970s, the average kitchen was chock-full of twaddle such as Cadbury's Smash, an instant mashed potato that was advertised by robotic Martians; and Bird's Angel Delight, a ghastly powdered-dessert that was inexplicably popular with the kids at my school. Freezers were rammed with produce from frozen-food speciality shops like Iceland and its then-larger rival Bejam's. By the 1980s, freezers were dominated by whatever food had the catchiest TV ad that week, from Birdseye Potato Waffles ("They're waffly versatile") to Findus Lean Cuisine ("Hey! Good looking! What you got cooking?") and Bernard Manning's turkey sausages ("Bootiful!"). I am having flashbacks just typing these…

The increase in foreign travel is often cited as a process that introduced the UK to food in the Mediterranean. But this was not just a simple course of one-way cultural tourism. It was just a part of a wider process of globalisation that took new products, new recipes and new people around the world and changed food culture everywhere forever. Let's start by looking at the countries of Southern Europe, North Africa and the Levant that make up the Mediterranean.

and Burger King, but there was a secondary market of American-style Italian food, chiefly the big chains of Pizza Hut and Domino's Pizza. Fairly niche until the mid-80s, pizza was suddenly young and nifty. This image was boosted by tropes within mass youth culture. For example, the underrated comedy Loverboy was released in 1989, starring the young Patrick Dempsey as a pizza delivery-boy who accidentally becomes a gigolo for his female customers (the codeword was "extra anchovies"). In another very telling example, the UK government's Department of Environment, Food and Rural Affairs started mapping the growth of pizza in the UK against the popularity of the Teenage Mutant Ninja Turtles.

Originally created as a parody of the X-Men comic books about mutated teenage superheroes, Kevin Eastmen and Peter Laird's Teenage Mutant Ninja Turtles was self-published as part of the post-punk independent comics scene. The original comics were black and white and fairly noir, but this changed when the property was picked up as a vehicle for action figures and a children's TV series. Soon they became the Platonic ideal of an overbranded global icon. The most popular character was the Californian surfer-dude, Michelangelo, a nunchuck-wielding goofball who loved pizza above all else. The fact that nunchuks were banned on UK television and that the word "ninja" was censored with the word "hero" only made him more popular with kids as it gave him a cool edge. The ensuing Nintendo video game was sold in a box containing a coupon for a free pizza courtesy of Pizza Hut, whose product placement swamped the game. To survive, players would have to guide their Ninja Turtle characters to eat slices of digital pizza to restore life points.

The big rival chain, Domino's Pizza, was not to be outdone. They created a pesky gremlin character called the Noid to help promote their guarantee that, if your pizza was not delivered within thirty minutes, it would be free. The Noid was always trying to prevent the pizza being delivered in time so it would go cold, thus making everyone annoyed ("a noid"). He was an ugly, pot-bellied creature in a skin-tight red bodysuit with flapping rabbit ears, brought to life in Claymation by the creators of the California Raisins mascots. American kids loved him. They snapped up the toys and merchandise as if they were slices of pizza. The TV cartoon show was nixed on the basis of product-placement having gone too far but the video games were a runaway success. The popularity of the Noid was not a happy occurrence for one man, though. Kenneth Noid was a troubled man in his early twenties who came to believe that the advertisements featuring the Noid were aimed at him. The relentless ubiquity of the ads eventually got the better of him and, one day, he walked into an Atlanta branch of Domino's with a .356 Magnum revolver and took two employees hostage. During the siege that followed, Noid forced his hostages to make him a pizza while he negotiated with the horde of armed police camped outside. He demanded a hundred thousand dollars, a getaway car and, mysteriously, a copy of The Widow's Son, a novel by the underground philosopher Robert Anton Wilson about a masonic conspiracy that imprisoned a man in the Bastille

(shortly before Robespierre and his revolutionaries liberated the prisoners).

"Belief is the death of intelligence."
- Robert Anton Wilson

The siege lasted for five hours before the two hostages managed to slip away and Noid was forced to give himself up to the police. He was arrested and charged with kidnapping, aggravated assault, possession of a firearm during a crime and theft by extortion (presumably for the book and the pizza). The police declared that he was "paranoid", an unfortunate choice of words, perhaps. The press widely reported that he was, variously, "mentally ill" or "paranoid schizophrenic". Either way, Noid was found not guilty on the basis of insanity and spent three months in a psychiatric institution. The resultant publicity was a public relations disaster for Domino's Pizza and they quickly retired the Noid character from their advertising. It is unknown whether this came as any kind of consolation to Kenneth Noid, who, sadly, killed himself six years later.

Domino's Pizza switched their allegiance to another set of cartoon mascots in the 1990s when it became the sponsor of Matt Groening's family of yellow misfits, the Simpsons, as their principal branding platform. This was not solely aimed at advertising to children, in the same way that the Simpsons is not solely a children's cartoon. It was ostensibly about targeting modern families but covertly established a chain of connections between pizza, fun times, pop culture and America.

At the same time as these hyper-globalised media hijinks, change was happening at a street level too. In American kitchens, the work that had been done by one ethnic group was being replaced by another. In the early 20th century, Italian immigrants had taken over kitchen work from the previous pool of Irish immigrants, but by the end of the century this work was being done by new immigrants from Asia and Latin America. Tastes changed in the USA too, with French cuisine giving way to Italian-style cooking and then new hybrids with Asian ingredients.

Chapter Three
Ethnicity & Pizza

Mediterranean food is popular throughout the world. The best pizza I ever ate was in Cairo; the best falafel I ever had was in Budapest; the most pasta I ever ate was in Tokyo; and the nicest kebab I had was in Brighton. Mediterranean food embodies ease, diversity, quality and passion. Part of the versatility is the portability: kebabs, pizza slices and borek are as handheld as the sandwich or Cornish pasty. Hospitality is important: the shared event of food and the communitas of eating together; but the most fundamental feature of Mediterranean food culture is the wanton enjoyment of food throughout some very different kinds of countries. Whether you are riding on a camel in the desert of Sudan, sitting at a seaside café in the Riviera or lounging in a Cypriot pool bar, the one commonality is the sheer dedication to gastronomy wherever you go.

But why did this passionate and globalisation-friendly cuisine emerge from the Mediterranean and not, say, Scandinavia or the Bay of Bengal? For one thing, the Mediterranean Sea is a volatile region where very different groups of people interact and trade. It is home to three of the world's main religions, with a wealth of history and culture around each one. The Mediterranean Sea is also itself an invitation to trade, travel, conquest, colonialism and immigration. It is not especially difficult to navigate and there are not a lot of natural overland barriers like mountains either that would act as natural borders, dividing groups of people and preventing communication. All of these factors come together through food culture. One book I read suggested looking at the flexibility of a simple ingredient like chickpeas as an example and see how it appears throughout the region in different guises. And it is true, there are so many variations. There is Lebanese houmous, Arab fatteh, Spanish chorizo stew, Moroccan harira, French socca, Syrian musaqaa and more. Chickpeas were even once known as Egyptian Peas and have been cultivated in that part of the world since the Stone Age. There are guidebooks on the best food in the Med that date back to 350BC. But the real Golden Age for the expansion of Mediterranean food was in the 1980s and was in the hands of some very strange cartoon characters.

American fast food restaurants expanded across Europe during the mid-1980s like cowboys opening up a new Wild West frontier. It was part of a wider global push of Americana that included stone-cold smashes like Bruce Springsteen's Born in the USA album (certified 3x Platinum with sales of 1.12m in the UK alone); monster hits like Rocky; Cold-War guff like Top Gun; and damp squibs like the hyped-up promotion of American Football to an indifferent British audience. The boom in American food was mostly driven by the burger joints like McDonalds

A similar process was underway in the UK. Just as the earlier Jewish foodsellers had seen sectors like fish and chips transfer to Greek and then Chinese ownership, these proprietors were now selling up to Turkish immigrants. In Brighton, increasing numbers of Italian restaurants were now being run by Iranians, with their waiters from Poland or Spain and their chefs from Kurdistan or Palestine. The Indian food scholar, Krishnendu Ray, calls this process "ethnic succession", the way that one ethnicity inherits the business from another, and it is linked to the way patterns of migration have changed and how these have influenced not just changing tastes but changing social positions. The succession has two sides: one is the type of food being served and the other is the type of people serving the food. An interesting thing about them is that they do not always happen at the same time, as if the new ethnicities and their new cuisines are moving through society at completely different paces.

There has not been a lot written about this process by academics or journalists because nobody wants to look like they are perpetuating stereotypes about ethnic minorities. Much in the same way that the transfer of newsagents from white British to Anglo-Asian owners in the 70s passed without comment, the transfer of newsagents away from those groups has also gone mostly unheralded. In the past decade, the trend amongst second-generation children of Pakistani, Indian and Bangladeshi newsagent owners has been to move into different sectors. But there is a lot more than simple stereotyping involved. Gujarti Hindus who had been living in East Africa as duka-walas for a hundred years began migrating to the UK in the 70s, especially after Idi Amin expelled all of the Asians from Uganda in 1972, and they brought their experience and family-connections with them. The practice of working longer hours was certainly one of the key ingredients in their economic traction, but the crucial factor was probably the willingness to work on Sundays which was then still a no-no for most white British grocers.

Avoiding the subject of ethnicity does a disservice to the daily reality of the workers who have to deal with a labour market that is rigidly segmented by ethnicity. Where you are from still has a huge bearing on what you get to do. Being foreign-born makes you statistically far more likely to work in the food industry than anything else, and your specific national origins often determine which subsectors are available to you. Not acknowledging this awkward truth does not make you more politically correct, nor does it make life any easier for those who are trying to make their way. Pizza was originally disdained because Italian immigrants were poor and disdained, not because there was something wrong with it as a foodstuff. So when Italian American immigrants had established themselves enough to climb out of the ghetto into sports arenas, political office and movie studios, their food was able to achieve a new position in American cultural imagination.

The process of succession is repeated every time there is a new demographic on the move. Immigrants arrive in the UK to discover they cannot easily find jobs. There are

a range of factors: language barriers, discrimination from employers, a lack of contacts and of recognisable qualifications etc. You may have been a doctor or a lawyer in your old country but there is a Kafkaesque bureaucracy of paperwork and requalification in between you and your old profession in the new country, just as Haval from Kambi's discovered when he tried to find work as a dental technician. The solution for many migrants is to start your own business and work for yourself, but they commonly lack significant assets or the ability to borrow money from the banks. So they borrow money from their fellow countrymen, creating a co-dependence within an informal inter-ethnic banking system that tends towards repeating the same business models (in our case the restaurant). Restaurants and takeaways are ideal for this process because of their relatively low startup capital costs and the significant markup from the cost of the original ingredients to the price of the finished meal. Their lack of assets and their unfamiliarity with local consumer society norms and language deepens the co-dependence on their countrymen for money and information about how the market works. The only competitive edge they have on their better capitalised native rivals is their cultural capital (their knowledge of unfamiliar foods) and their capacity for self-exploitation. Just as the Asian newsagent was prepared to open longer for later and on more days that their native rivals, so too the ethnic minority restaurateur is prepared to exploit themselves through levels of overwork that would otherwise be illegal and to utilise the unpaid labour of family members such as elderly relatives and youngsters. Krishnendu Ray says that this process turns sweat and loyalty into money.

Of course it is a gamble. The entrepreneurial immigrant is making a bet with the Universe that they can withstand endless overwork without collapsing mentally or physically. Many run themselves into the ground in the process. Those that do survive are those who have better English language skills, those with better connections and those who had better assets to begin with. They are the ones who are able to make the transition to less labour-intensive models such as the change from a takeaway to a white-tablecloth sit-down restaurant where the returns are far greater and the workload is more equally shouldered amongst a broader pool of workers.

Not all of those who do succeed will make an impact on British food culture, either. Gaining cultural traction is all about maintaining a steady pace of integration and upward mobility. Too much or too little upward social mobility creates a shallow dent on dining habits. In Brighton, the Iranian diaspora is dominated by the upper middle-class emigrés who arrived in the 1970s fleeing the republican revolution. Despite the presence of a number of Iranians in the Brighton food industry, this has not translated into a commensurate impact on fine dining tastes because the Iranians had too much upward mobility: they did not need to spend decades and decades establishing their cuisine in order to find financial security and were able to move on from the industry more rapidly. By contrast, the equally large Sudanese population of Brighton have experienced too little upward mobility. Even though there has been a marked number of Coptic Christians from Sudan and Egypt living in Brighton for decades, possibly

more than any other ethnic group over time, there are apparently no restaurants for them and the local chefs are not adopting their ingredients or adapting their recipes.

Something like this must be at work in Afro-Caribbean cuisine in the UK. Despite the sizeable population of Jamaican immigration to the UK since the 1950s and the establishment of settled communities, especially in South London and Birmingham, West Indian food is the most under-represented cuisine in UK restaurants. And yet Caribbean cuisine contains an accessible and longstanding tradition of dishes such as jerk chicken and curried goat with cornerstone ingredients like Scotch bonnet peppers, fresh thyme and saltfish that would definitely have mass appeal. Given the success of Indian and Chinese restaurants since the 1960s it seems strange that the Caribbean takeaway is not even remotely as common a sight on the average highstreet. Even within parts of the UK with dense proportions of Afro-Caribbean residents, they are still relatively rare. The only really noticeable impact of Jamaican foodways is the higher percentage of fried chicken takeaways in those areas. Based on the model of the Kentucky Fried Chicken (KFC) franchise, the sector is characterised by innumerable knockoffs. Most of them substitute the word "Kentucky" for a similarly Southern state such as Texas Fried Chicken or Kansas Fried Chicken, but one takeaway seems to have got the wrong end of the stick with the questionable sobriquet of Alaskan Fried Chicken (Alaska not being noted for its Southerly latitude).

Linking Afro-Caribbeans to fried chicken is often regarded as dubious and borderline racist, much like the watermelon stereotype in America which has been a major symbol in the iconography of racism for over a hundred years. But to ignore the prevalence and popularity of fried chicken takeaways in majority Black areas is to disregard evidence of a notable process: namely that these business are not Black-run. Both the ownership and workforce of the sector is dominated by immigrants from Turkey and the Levantine and before them from Greece. Furthermore, the pervasiveness of these non-ethnic pseudo-American fried chicken takeaways is in opposition to the establishment of identifiably Caribbean culture and cuisine for the consumption of the broader host population.

Black families in the UK are two to three times more likely to experience poverty and low incomes. Young black men in particular have a higher unemployment rate than any other youth group. Despite a rising number of high-profile individuals, the black experience in the UK remains overwhelmingly working class. And this lack of upward mobility is evident in the relatively small impact that Caribbean cuisine has had on British food culture. This does not mean that it will always be the case, however, and a growing Black middle class is predicted to coincide with the expansion of Caribbean restaurants in the future.

Krishnendu Ray states that large-scale immigration from any source is inversely related to the number of fine-dining ethnic restaurants native to that group at the temporal peak of the group's in-migration. What this means is that at the very point you have large numbers of people arriving from, say, Poland, you will have very few white-tablecloth Polish restaurants. At exactly that moment, though, the very same group will predominate in the restaurant labour force. Another interesting switch that occurs is that once a particular ethnic group achieves higher mobility, then their restaurants are no longer considered "authentic". So if Italian food no longer tastes authentically Italian, is it our sense of taste that has changed or is it the status of the immigrant producer that has changed? Or is it weirdly two things at the same time? It goes both ways. There are lots of Mediterranean restaurants in the UK but there are also lots of British restaurants now in the Mediterranean. In any touristy area of Spain, say, you will find British pubs and British cafes selling full English breakfasts. Even the natives in those areas are beginning to forsake their Continental breakfasts in favour of something different. In Majorca you can find Spanish teenagers eating chips, so it is a process of exchange in both directions. But of course the food does not taste quite "right", or the same, as it does back home, due to alterations in the ingredients: maybe the oil in the fryer is different, or the potatoes are not Maris Pipers. So the British food in the Mediterranean has adapted to suit local possibilities, just as the foreign food has adapted in the UK. It is no longer "authentic".

"Cooking is a language through which society unconsciously reveals its structure."
-Claude Lévi-Strauss

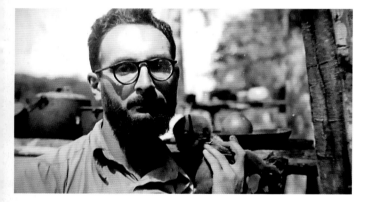

Chapter Four
Authenticity & Class

This is called culinary tourism, or exploratory eating. We all know someone who is more adventurous than normal in trying new things and who even prides themselves on this fact. This kind of exploratory eating is about having an adventure and trying new food that is outside of your culture, religion, class or even time. Of course the food that is exotic to one group is completely familiar to another, as is the venue itself and the type of music they play there. Being exploratory in this way is an assertion of your sophistication. You are open to new food so you can identify as an open-minded person. You are discovering the exotic new world or new cuisines, sometimes hidden within your own high street. It is tourism without the travel.

"The discovery of a new dish confers more happiness on
humanity, than the discovery of a new star."
-Jean Anthelme Brillat-Savarin

Darwinists and socio-biologists would probably tell you that this behaviour makes genetic sense and they would probably be right. Without those adventurous spirits, the average Neolithic caveman would never have discovered half of the edible plants and animals that we now take for granted. Every small hunter-gatherer community needed at least one person with the courage and requisite constitution to try new, possibly poisonous, foodstuffs. This continued with human expansion across the planet from Africa to Eurasia and then on into the new continents. As the new tribes of Homo Sapiens made their way north across Europe and east into Asia they had to test new food sources as they went. With so much unfamiliar flora and fauna they would have died of starvation unless they widened their diets. The ways in which these early societies classified different items as either edible or inedible were the building blocks of the way they understood the world around them and were the basis of forming abstract notions about the new environments and the social structures that they required. What we mean when we use the word "cuisine" is really just a system of classification which involves defining some things as food and some things as non-food; few cultures ever ate everything edible that was available to them. At the same time, there is a moral hierarchy between food that is cooked and food that can be eaten raw, as if the transformative power of fire was in itself a way of burning away the primitive. In Mediterranean mythology, fire was a secret knowledge that was stolen from the gods. In this way, cooking is always a kind of alchemy.

This food exploration is endlessly exciting, as it is constantly contains the possible peril that you will eat something poisonous. It can be a deadly adventure. And the thin end of this excitement is a kind of fear that manifests as disgust. Exploratory eating in the unfamiliar restaurants of ethnic minorities is on some level a play with the anxiety-inducing concepts of race, gentility and class. It can also bleed into anxieties about hygiene.

In British food culture, the takeaway is almost synonymous with the fear of unhealthy food prepared in unsanitary conditions. This fear often presents itself as part of a racist discourse about the "dirty foreigner". In the same way that diseases are often ascribed to foreigners, their food is also held up to be unpalatable and poisonous. Much early racism towards Asian migrants, for example, centred on the accusation that their food was smelly, and much early racism towards Greeks and Turks was that their food was overly greasy or that the meat was of questionable provenance. This can also be seen in racist jokes about Chinese takeaways containing meat from other animals, such as dogs or even cats. It may well be that these ideas are purely about people being uncomfortable with difference or about people asserting their superiority to "dirty" or "primitive" foreigners, but a question for inquiry is why they arise around negative judgements about food, as opposed to, say, perceived differences in intelligence or sexual behaviour, which would presumably be even more insulting. It is possible that it is informed by history and personal experience: history in the sense that there was once a widespread culture of street food in Britain up until the 19th century that was restricted by new legislation related to hygiene and left a lasting image of street food or takeaways as unclean; and personal experience in the sense that many people may well have experienced some form of food poisoning after a night of over-indulgence (although it is unknown whether that was as a result of that dodgy kebab at the end of the night or the ten pints of fizzy lager that preceded it).

Food differences often form the basis of ethnic slurs, as seen previously with the "les rosbifs" tag. To the Americans, the British are "teabags" or "limeys" (after the practice of eating citrus fruits to ward scurvy) and to the Australians they are "poms" (most likely after pomegranates). In response, the British call the French "frogs" (allegedly due to their fondness of cuisses de grenouille) and the Germans krauts (as in sauerkraut). Food discrimination and food preferences also serve to separate individuals and groups from each other in material ways. For example, I once worked at a Persian rug factory in South London that was owned by an Asian trader and had a mixed workforce of mostly either Afro-Caribbean or Pakistani labour. The memorable thing about it was that there were two canteens: one upstairs and one downstairs. I was told on my first day that all the Asians ate in one canteen and all the black workers ate in another because they disliked the smell of the Asian food. As a white employee, I felt conflicted because the one or two other white workers ate in the black canteen but if I joined them I would be tacit to the pejorative stance

on Asian food. I tried to eat in the Asian canteen but it was made evident to me by the Asians that I was not really welcome because I was white. So I tried to eat in the black canteen but I did not fit in any better there due to a perception that I was not the right kind of white person. And this was less about race and more about the way I spoke and where I was from in London, which brings us round to the issue of class.

Food discrimination is not just a way to separate people of different ethnicities, but also a way to mark the social boundaries between different classes. Attitudes to things like globalised fast food restaurants have become a globalised diagnostic of class, but the class distinctions around food, as around everything else, are much more nuanced in British culture.

In terms of eating out, swanky hotels are at one end and Sky Sports pubs are at the other. These are often larger mock-tudor pubs on the corners of unattractive junctions where you can watch the football on a big screen while eating curry and chips with a cheap pint of Fosters or Carling, generally in the company of plumbers and old soaks (there is often a karaoke machine on the weekend "for the ladies"). In between the two poles are a vast array of different places: there are Greasy Spoons (an endangered species of working men's cafés serving all-day breakfasts while blasting Heart FM on the radio) and there are hipster coffee houses (where freelance web-designers work on their laptops while unemployed web-designers serve them overpriced coffee and wipe down the reclaimed timber tables); there are carveries (aspirational

steakhouses often found in provincial hotels on Saturdays and Sundays) and there are Berni Inns (less aspirational steakhouses for people who are more comfortable with their social station, now more commonly run as Harvesters or Tobys); there are sandwich bars and there are Pret a Mangers; there are transport cafes, jazzy pizzerias, chintzy teashops, Wimpy Bars, bistros and takeaways. There are elaborately decorated Turkish restaurants with full charcoal grills and Arabian lamps and then there are utilitarian kebab shops with metal counters, wipe-down chairs and all the exotic ambience of a dentist's waiting room. All of these thousand tiny differences communicate deep data about class and social position, from the geographical location of the building on the map down to the ketchup on the table (be it served in a glass bottle, a silver tureen, a plastic tomato or in a Grab-it sachet that costs 25p extra).

People who went to university are more likely to eat out and are more likely to be prepared to try new foods. But a higher amount of money is spent on takeaway food by low-income groups. The pub is now a contested site of class conflict. From the time of the Second World War all you could get was a "Ploughman's Lunch" of bread, cheese, pickle and maybe an onion. This expanded over time in some places to include packets of crisps (one flavour), peanuts or pork scratchings. By the 1980s many pubs had microwaves and a weary landlord could offer to reluctantly heat up a steak pie if you were really insistent but this was generally just reserved for lunchtime. Admitting that you needed food as well as beer to survive an evening session was not seen as especially manly. In the lad's version of British food culture you should only really eat after you've finished drinking, rather than the more Mediterranean style of having food and drink together. By the end of the 1980s, in a bid to keep up with the Yuppie-friendly wine bars, pubs were also offering chicken nuggets in a basket or maybe, if you were really lucky, deep-fried scampi. It is acknowledged that the serving of food makes pubs more attractive to female customers and, thus, more feminine. The nationwide fad for the "gastropub" (a horrible portmanteau) is part and parcel with the bourgeoisification (that's how to portmanteau) of a lot of British working class culture, from the exclusive rise in football ticket prices to the locating of indie festivals at Butlins holiday camps. With their non-smoking atmosphere and their new child-friendly attitude, pubs are no longer a male domain like the Greek taverna; now they are more like a Swedish crèche.

One particularly middle class form of eating out is the dinner party. Up until the middle of the 20th century these were a fairly stiff affair, but in recent decades they have become more casual, possibly because of a rising self-consciousness about their inherent pretension triggered by satirical portrayals like Mike Leigh's 1977 play, Abigail's Party, where the practice had evolved into a suburban drinks party (arguably more of an influence on the decline of the tradition than Luis Buñuel's bourgeois-baiting 1962 film, The Exterminating Angel, where the guests of a dinner party are mysteriously trapped together). The practice of middle

class couples inviting each other over for dinner now forms part of a network of mutual reciprocal hospitality that resembles the Moka exchange system of Papua New Guinea (as depicted in the classic 1976 Disappearing World documentary, Ongka's Big Moka). The more generously you give, the higher your status.

Writing in her book, Watching the English, the journalist Kate Fox states that all food in England comes with an invisible class label. Tinned fruit, for example, is not for the posh. If you buy the one that comes in syrup then you are definitely working class. If you buy the one with fruit juice instead then you may be able to pass for lower middle-class. If you put hard boiled eggs or sliced tomato into a green salad then you are working class. If you are middle class you would use cherry tomatoes and you would use the egg for a soufflé instead. How you drink tea is a minefield. The upper classes enjoy weak Earl Grey without any milk, whereas, for everyone else, tea is effectively a hot milk delivery system. Sugar in your tea is considered to be lower class. If you have more than one you are definitely lower middle-class at best but if you have more than two you are definitely working class. The stronger you have it is also a factor, with the working classes leaving the teabag in for longer and squeezing it the harder.

Not only what you eat but how is also indicative of your social standing (not that I have the willpower to even address the issue of table manners and class etiquette in this chapter). Added to this is the question of when you eat (and what you call it). According to Kate Fox, the working classes eat "tea" at half past six. The northern working class refer to this as "your tea" or "my tea" as in: "Have you had your tea yet?" For the rest of the population "tea" could mean a small snack taken around 4pm involving a cup of tea and a slice of cake or possibly a cucumber sandwich although this feels increasingly old fashioned and formal. If the working classes do indulge in this snack, which is also increasingly unlikely, they would call it "afternoon tea".

The lower-middle or middle middle-class eat their evening meal around 7pm and refer to it as "dinner". The upper class and the upper middle-class reserve the use of the word "dinner" for a formal event. Their ordinary evening meal is called "supper" and is taken around 7.30pm.

The working classes call their afternoon meal "dinner". Everyone else calls it "lunch". This distinction has interesting institutional cachet. The afternoon meal at a comprehensive school is called a "school dinner" and the person who serves it and policies the cafeteria is known as the "dinner lady". At a public school like Eton, it is known as "lunch". Conversely, the meal tokens issued by white-collar companies were known as "luncheon vouchers" (also gratefully received as payment for services rendered at certain white-collar brothels in South London such as that of Cynthia Payne).

The class distinctions in mealtimes can probably be traced back to the rise of commerce in London. As recently as five hundred years ago, most people in the country dined at the curiously early times of ten or eleven o' clock in the morning. By the sixteenth century this had advanced to eleven or twelve. A hundred years later it had settled around one o' clock. This may have remained stable, but in the eighteenth century it suddenly shifted from two o' clock all the way to six o' clock, most likely in order for merchants to fit their main meal around the opening and closing of the Royal Exchange, a habit which had a knock-on effect on the rest of the banks and traders and then on to the wider populace. Not to be outdone, this is when aristocratic diners started showing up at eight or nine. The moralists of the time blamed the delay in mealtimes on the rise of social decadence and the decline in moral fibre, once again linking food control to moral goodness.

"There is such a thing as food and such a thing as poison. But the damage done by those who pass off poison as food is far less than that done by those who generation after generation convince people that food is poison."
-Paul Goodman

One of the most powerful ways in which food is used to divide classes these days is through health-correctness. This is the backbone of an entire industry for the middle classes. Kate Fox writes that food has taken over from sex as the principle concern of the "Interfering Classes"- those nannyish, middle-class busybodies who have appointed themselves guardians of the nation's culinary morals and who are currently obsessed with making the working classes eat up their vegetables. They have replaced the likes of Mary Whitehouse who represented the nation's moral fibre by drearily banging on about the evils of sex on TV. These new crusaders now complain instead about adverts for junk food during children's TV and the effect it will have on the (unstated but implied) working class children who are watching. The apotheosis of this was the broadcast of Jamie's School Dinners, a campaign led by the "Naked Chef" and fake cockney, Jamie Oliver, which demonised the eating habits of working class children. The blame was directed mostly at the female catering staff and the mothers

of the children, much in the same way that the sexual morals of working class women were vilified by the Victorians for the negative influence they had on the young.

The desexualised moral crusade of the health-evangelists is internalised in the body of the middle-class woman through neurotic eating. In recent years there has been an explosion of food allergies, gluten intolerances, lactose intolerances, vegetarianism, veganism and eating disorders such as anorexia nervosa and bulimia nervosa. Kate Fox is scathing on the issue, dismissing the majority of food intolerances as imaginary: "The English chattering-class females seem to hope that, like the Princess and the Pea, their extreme sensitives about food will somehow demonstrate that they are exquisitely sensitive, highly tuned, finely bred people, not like the vulgar hoi-polloi who can eat anything." This is unforgiving but it is notable that the basic foods which are mostly singled out for disapproval and intolerance are some of those most closely associated with lower income or rural diets such as milk and white bread, suggesting that the energy with which they are policed is evident of an anxiety around social mobility and the attempt to differentiate one's self from a prior familial class identity.

The casual way people abuse the term "allergy" to glorify a dietary intolerance is a case in point. Food allergies are rare and are an immediate response by the immune system that can cause anything from a painful rash through to anaphylaxis, a fatal breathing difficulty that requires emergency medical treatment; whereas food intolerances come on after a few hours and can cause a feeling of bloating, also known as a tummy ache.

It is not so easy to dismiss eating disorders, though. More rationally, we might put it that women of all classes have a problematic relationship with food, having one role as providers and nurtures but another in which slimness is equated with attractiveness. But eating disorders are not exclusively female, nor are the pressures of body fascism entirely gender-bound. It is worth noting that in the contemporary discourse on food and health, the ultimate focus is on body shape rather than overall wellbeing, in spite of the trend towards pseudo-scientific diets.

The concept is manifest in the current fad for "clean eating", where certain types of food, or "superfoods", are treated as medicine and ascribed miraculous healing powers. Instead of recipes we now have prescriptions. An early proponent was "Dr" Gillian McKeith, a self-described "Holistic Nutritionist" who rose to fame as the presenter of You Are What You Eat, the title a bastardisation of the Brillat-Savarin quote that opens this chapter. McKeith dedicated her programme to an analysis of people's faeces (I'm not making this up) and a diagnosis of deficiencies in their internal organs which she would attempt to correct with a diet of things like nettles, tamari sauce and carrots. McKeith's advice was undermined by the discovery that she had exaggerated her qualifications and in 2007 the Advertising Standards Authority required her to remove the title "Doctor" from her name.

She now exists on the periphery of reality television as a sort of pantomime witch on Celebrity Big Brother and I'm a Celebrity… Get Me Out of Here!

Her place on the cookery book shelves has been largely taken by the Hemsley sisters. Like a weird grown-up version of the twins Terri and Sherri from The Simpsons, the Hemsley sisters always come as a pair. They also seem to suffer from the twin's habit of having a made-up language that only they can understand, fostering ingredients such as, ahem "biodynamic eggs". They have no qualifications but advocate a fifteen-pillared regime of "wellness" including fasting and detoxing for infants as a way to cure everything from autism to schizophrenia. They even have a café in Selfridges, that cathedral of middle-class aspiration, from which to promote their fashionable, smiling, unscientific concept of nutrition.

The current reigning Princess and the Pea, though, is Ella Woodward, author of Deliciously Ella. Not only is she a vegan who eschews gluten and sugar but she also suffers from postural orthostatic tachycardia syndrome. It is an unfortunate condition that is perhaps not quite as serious as it sounds but is unpleasant to live with. In the context of clean-food culture, however, an affliction like that can turn you into Joan of Arc. Woodward's recipes include brownies made not with chocolate, flour and butter but instead knocked together out of sweet potato, buckwheat and dates. I can't wait.

The language of the clean-food police is awash with moralising terms. Some foods are "bad". Some are "good" or even "super". Pleasure is associated with

unhealthiness, denial with wellness. When the supermarkets follow the fad to label sugar-free foods as "guilt-free" it implies that the bad food makes you guilty. But in reality food cannot be said to have any intrinsic moral worth and nor can the body, surely? Food can be categorised as that which contains essential nutrients and that which is neither inedible nor poisonous. There is technically no such thing as "bad food", just too much of one thing and not enough of another. Everybody's body is different and needs more or less of different things. The most sober advice counsels moderation and exercise, not abstinence and guilt.

"A dessert without cheese is like a beautiful woman with only one eye."
-Jean Anthelme Brillat-Savarin

In the absence of academic qualifications or objective verification to justify their dietary advice, the clean-foods crusaders are left to rely on their looks. The visual medium of television and of the internet is structurally complicit in the emphasis on, above all, being skinny. This is a moral crusade, an attack on moderation and sensible eating through the pseudo-science of unqualified nutritional advice that can only harm body image and makes a mockery of those in the world who lack access to enough to eat.

Finally, there is an overlap between food-health evangelism, anorexia, religious

fasting and international famine embedded in the body that is worth exploring further but is outside of the scope of this book. Briefly, there is perhaps some kind of continuum of spiritual/neurotic behaviour bound up with the control of bodily desires including both the deliberate renunciation of food and concern for the welfare of those deprived of food. The charitable responses to famines have always been driven by, and frequently delivered by, religious groups. In the late 1970s and early 1980s some of the more liberal churches began to equate a charitable Christian response to world hunger with the reformation of one's personal diet. By the late 1980s and early 1990s there was a rise of vegetarianism in the UK that was derived from the spiritual concerns of Buddhism but largely stripped of its religious meaning and bolted on to a growing environmental concern. The London Greenpeace leaflet "What's Wrong with McDonalds" accused McDonalds of being complicit in Third World starvation and destroying rainforests (the group was unsuccessfully sued by the corporation in the twenty-year McLibel case). McDonalds restaurants became frequent targets during anti-capitalist and environmental demonstrations of the 1990s (usually by being daubed with paint or having their windows smashed) and many people turned to vegetarianism as a way to redress deforestation. This denial of the physical in pursuit of a higher moral goal or a wider social change is immediately reminiscent of the Christian fasting for Lent or the Muslim fasting for Ramadan. It is most lethally prevalent in the cult of Breatharianism, or Inedia, whose adherents believe it is possible to live without food on the sustenance of the air and sunlight alone. Needless to say, many have died trying.

"The pleasure of the table belongs to all ages, to all conditions, to all countries, and to all areas; it mingles with all other pleasures, and remains at last to console us for their departure."
-Jean Anthelme Brillat-Savarin

In conclusion, the story of British food culture is far more bound up with immigration, poverty and class than can be imagined from the trendily dismissive attitude taken by many people today. The sneering dismissal towards working class food culture in particular is disrespectful towards the suffering of the Victorian poor whose labour built the country we all now take for granted. The story, like the food itself, is a little bit subtle.

As for the future of British food culture, such divination is beyond our powers. Changing class dynamics and the unpredictable drift of immigration make it impossible to predict. What we have observed is that, in Brighton at least, the familiar flavour of the restaurant will continue to provide a city of refuge for immigrants navigating a foreign culture and the border-crossing hybridity of food will continue to provide both newcomers and natives with a universal language of hospitality.

Suggested Reading:

As this is not an academic book it was decided to avoid in-line citations, but an effort has been made to acknowledge direct quotes wherever possible without cluttering the text.

Ackroyd, Peter. 2001. London, the Biography. Vintage.
Beriss, David & Sutton, David (Eds). 2007. The Restaurants Book. Berg. (Includes Michael Hernandez, Krishnendu Ray and Eve Jochonowitz).
Brillat-Savarin, Jean Anthelme. 1825. The Physiology of Taste, Or Meditations on Transcendental Gastronomy.
Fox, Kate. 2004. Watching the English. Hodder.
Goffman, Erving. 1956. The Presentation of Self in Everyday Life. Anchor Books.
Hestosky, Carol. 2009. Food Culture in the Mediterranean. G reenwood Press.
Mason, Laura. 2004. Food Culture in Great Britain. Greenwood Press.
Navia, Luis E. 2005. Diogenes the Cynic. Humanity Books.
Watson, James & Caldwell, Melissa (Eds). 2005. The Cultural Politics of Food and Eating. Blackwell.
Wilson, Robert Anton. 1983. Prometheus Rising. New Falcon Publications.

About the author

Stephen Silverwood is the founder and Chief Executive of Refugee Radio, a charity supporting refugees, asylum seekers and vulnerable migrants. He has worked with refugee communities since 1998 and has been the host of the Refugee Radio Show since 2007. His previous publications include the Refugee Radio Times (2014, Refugee Radio Books), co-edited with Lorna Stephenson; and a chapter on refugee integration in Community-University Partnerships in Practice (2007, Niace). He also writes fiction and his credits include "The New Black" in the anthology Alt-Future (2006) and "The Founding of Brighton" in Alt-History (2005), both published by QueenSpark Books. He has written features as a freelance journalist for The Big Issue and The Guardian.

 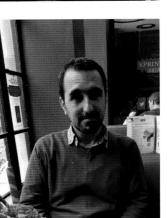

Acknowledgements

This book was the result of a joint project between two Brighton charities, Refugee Radio and Euro-Mediterranean Resources Network (Euro-Mernet for short). Our aim was to capture the hidden heritage of the people at the frontline of migration and cultural change in the unsung everyday places. We also wanted to improve the status of the people working in the hospitality industry and raise the profile of Mediterranean food.

We recruited and trained a team of volunteers, including local people as well as migrants, students and refugees. Together with the volunteers we visited dozens of cafes and kebab shops, restaurants and takeaways and tried to convince as many people as possible to take part in a series of oral history interviews. Some of these were filmed and the videos are available online at our dedicated website for this project: www.takeawayheritage. org. All of the interviews were recorded and have been edited into radio documentaries.

My inspiration and joint project-lead throughout the whole project was the indefatigable manager of Euro-Mernet, Umit Ozturk. An accomplished journalist in his homeland of Turkey and an unflagging political activist and campaigner in the UK, Umit somehow found the time to marshal all of his contacts and manifest all of his unflagging charm to help broker and support nearly every single one of the interviews for this book. It became a running joke that we had to crop the back of his head or one of his ears from most of the photos we used as he was an ever-present figure. It is in his honour that I have hidden a photo of a cat somewhere in this book. Happy hunting!

After the interviews, we then began the mammoth task of transcribing the dozens of hours of audio recordings and writing them up so they could be edited into the narrative chapters of the book. At that point it became clear that these might serve as ethnographic notes in some way and so we decided to add some of the theoretical conclusions we had arrived at during the course of the research.

I would like the thank all of the interns of Euro-Mernet who valiantly supported me during the long process of writing up the verbatim transcripts, in particular Debora, Andrea and Roberta but not forgetting Mardea, Laura, Metteo, Arianna, Debora Q. and Federica who were all invaluable during our photo exhibition at Brighton library.

In addition I would like to thank all of the volunteers who helped make this project possible: Barbora, Farah, Baran, Maria, Sophie, Ezgi, Chinatsu, Guy, Gareth and Rami. Special thanks go out to Sussex student and talented photographer, Mahmudul Moni, who took a number of the pictures used in this book and whose exhibition at the Institute of Development Studies raised some vital funds for the project.

I would also especially like to thank Shintya Kurniawan who joined Refugee Radio on a work placement as part of her adventure from Indonesia and put in so much time photographing the interviews, editing the videos and producing the website.

My eternal gratitude to Christianne for all of the proofreading and support and to Charlie and Amelie for bringing the anarchy.

Finally I would like to thank all of the owners, managers, chefs, waiters and customers who agreed to take part in this project and open up their life stories.

This book would not have been possible without the generous support of the Heritage Lottery Fund.

Stephen Silverwood. 2016.

◀ Top to bottom, left to right:
Shintya, Barbora, Andrea,
Farah, Baran, Roberta,
Rami, Mahmudul, Debora,
Arianna, Federica and Sophie.

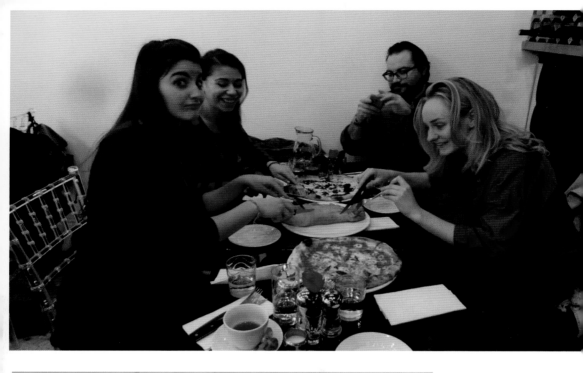

▲ **Topogigio**

▲ **Shish Kitchen**

▼ Umit Ozturk,
head of Euro-Mernet
and friend to cats
everywhere

▲ Stephen
Silverwood of
Refugee Radio

▼ Cafe Venus

◀ **Top to bottom: Blue Nile, A Taste of Sahara, Makara & Buon Appetito**

www.takeawayheritage.org

Refugee Radio
Registered charity
1133554
www.refugeeradio.org.uk

Euro-Mernet
Registered charity
1132535
www.euromernet.org